Y0-AGJ-643

For Warren and miss
1999

James-Paul Brown

James-Paul Brown

JAMES-PAUL BROWN

CAPRA PRESS
SANTA BARBARA

COPYRIGHT © 1998 JAMES-PAUL BROWN
ALL RIGHTS RESERVED.

Dedication page painting: *For Iulí,* 1998 (Mixed media)
Art photography by Wm. B. Dewey, Santa Barbara

LIBRARY OF CONGRESS CATALOGUING-IN-PUBLICATION DATA

Brown, James-Paul, 1938-
The paintings of James-Paul Brown / James-Paul Brown.
p. cm.
ISBN 0-88496-434-5 (alk. paper)
1. Brown, James-Paul, 1938- --Catalogs. I. Title.
ND237.B8737A4 1998
759.13--dc21 98-8804
CIP

CAPRA PRESS
Post Office Box 2068
Santa Barbara, CA 93120

FOR JULIET

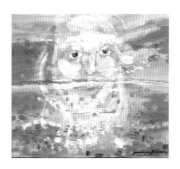

THE PAINTINGS OF JAMES-PAUL BROWN

JAMES-PAUL BROWN'S captivating paintings of wildly expressionistic landscapes, exotic seaports, musical and theatrical extravaganzas, flowers, and people – dancers, athletes, musicians, and movie stars – are a direct extension of his personal delight with life and his exuberant nature.

A colorist, Brown continues and expands the exploration of light and bright colors through his vivid suites of images, especially his energetic landscapes – charming country lanes, fields of wildflowers, sun-splashed rolling hills – transforming each idyllic scene into a rich panoply of visions and emotions. Brown's joyous and playful works are a visual translation of his passionate feelings, not only for art, but for the world at large. An inexhaustible love of creativity is contained in each of these paintings – James-Paul paints for the sheer pleasure of it, and delights in sharing his enthusiasm with others.

Michael Zakian, Director of the Frederick Weisman Museum of Art at Pepperdine University observed, "James-Paul is a sensitive and caring recorder of intimate sights and events. His best paintings are lyric. As in lyric poetry, the art results from a rapid outpouring of intense personal feeling. For Brown, there is little concern for established forms or traditions. Intuition and spontaneity rule. Yet these paintings offer more than just uncontrolled passion. The artist's concern for beauty, propriety, and the integrity of all things gives his art a certain balance and restraint."

The people that attract him as subjects for his art are those who have extended themselves beyond the ordinary into the realm of celebrity and near-myth. James Reed, Curator of the Riverside Art Museum wrote, "Brown takes today's heroes from the worlds of entertainment and sports and transposes each likeness to canvas and paper with vibrant energy. He fuses the powerful dappled brush strokes of the Impressionists and the unique color field of the

Fauves with contemporary iconography, setting these invigorating figures in an environment that borders on psychedelic frenzy."

Brown's attitude towards life is romantic, and it is not surprising he has created a large number of paintings inspired by his beautiful wife Juliet. An actress and PhD candidate in psychology, she appears throughout his work in various guises – as a mermaid, as Ophelia, as an ethereal sprite, or simply as herself, sunning beside a pool. She is his muse, and in those paintings featuring her, the subject is without question Eros.

James-Paul Brown has had a remarkable career. In 1980 his first art exhibit at the West Beach Café in Venice, California sold out. Soon thereafter, the entire run of a limited edition lithograph of his painting *Artist's Table* also sold out. At this point, following a relationship with the Los Angeles Ballet, his career took off: In 1982, CBS Sports hired him to capture the World Games in Canada and the 1983 Pan-American Games in Venezuela. For the 1984 Olympics in Los Angeles, he joined David Hockney and Leroy Neiman as official artists of the Games. The 1996 Olympics in Atlanta inspired 20 paintings and three bronze sculptures. His stirring colors and hyperkinetic forms are ideal for capturing thrilling moments of major sporting events – Super Bowl XXX, Wimbledon 1985 (for NBC), the 1988 America's Cup, Kentucky Derby, the Las Vegas Marathon, and the Swimming Hall of Fame, to name a few.

James-Paul has also done exceptional pictorial work for the Ballanchine Ballet Company, the New York Philharmonic, the Bolshoi Ballet, and the Cannes Film Festival. He was commissioned by the U.S. State Department to paint a portrait of Pope John Paul II during the Pope's visit to the U.S. He has also painted inaugural-event portraits of Presidents Reagan, Bush and Clinton.

Brown's art appears in numerous private and public collections in the U.S. and abroad, including the collections of Clint Eastwood, Robert Altman, Joan Kroc, Mrs. Anwar Sadat, Elton John, and Hank Aaron. For many years, James-Paul has donated works to charitable causes, such as the Children's Hospital and Cedars of Sinai Hospital in Los Angeles, the American Cancer Society, and Easter Seals. As a wine connoisseur, James-Paul's art has graced over 50 wine labels for Creston and Sunstone Vineyards, both of California. He has also released his own wine "Artiste."

James-Paul Brown's art reflects a positive, upbeat attitude towards life. The romantic and irresistible charm of his paintings will surely lift the spirits of all who encounter them.

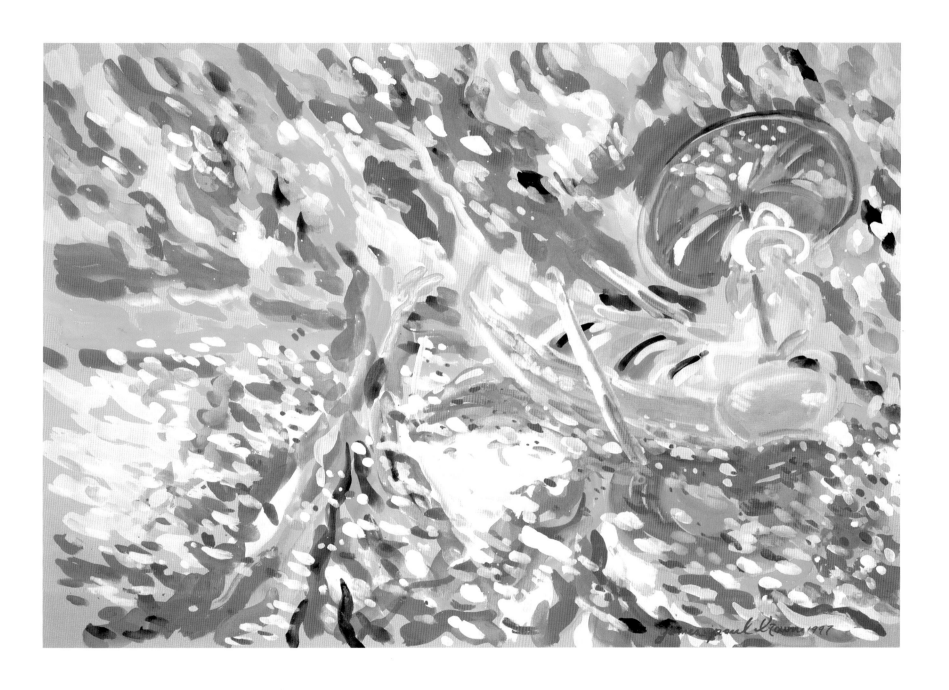

Summer Afternoon, 1997 (mixed media)

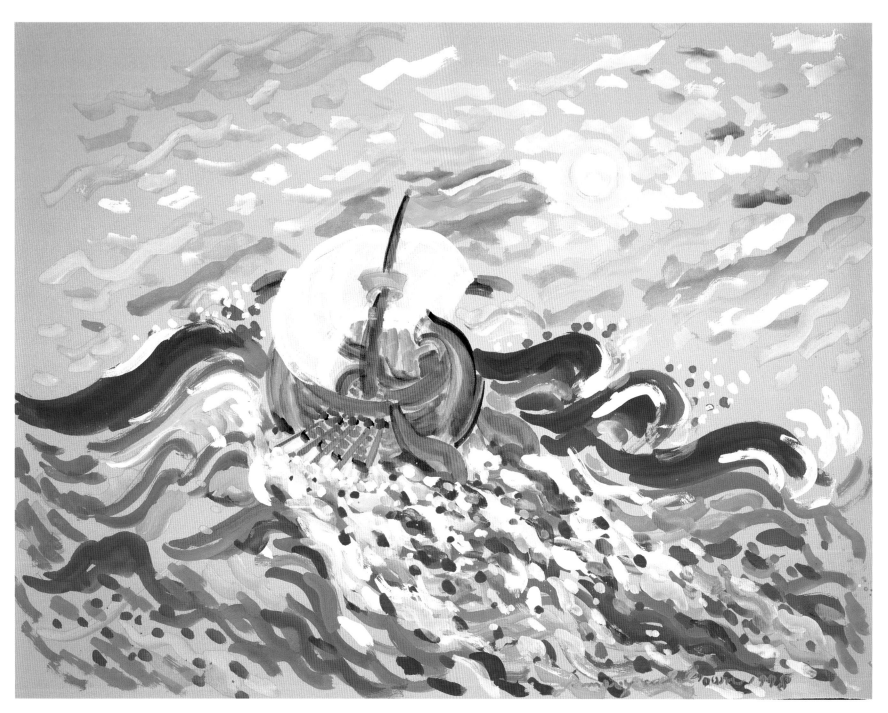

Sinbad's Voyage, 1997 (mixed media)

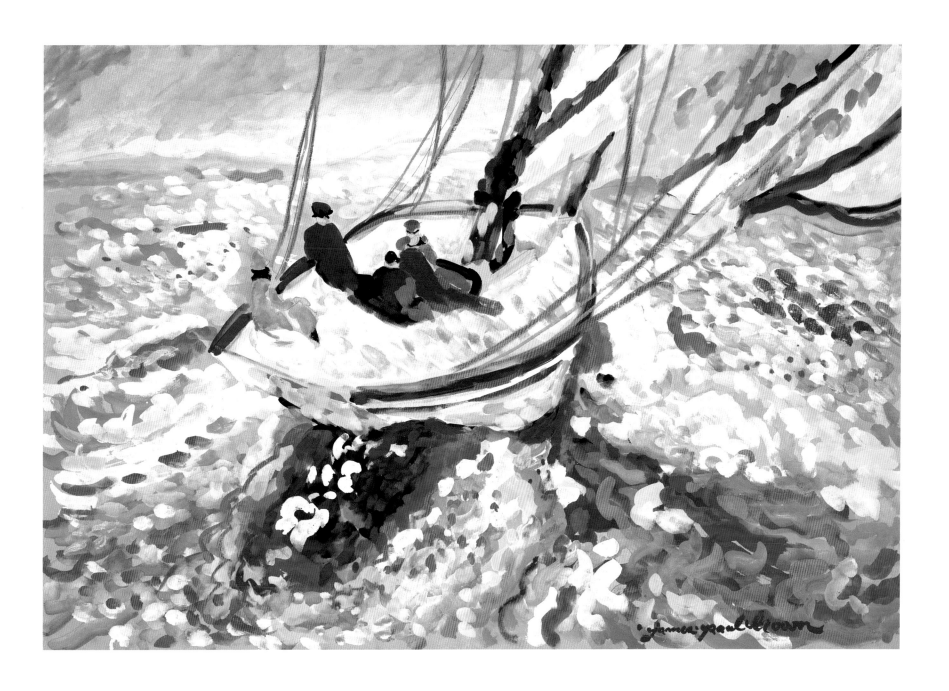

Sunday Afternoon, 1995 (mixed media)

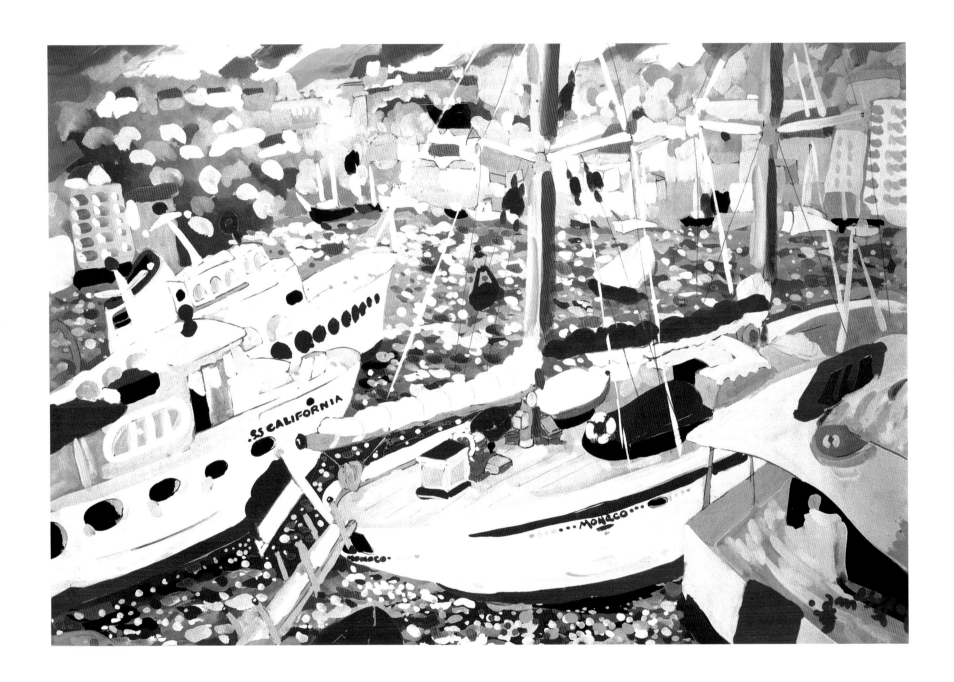

Monaco Harbor, 1993 (mixed media)

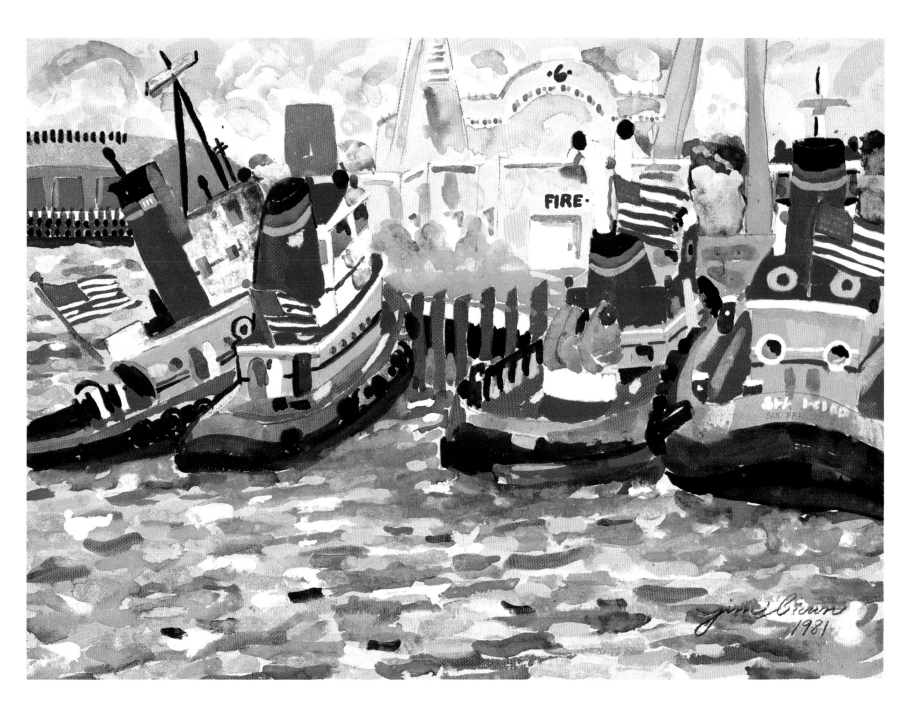

Tugboats, 1981 (mixed media)

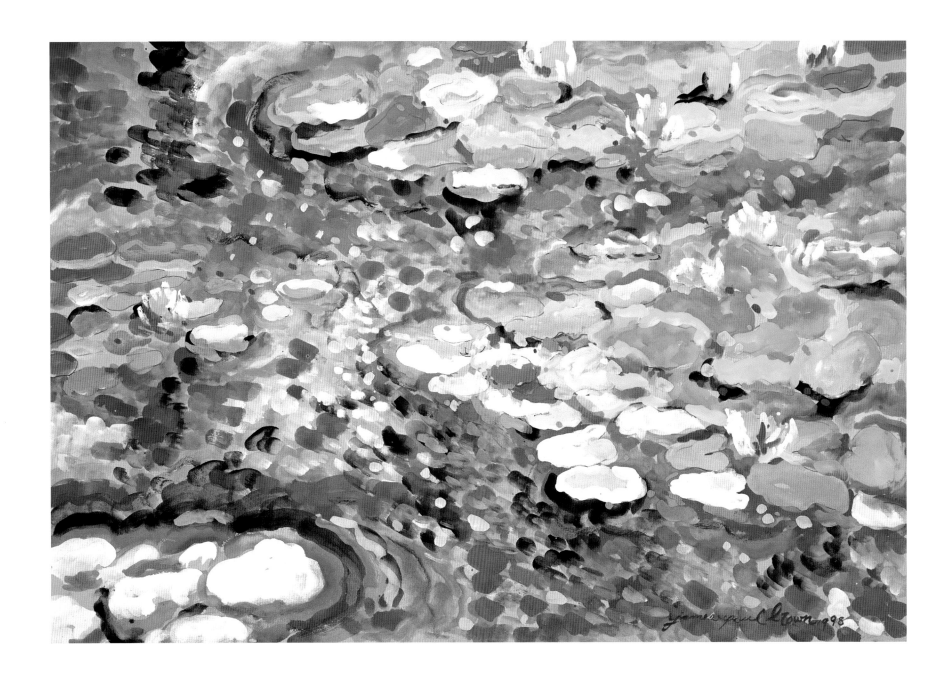

Lily Pads I, 1998 (mixed media)

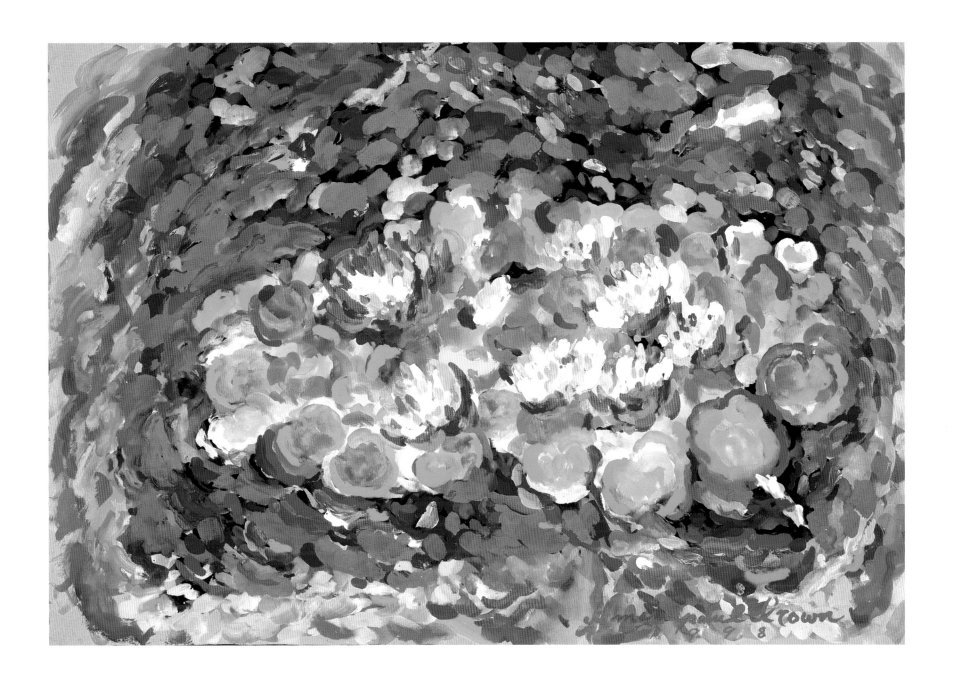

Lily Pads II, 1998 (mixed media)

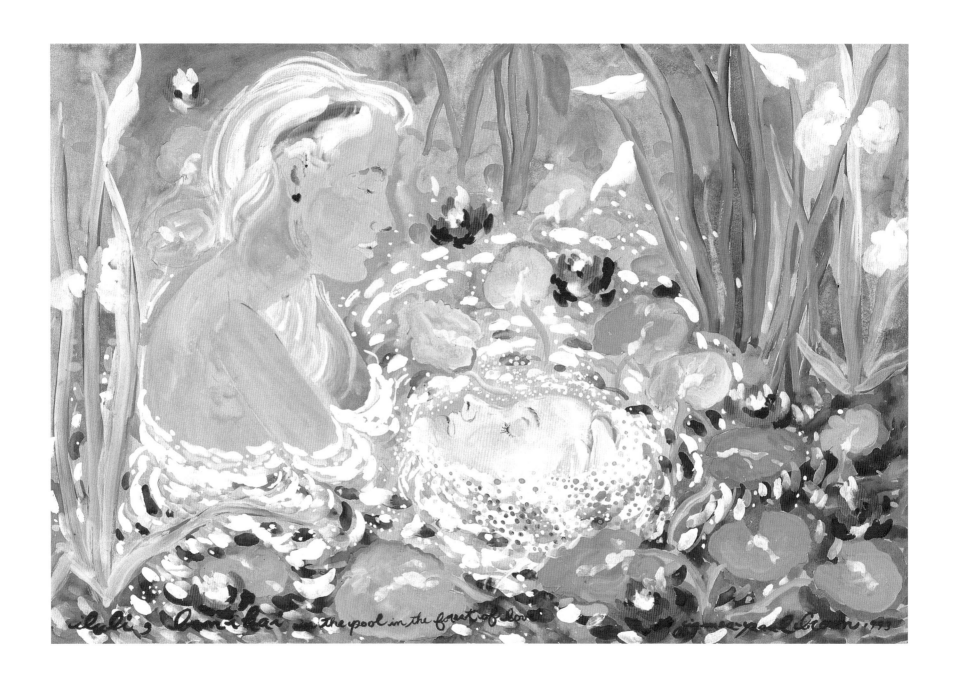

Juliet's Reflection on the Water, 1993 (mixed media)

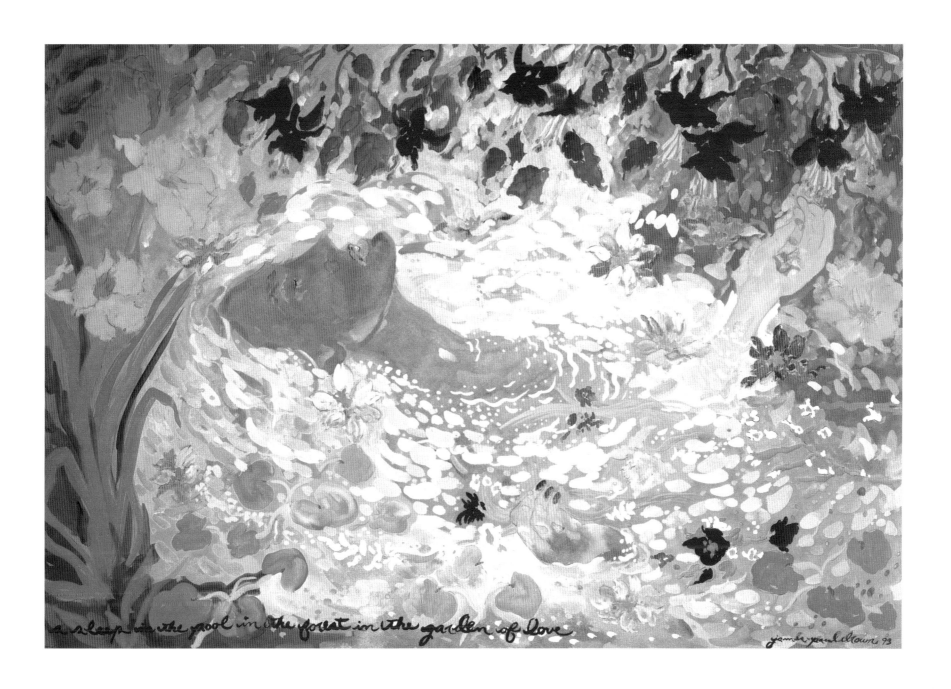

asleep in the pool in the forest in the garden of love

james paul brown 93

Ophelia I – Asleep in the Pool of Love, 1993 (mixed media)

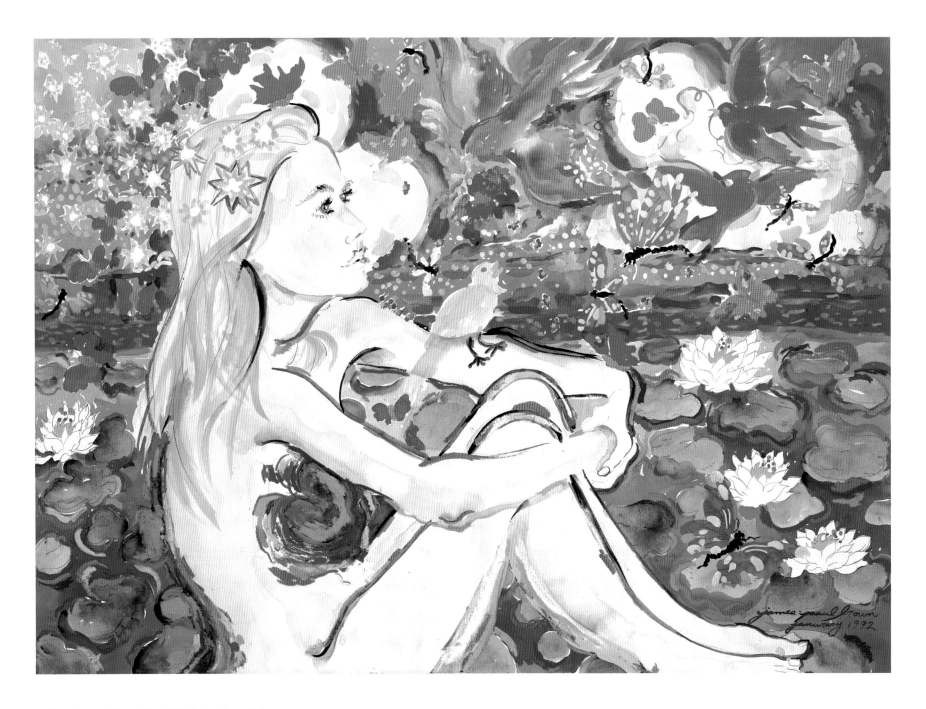

Juliet – Queen Water Lily, 1992 (mixed media)

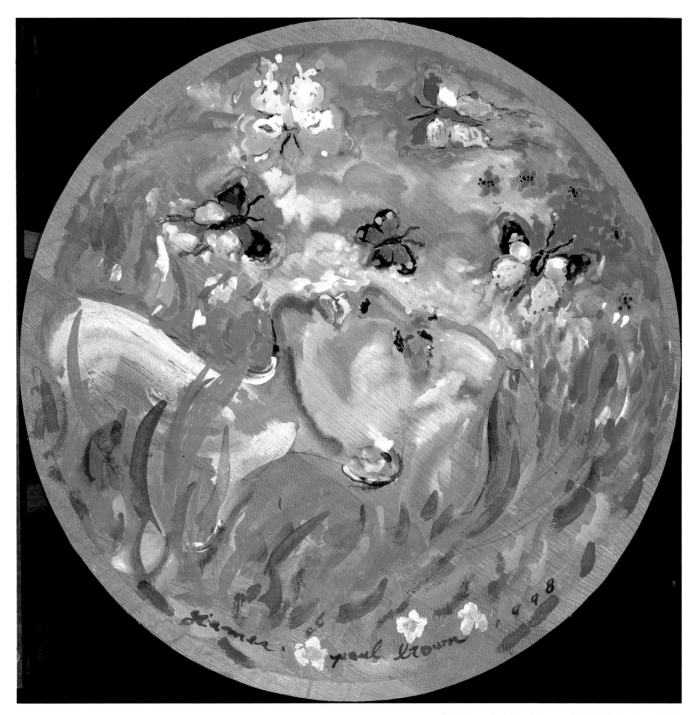

Juliet Dreaming in a Vineyard, 1998 (mixed media)

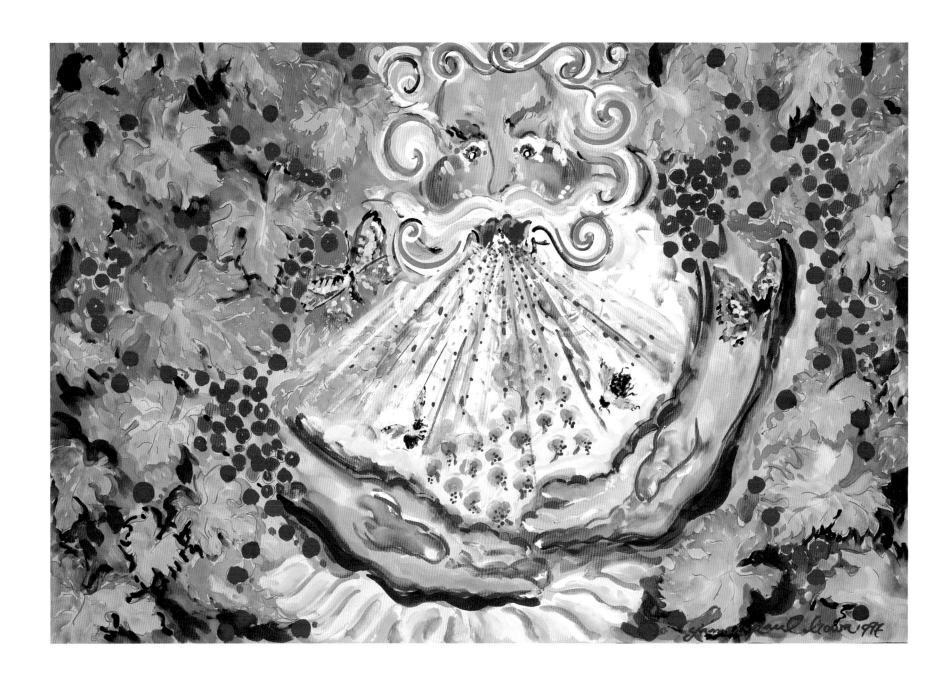

Mighty Winemaker 1, 1997 (mixed media)

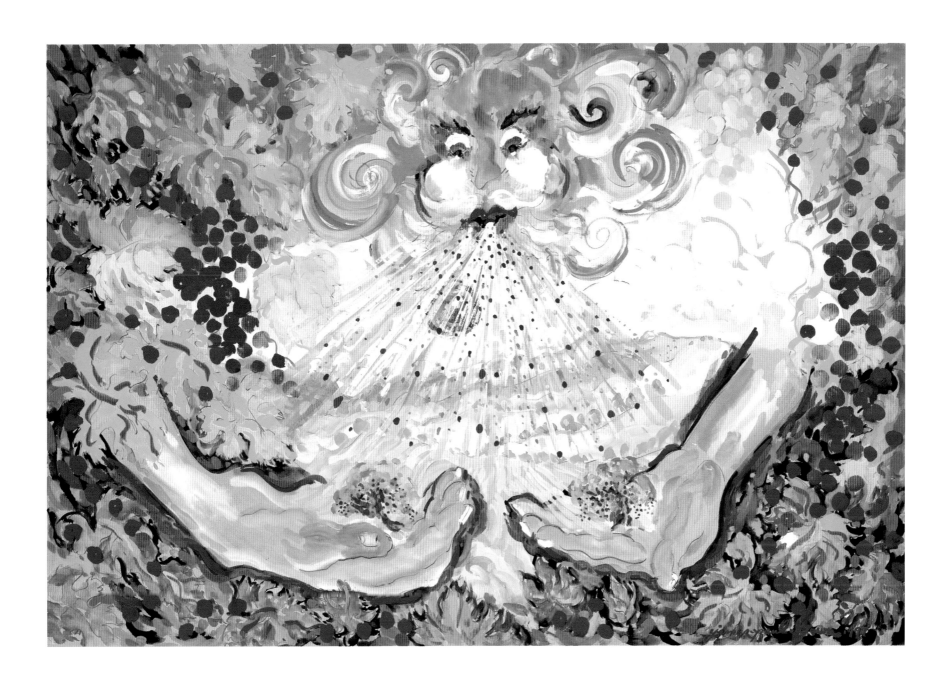

Mighty Winemaker 11, 1997 (mixed media)

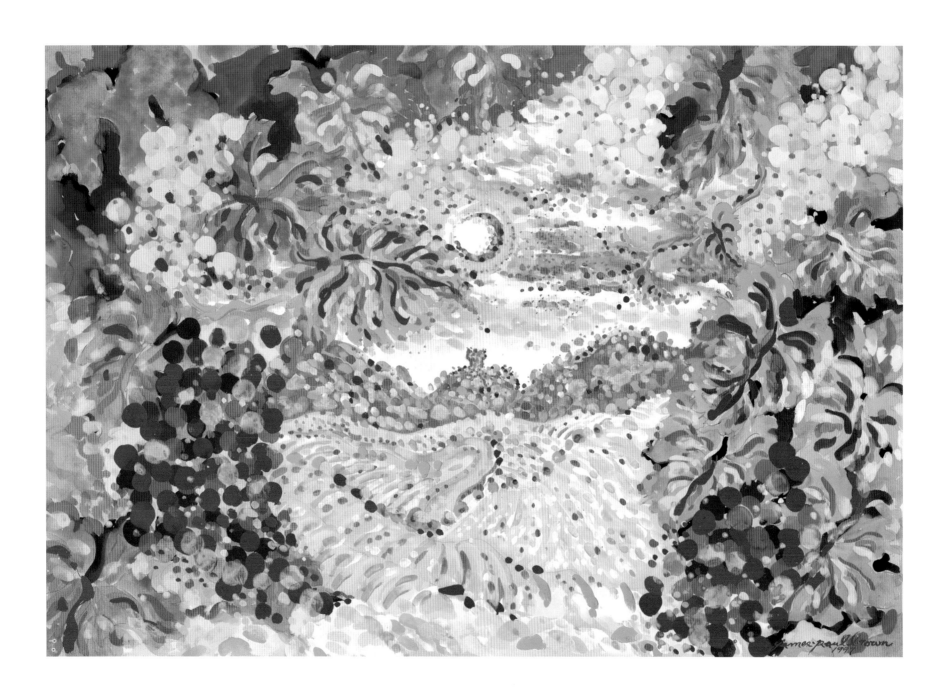

California Vineyard I, 1997 (mixed media)

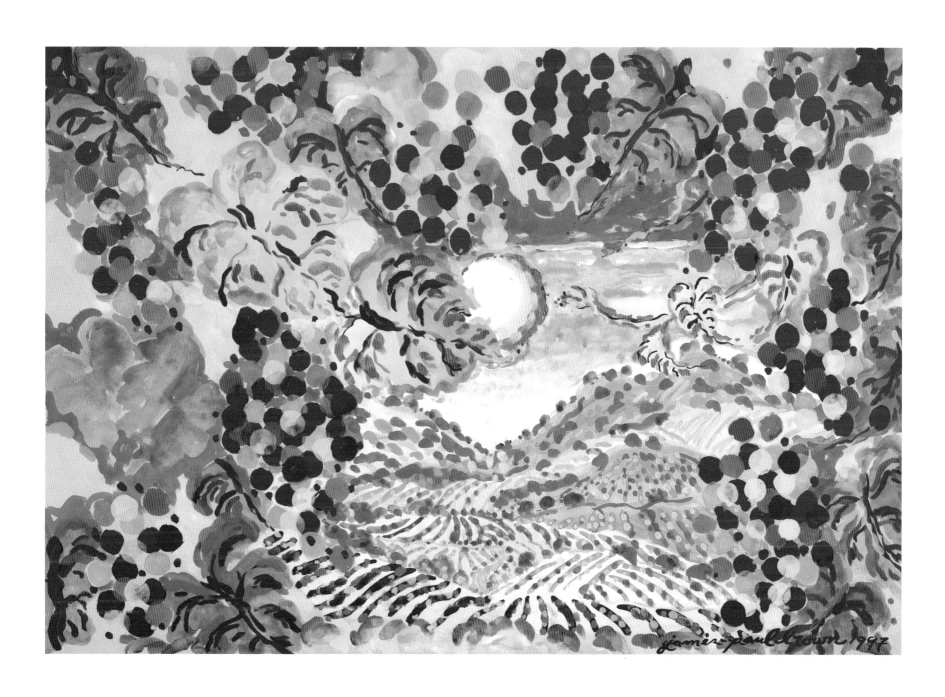

California Vineyard II, 1997 (mixed media)

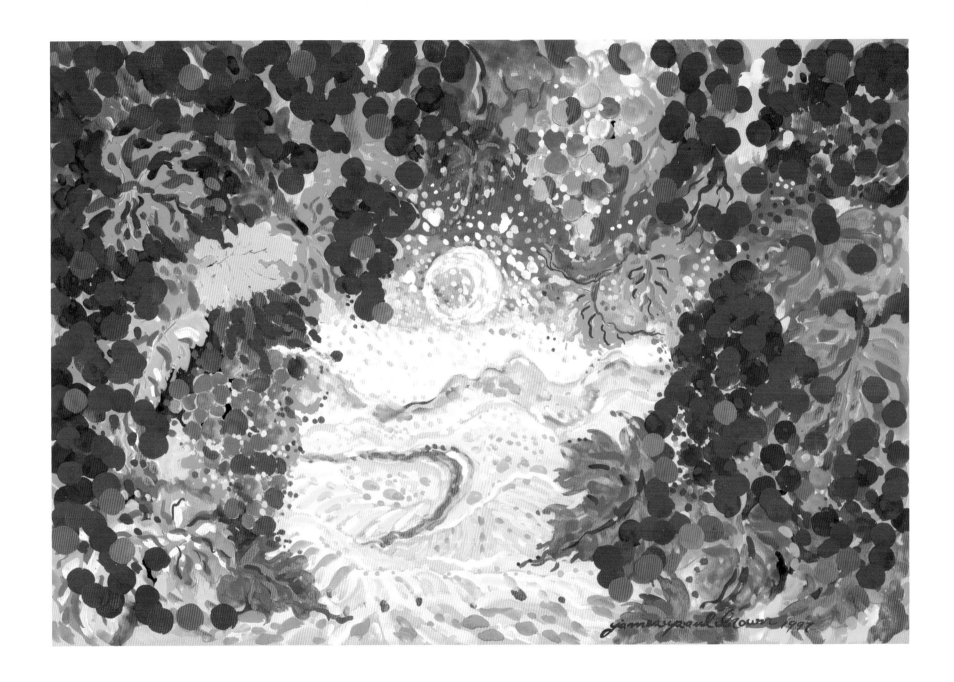

California Vineyard III, 1997 (mixed media)

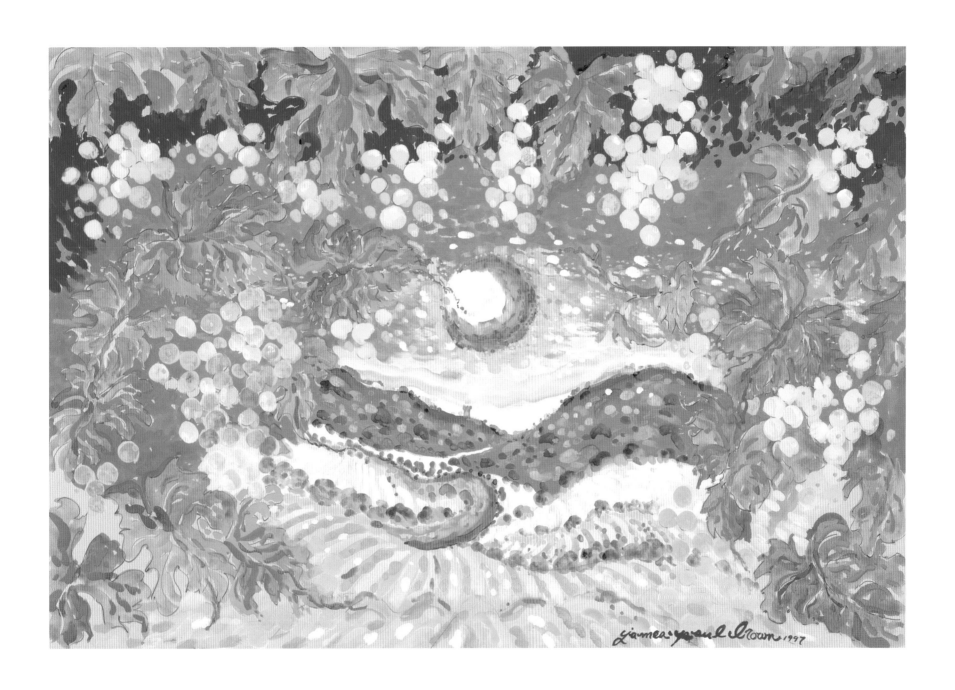

California Vineyard IV, 1997 (mixed media)

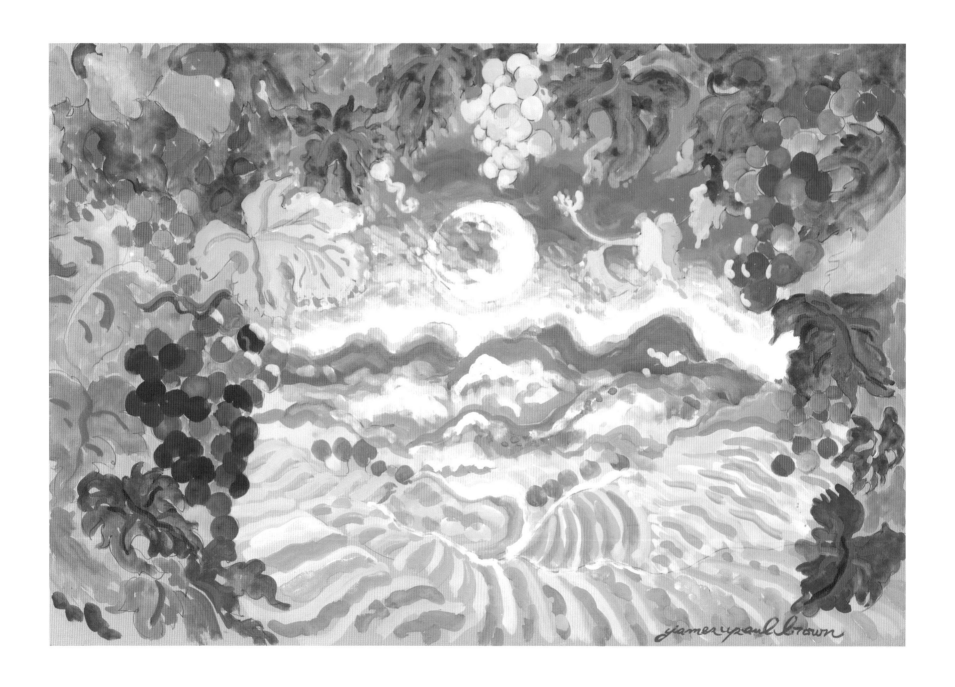

California Vineyard V, 1997 (mixed media)

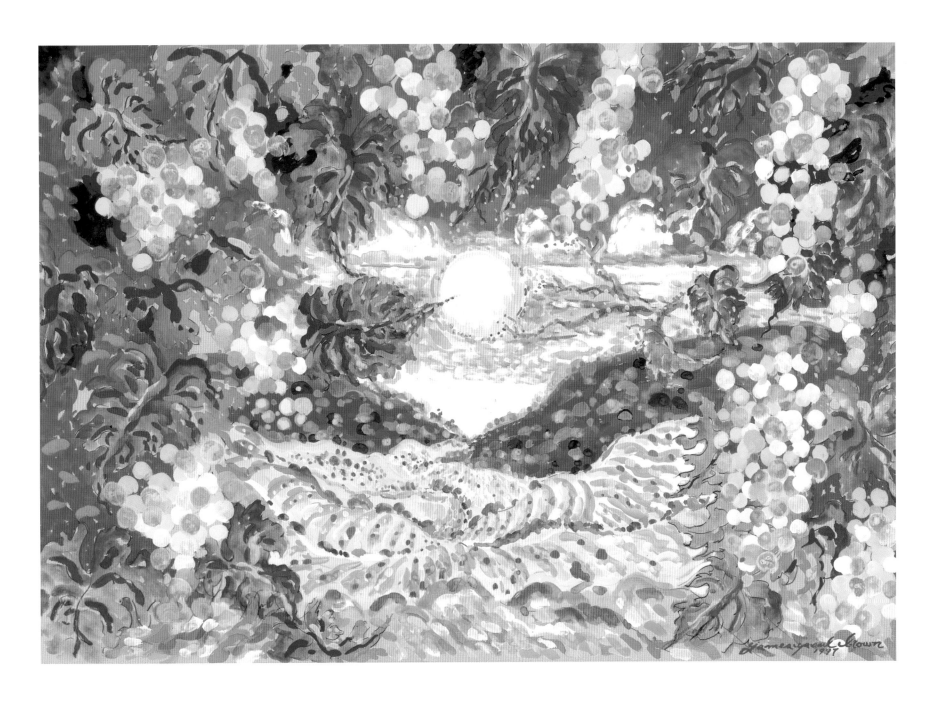

California Vineyard VI, 1997 (mixed media)

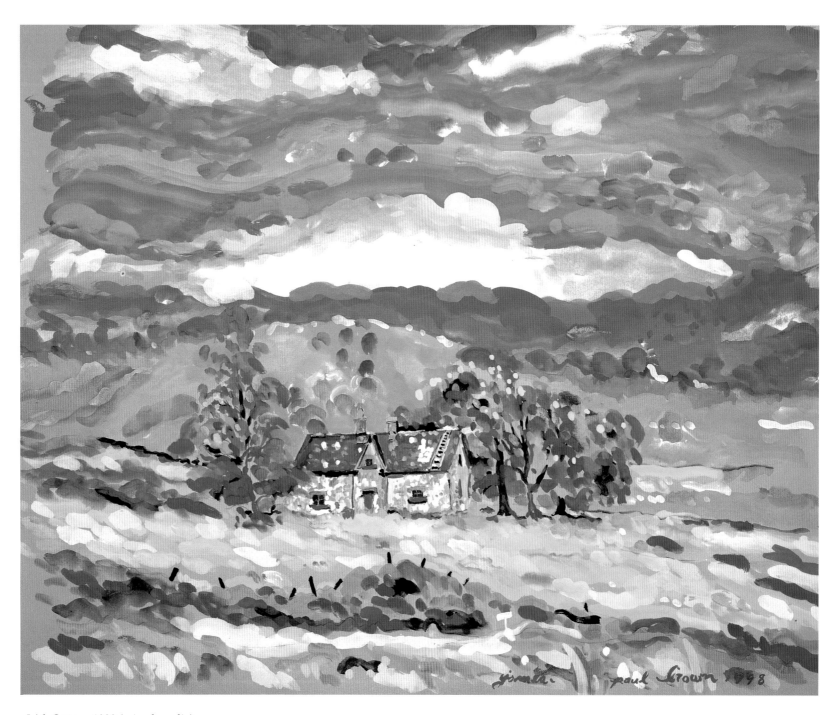

Irish Cottage, 1998 (mixed media)

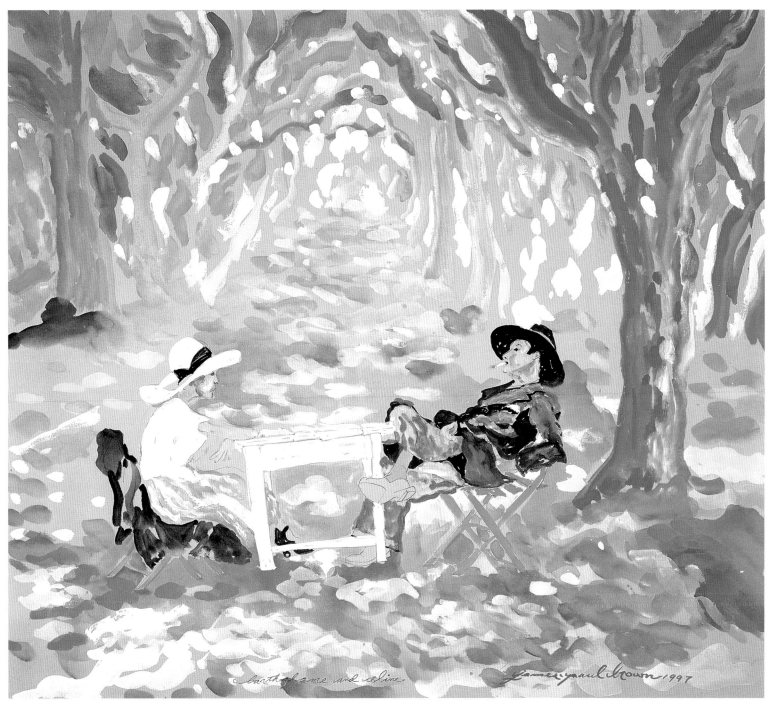

For Yvette & Archie, 1998 (mixed media)

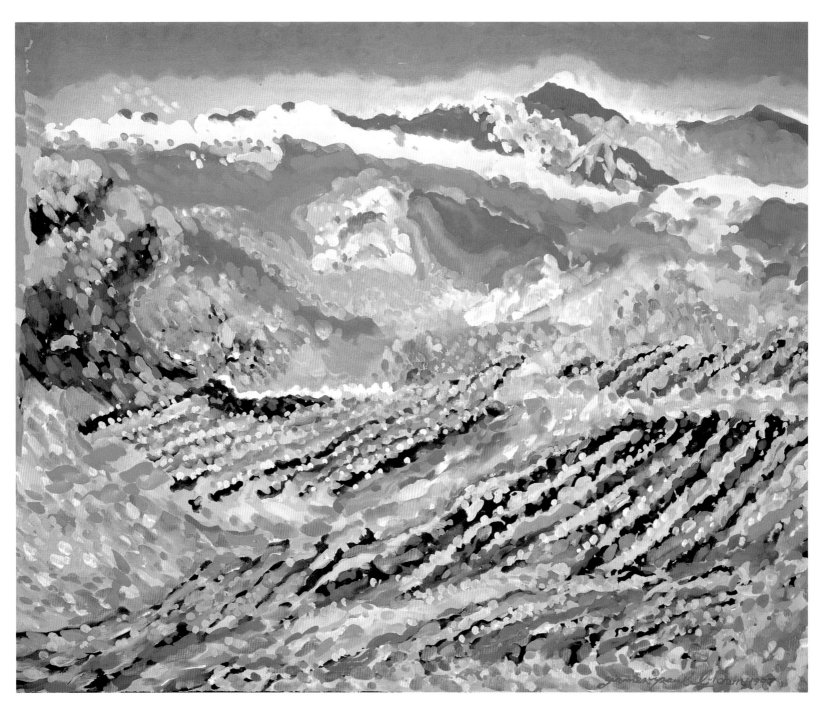

Justin's Vineyard from Gary Conway's Hill, 1997 (mixed media)

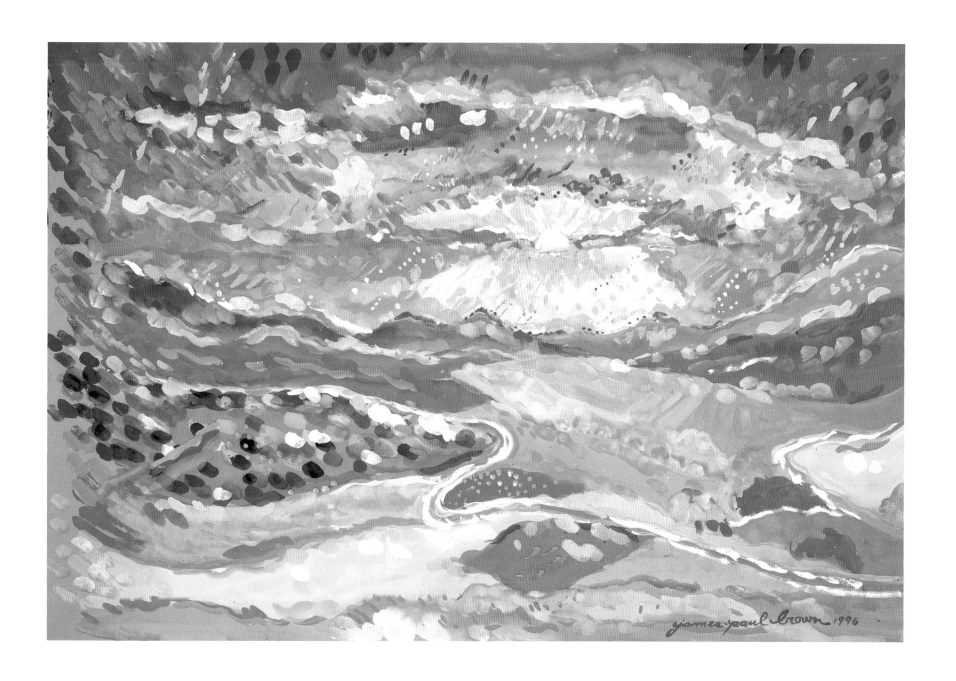

Coastal Sunset, 1996 (mixed media)

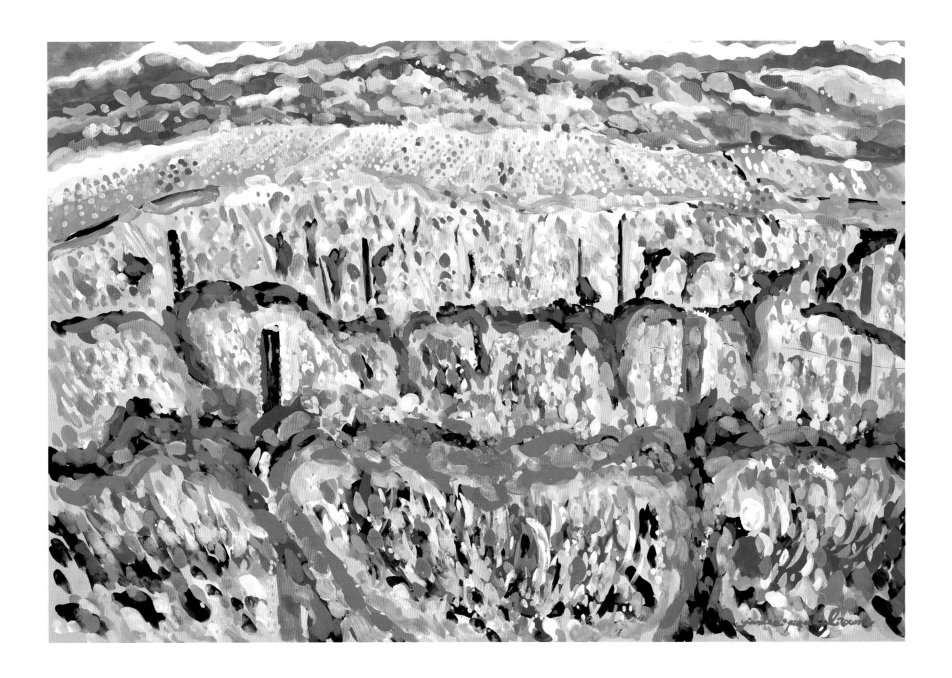

Sunstone Winery, 1996 (mixed media)

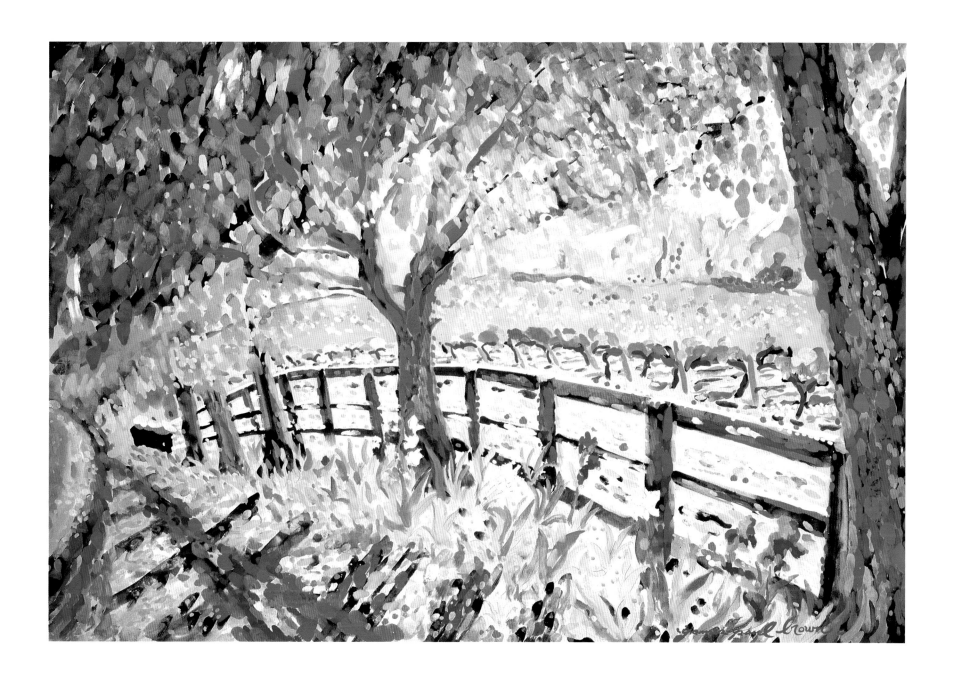

Road to Romance, 1996 (mixed media)

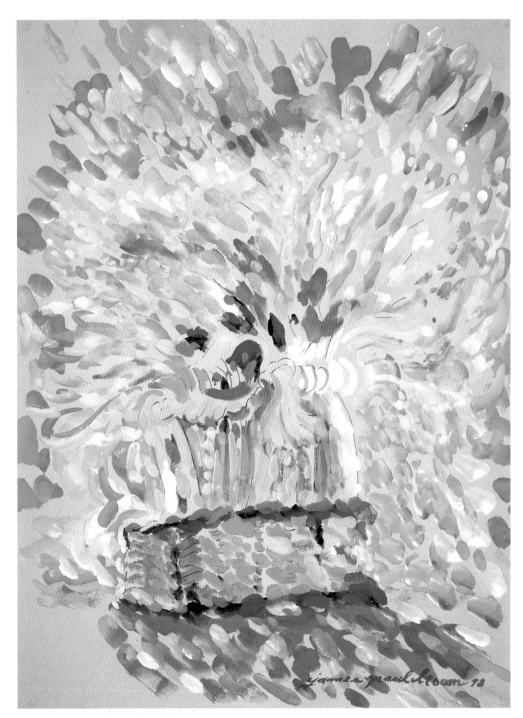

Haystack I, 1998 (mixed media)

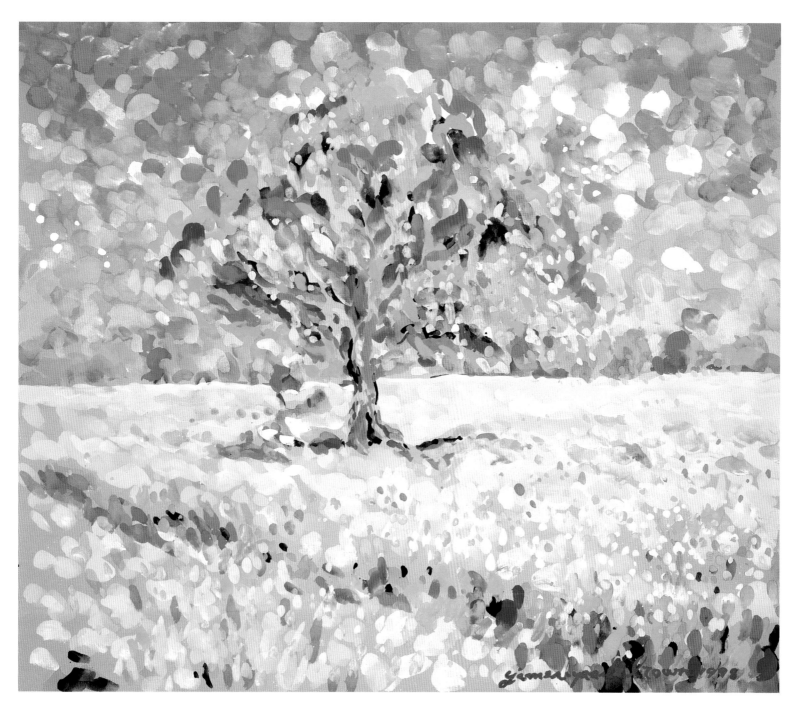

Oak and Spring Grass, 1998 (mixed media)

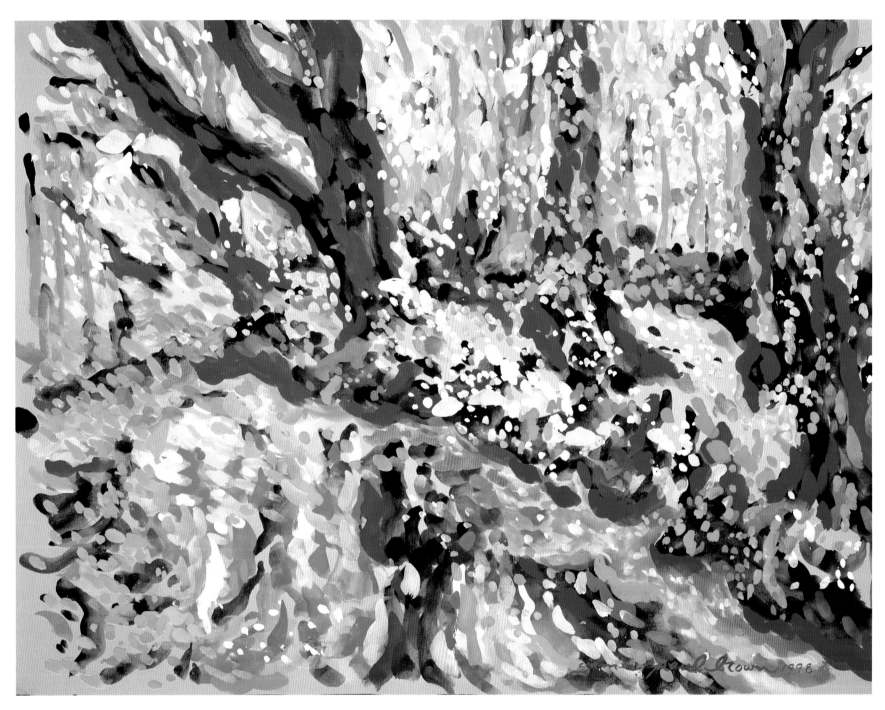

Sylvan Stream, 1998 (mixed media)

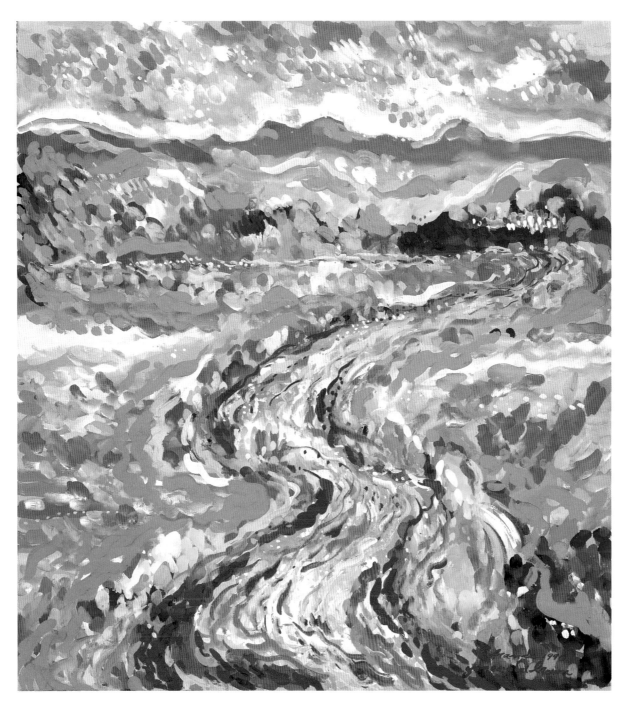

Provence River, 1996 (mixed media)

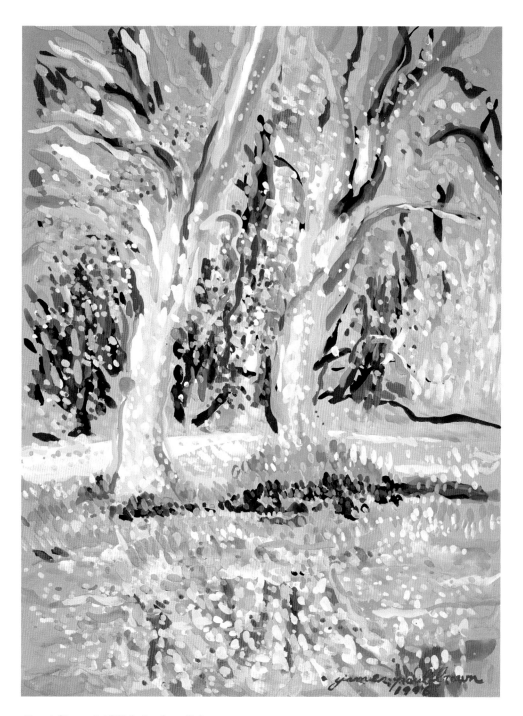

Forest Stream I, 1998 (mixed media)

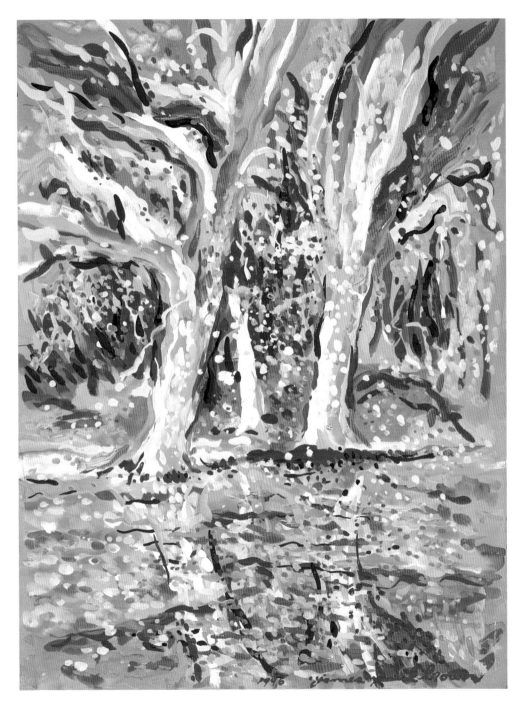

Forest Stream II, 1998 (mixed media)

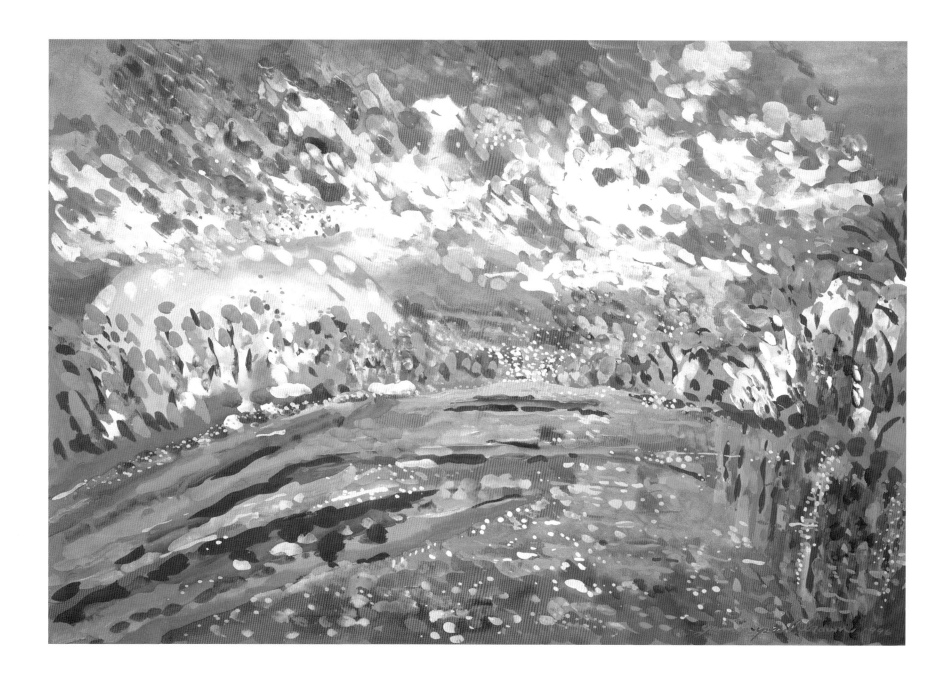

Sunset on the River, (mixed media)

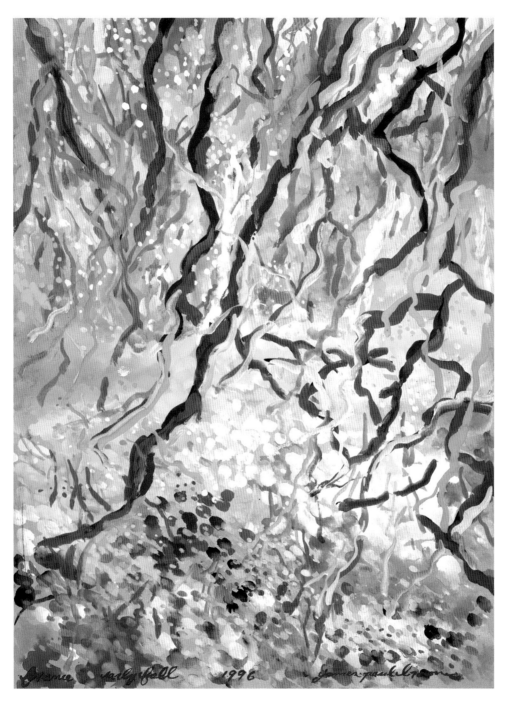

Parisian Stream, 1996 (mixed media)

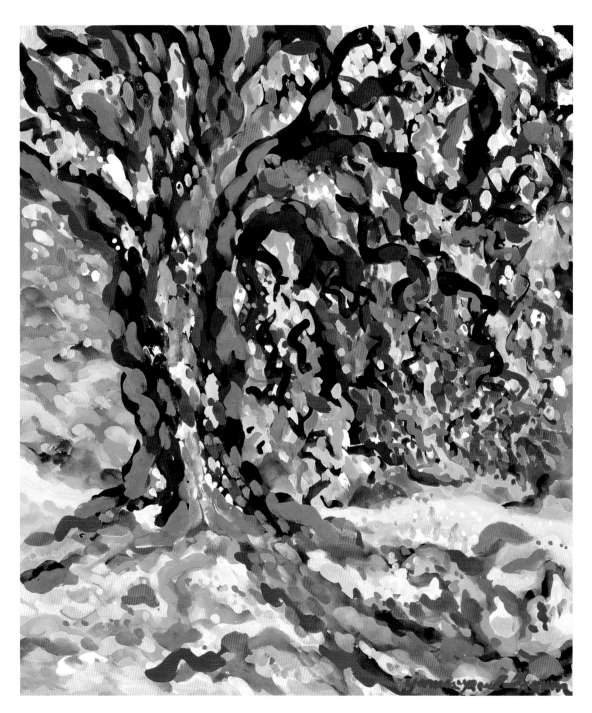

Magic Tree I, 1997 (mixed media)

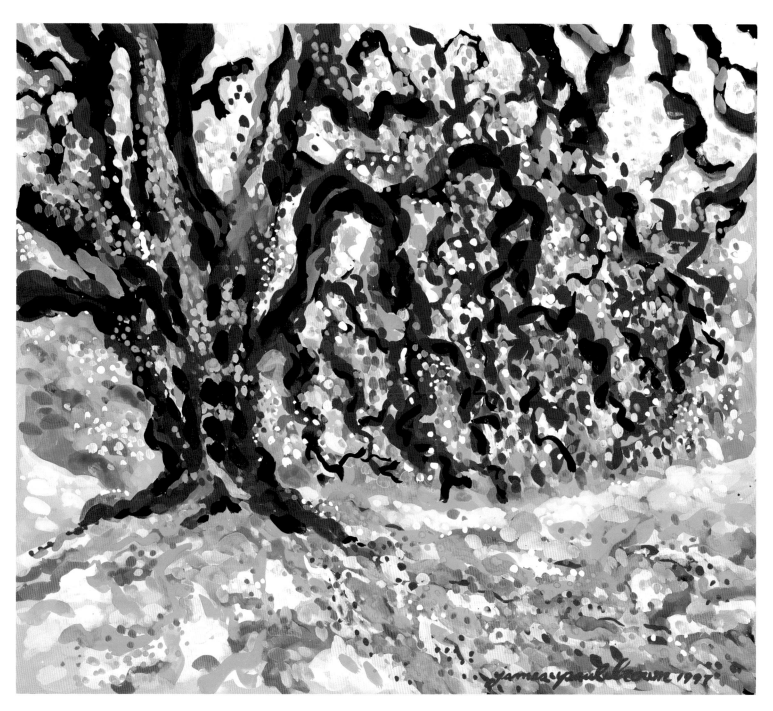

Magic Tree II, 1997 (mixed media)

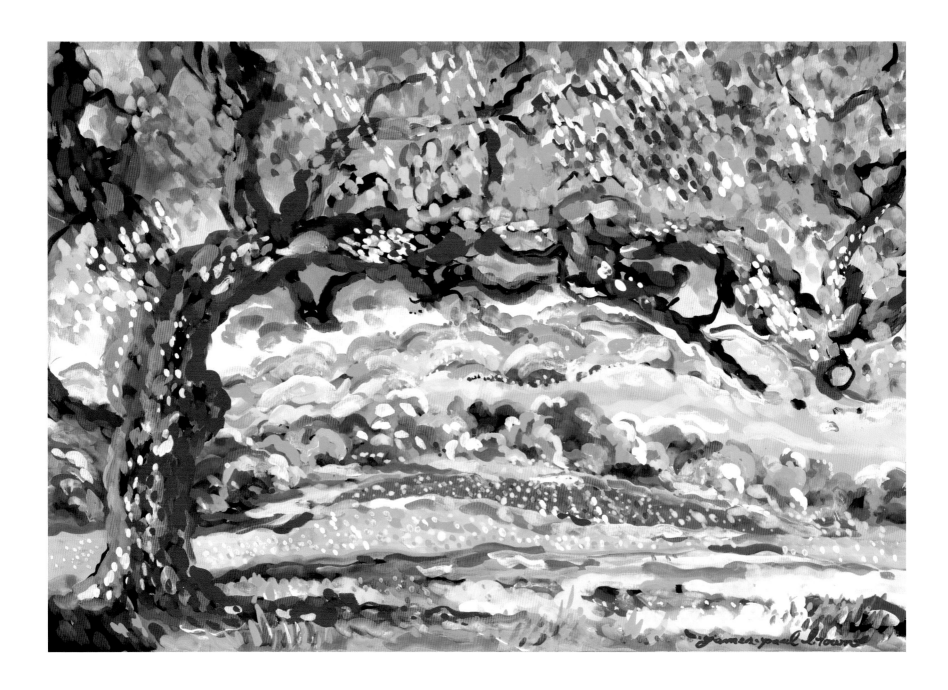

Enchanted Tree, 1997 (mixed media)

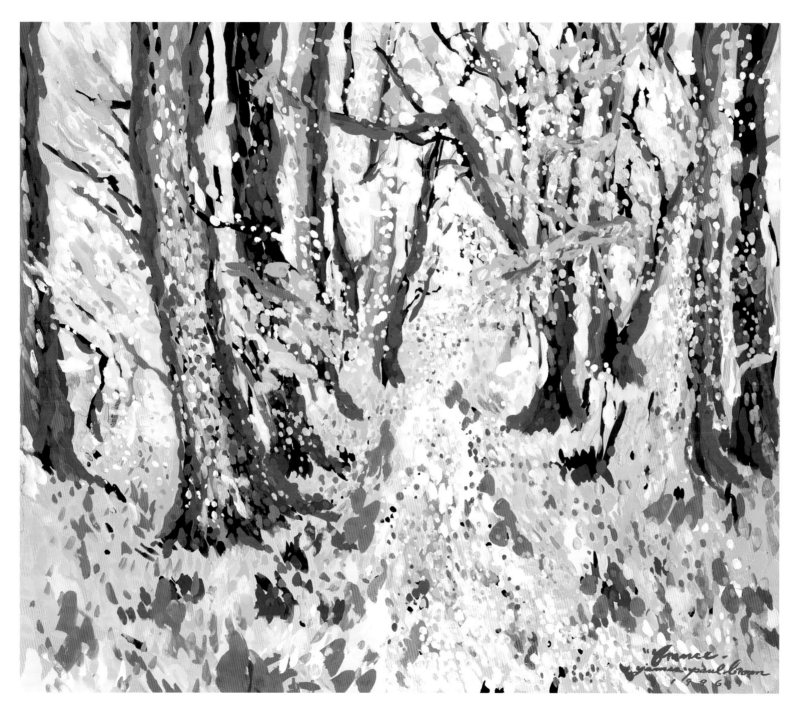

Secret Path I, 1998 (mixed media)

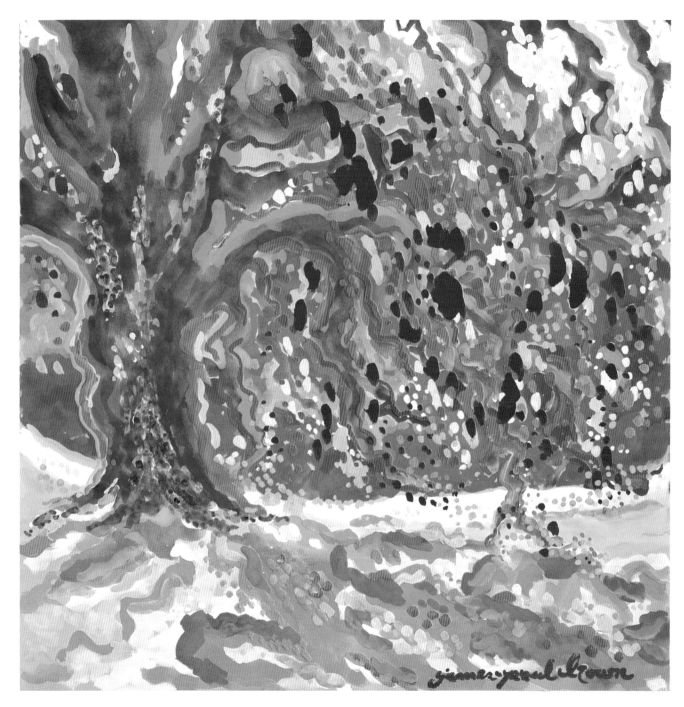

Magic Tree III, 1997 (mixed media)

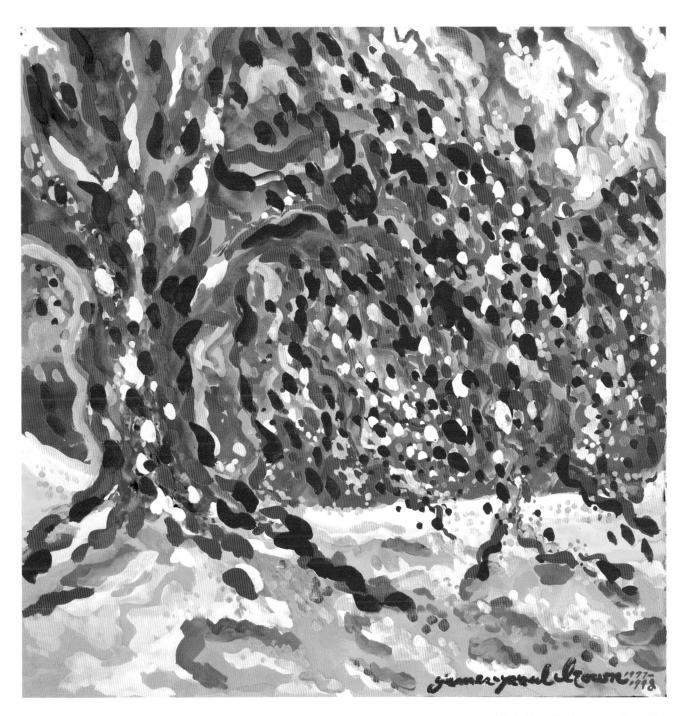

Magic Tree IV, 1997 (mixed media)

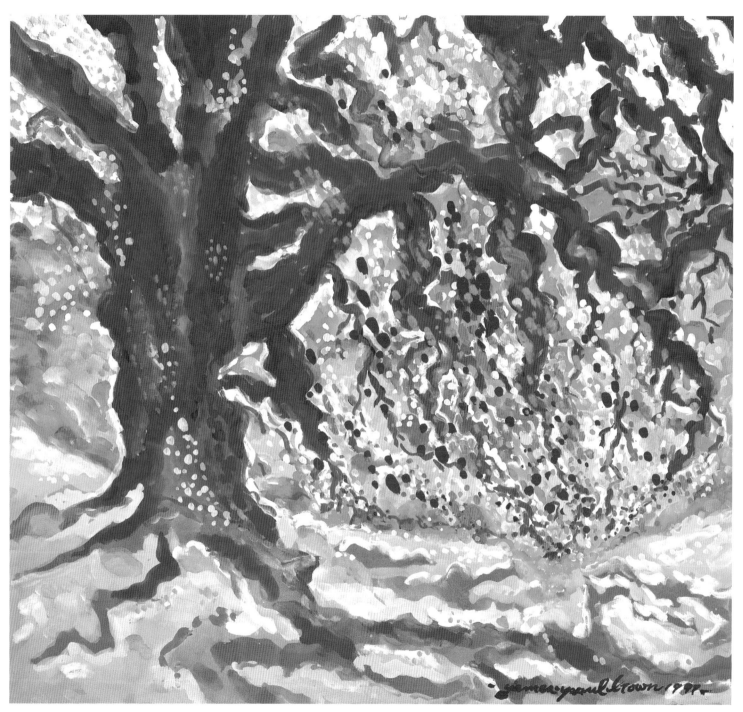

Magical Tree V, 1997 (mixed media)

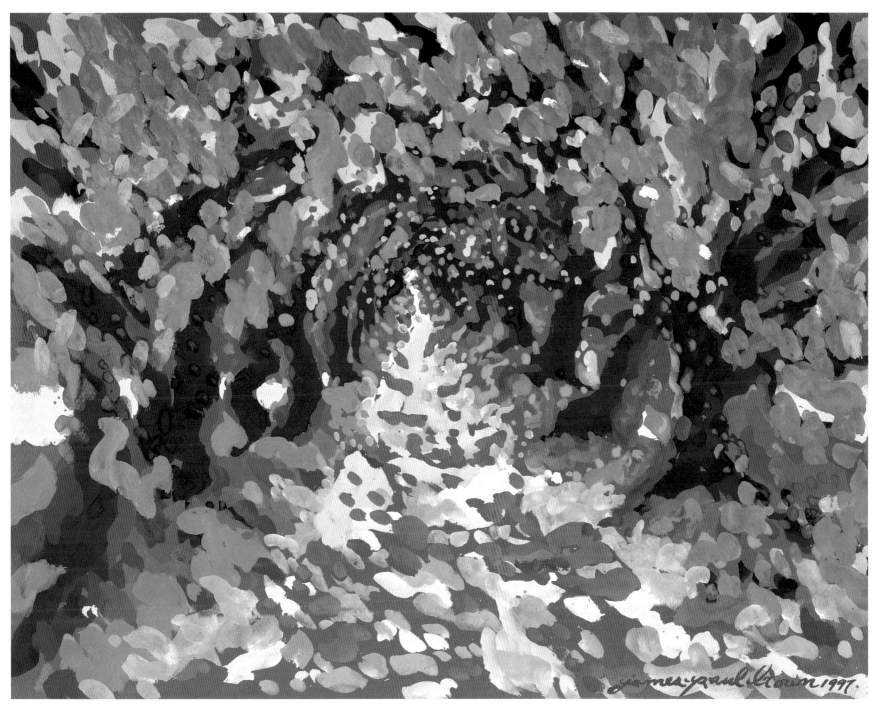

Secret Path II, 1997 (mixed media)

49

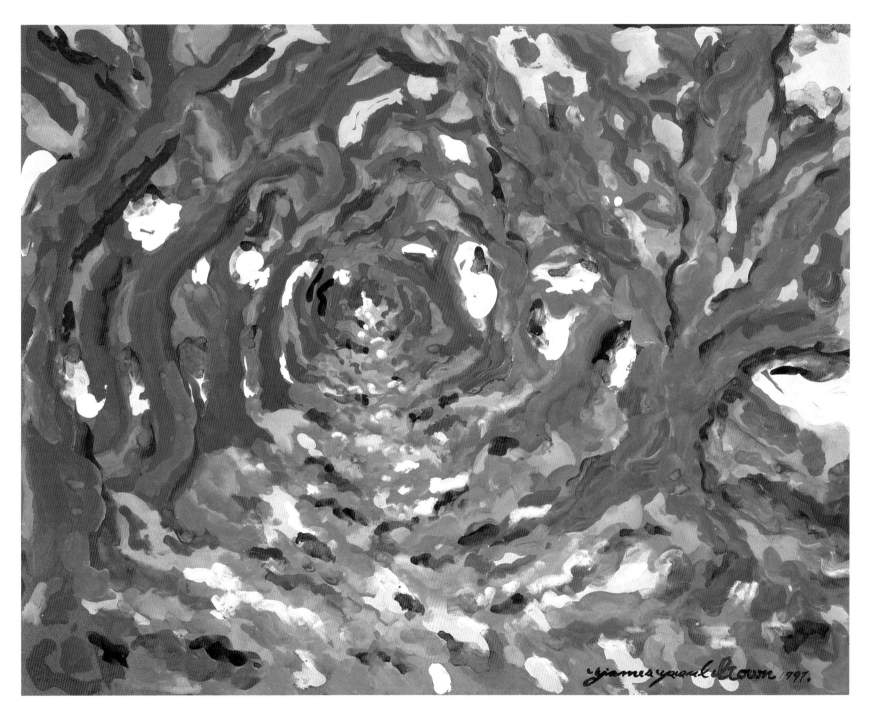

Secret Path III, 1997 (mixed media)

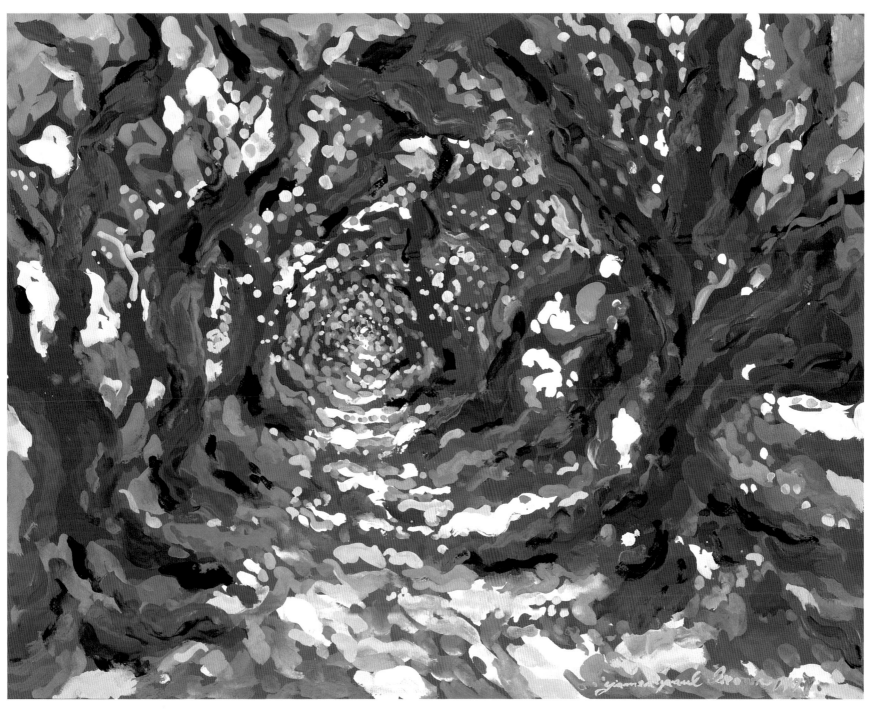

Secret Path IV, 1997 (mixed media)

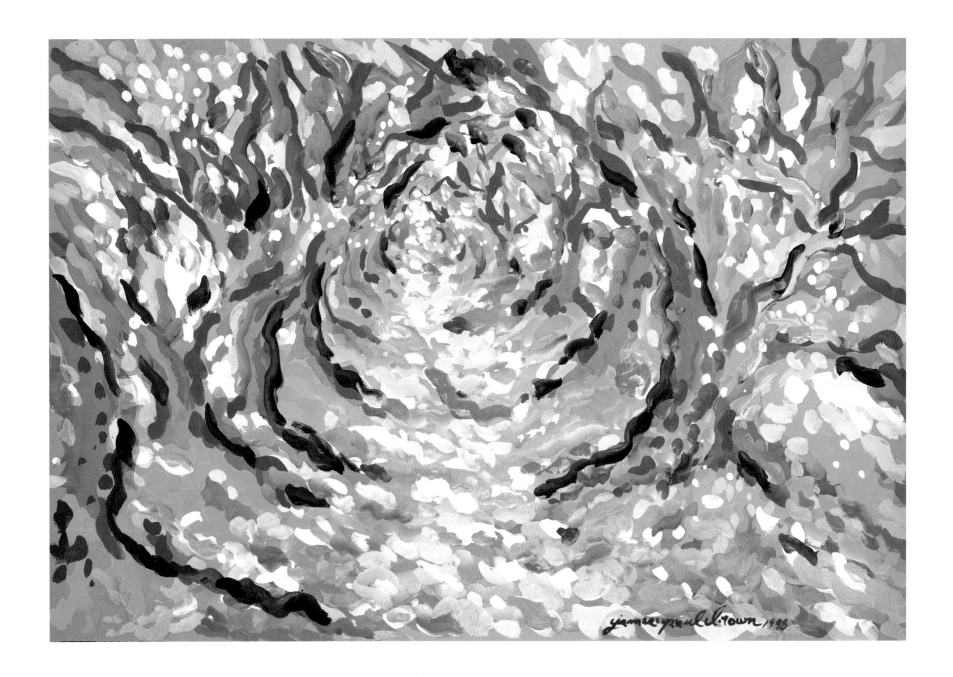

Secret Path V, 1998 (mixed media)

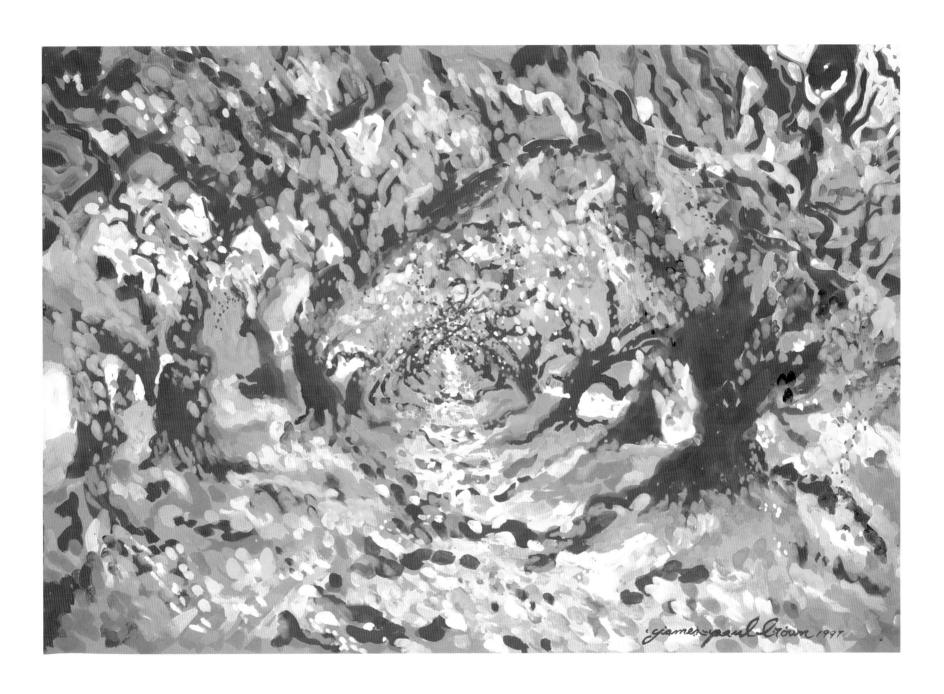

Secret Path VI, 1997(mixed media)

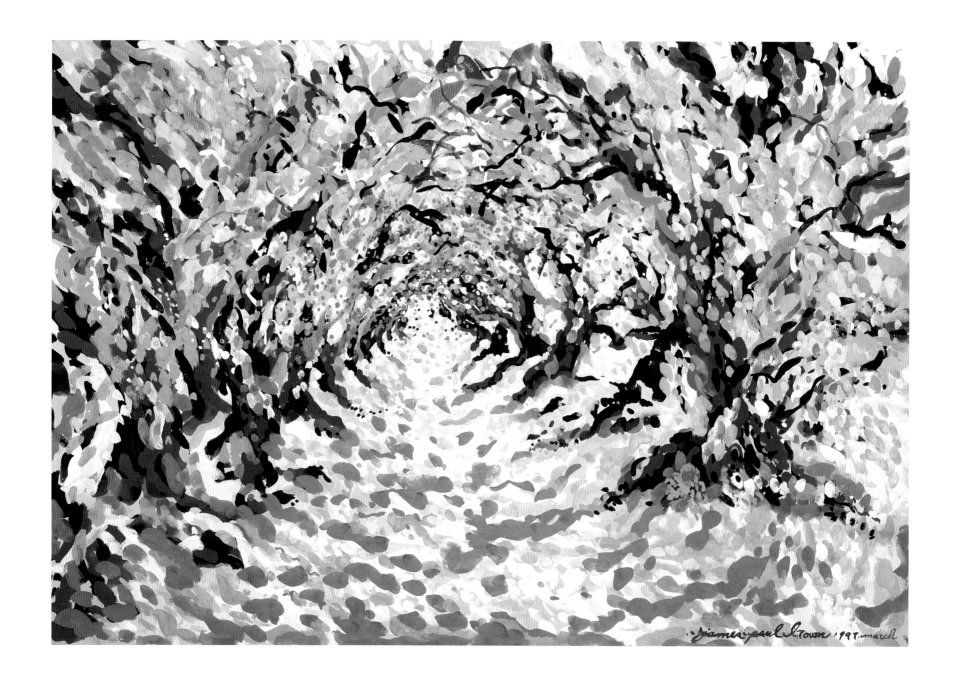

Secret Path VII, 1997 (mixed media)

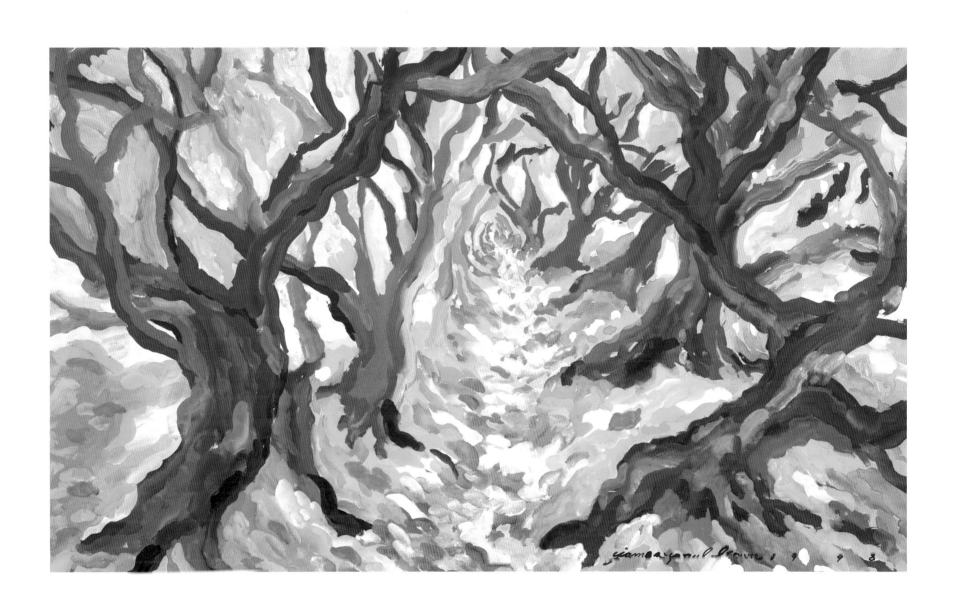

Secret Path VIII, 1998 (mixed media)

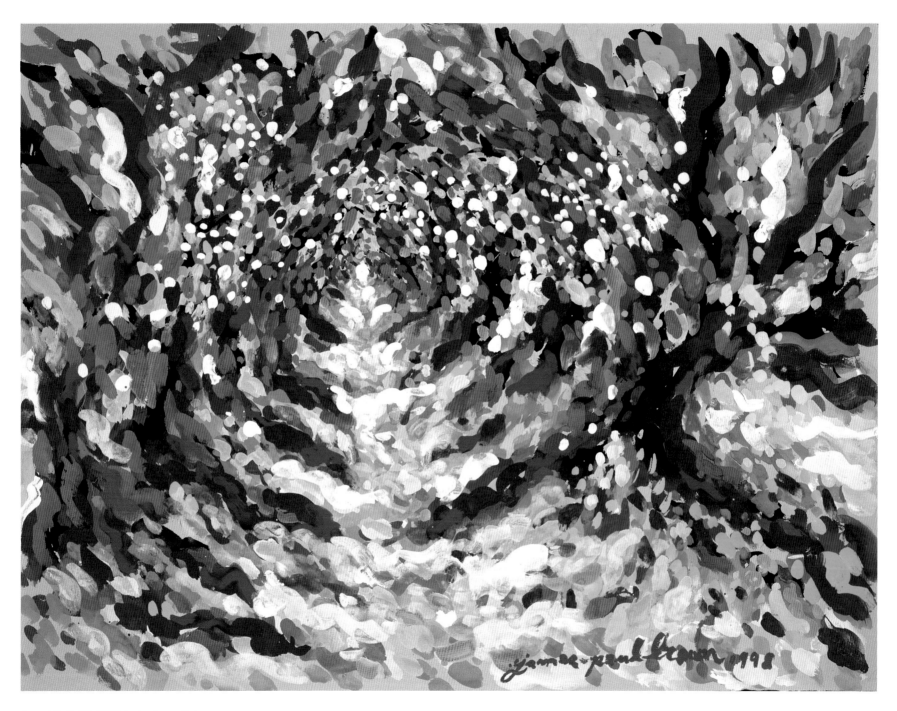

Secret Path IX, 1998 (mixed media)

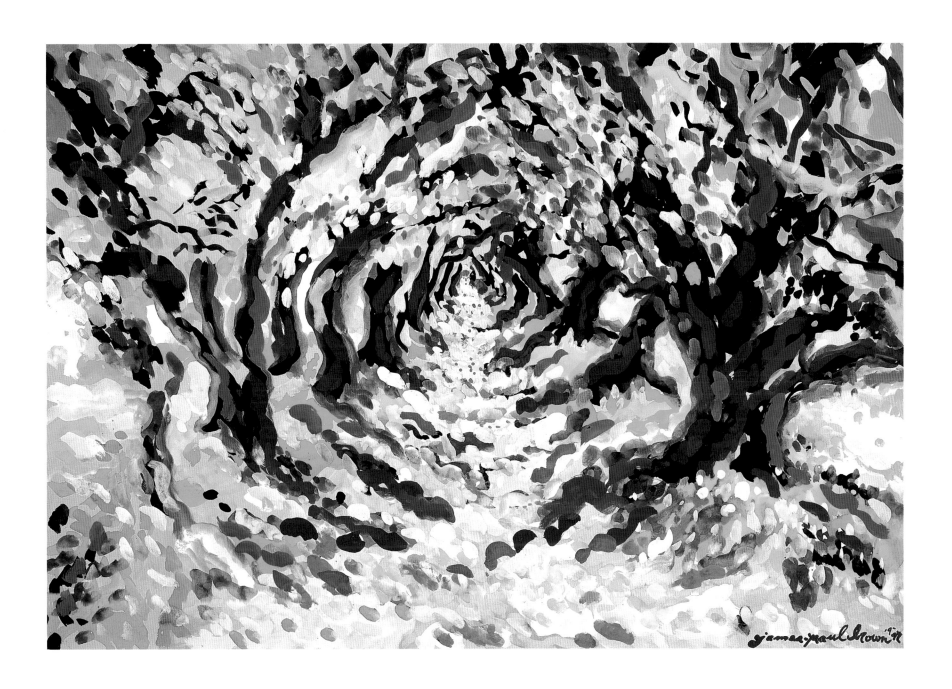

Secret Path X, 1997 (mixed media)

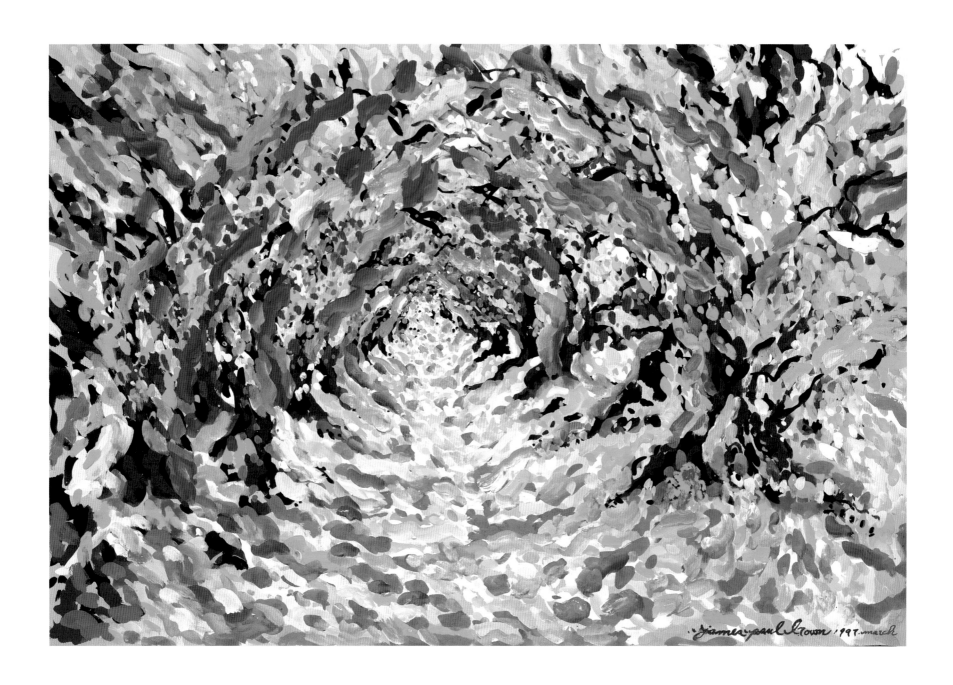

Secret Path XI, 1997 (mixed media)

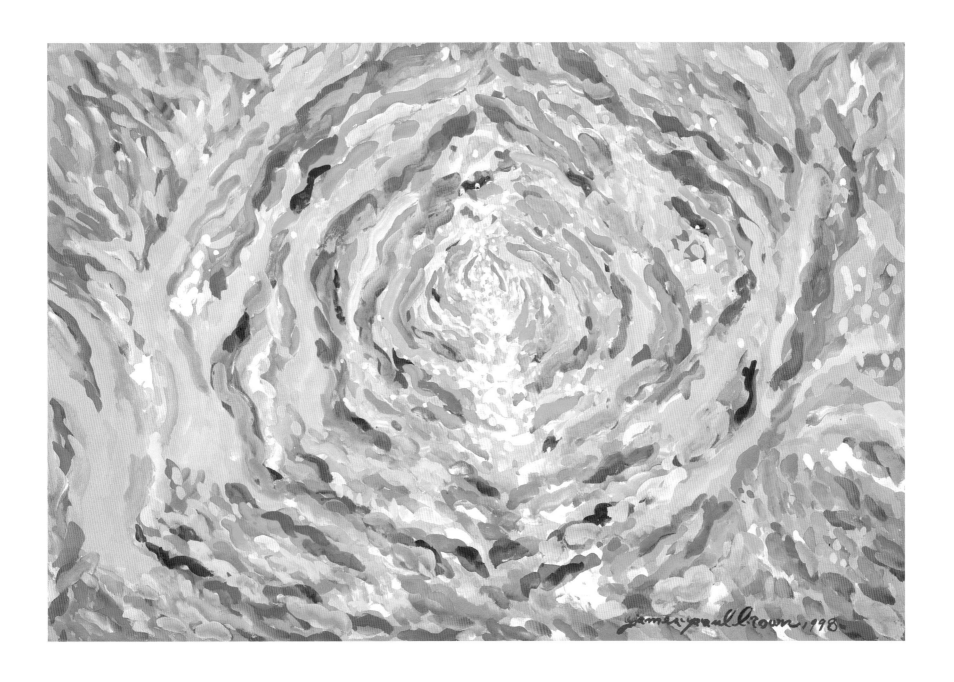

Secret Path XII, 1998 (mixed media)

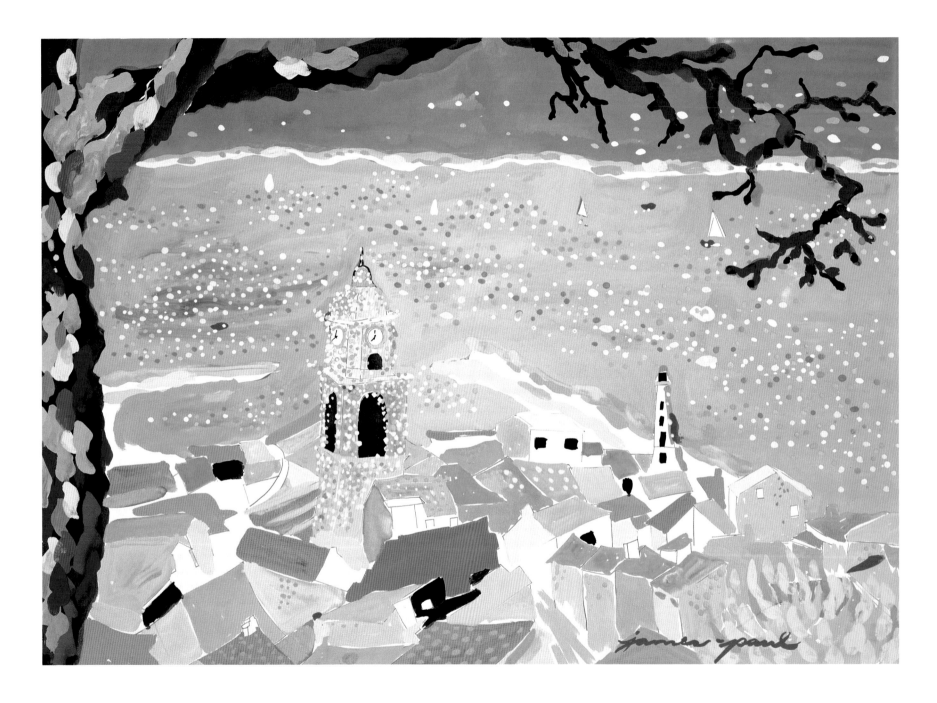

St. Tropez (mixed media)

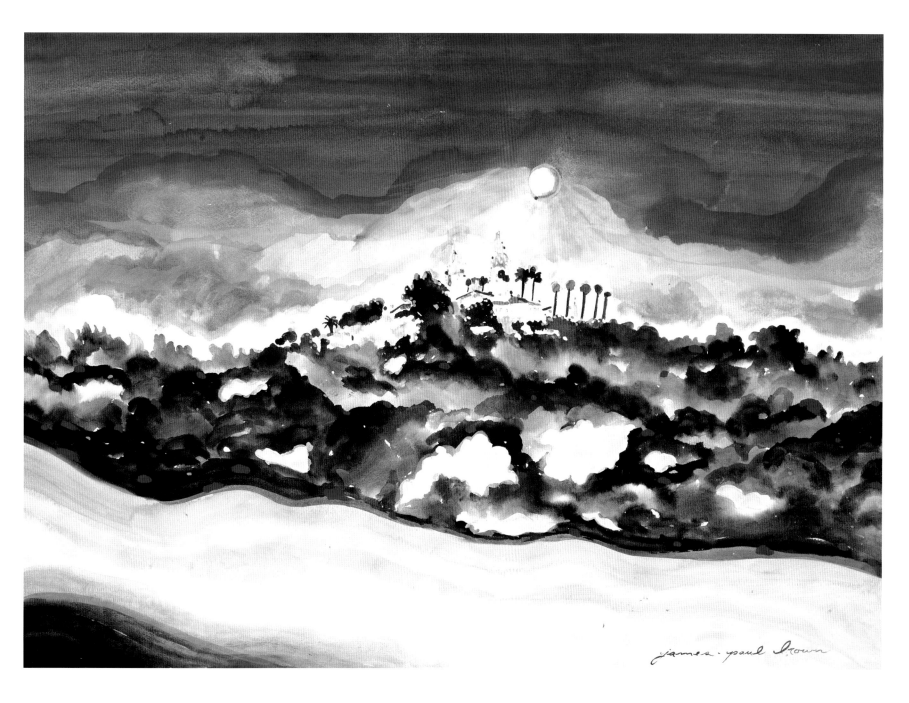

Hearst Castle I (mixed media)

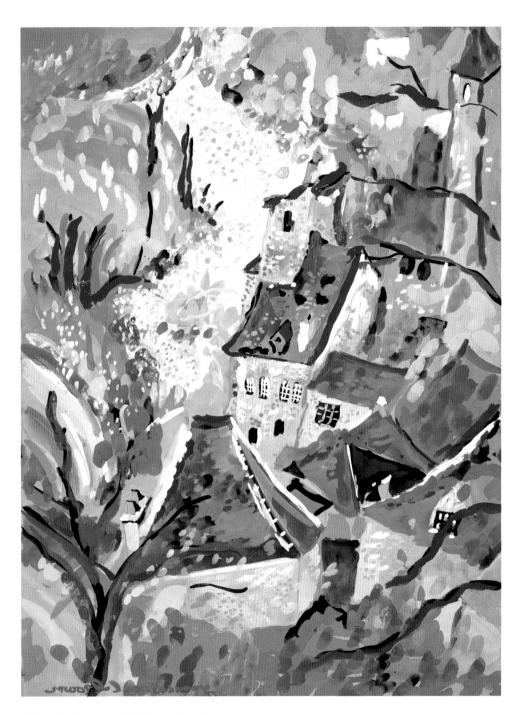

Village in Provence, 1998 (mixed media)

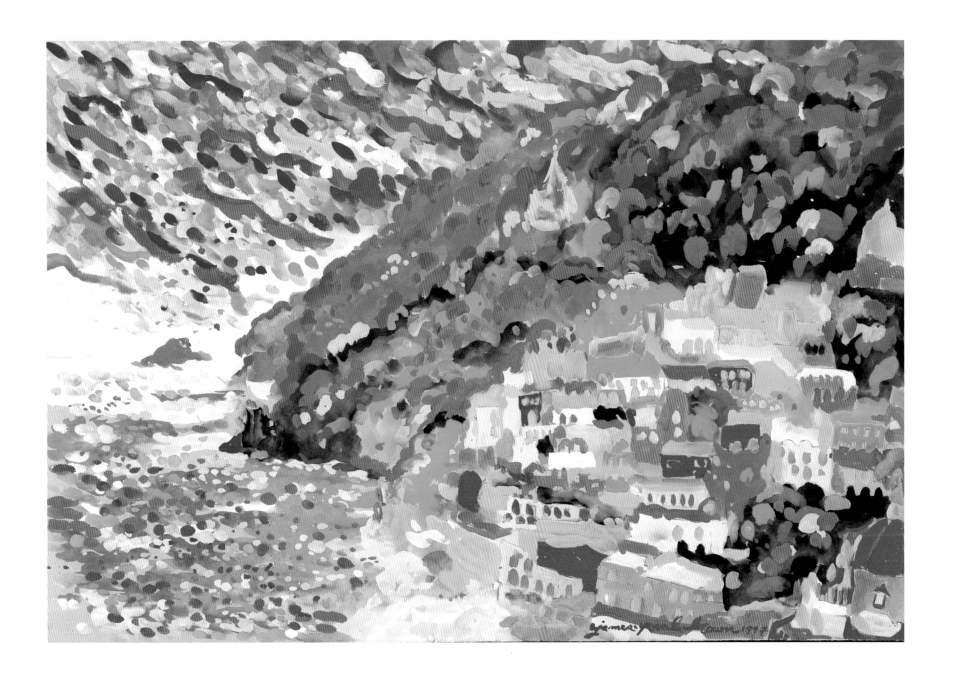

Mediterranean Village (mixed media)

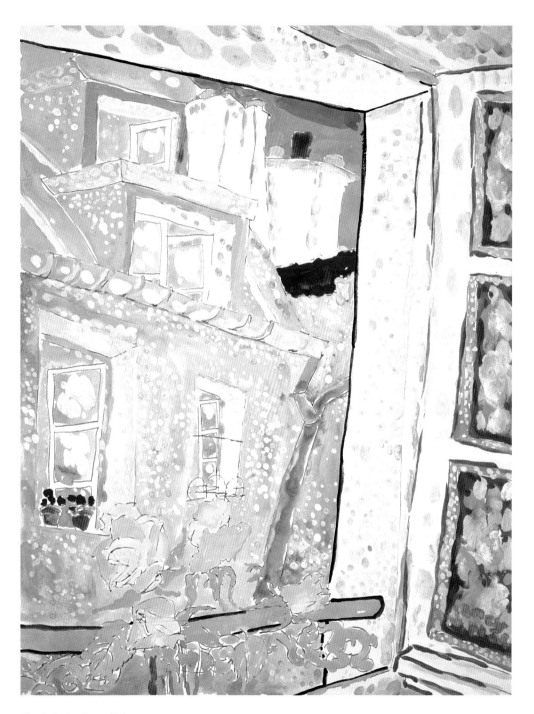

Paris (mixed media)

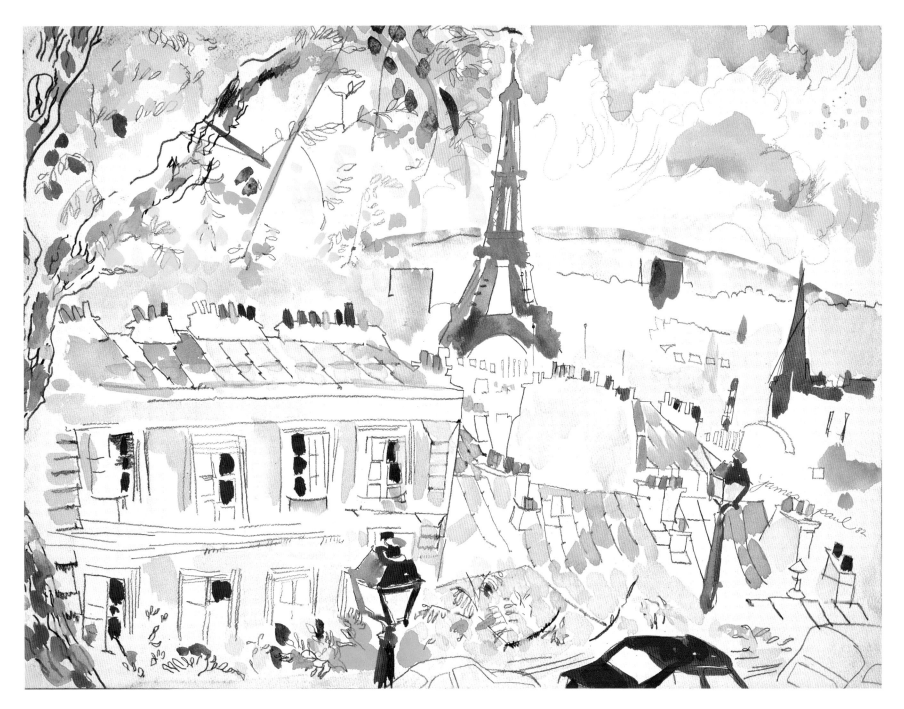

Montmartre (mixed media)

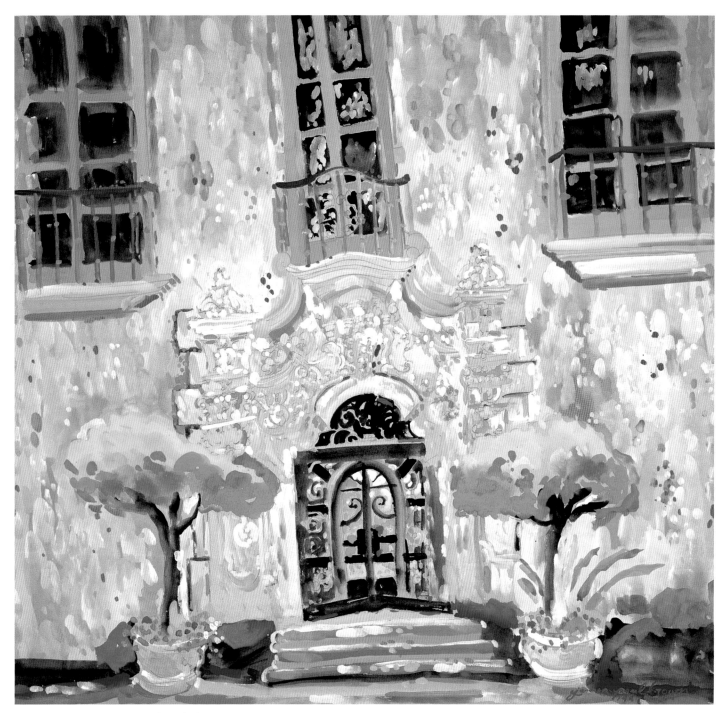

Castle Entrance, 1997 (mixed media)

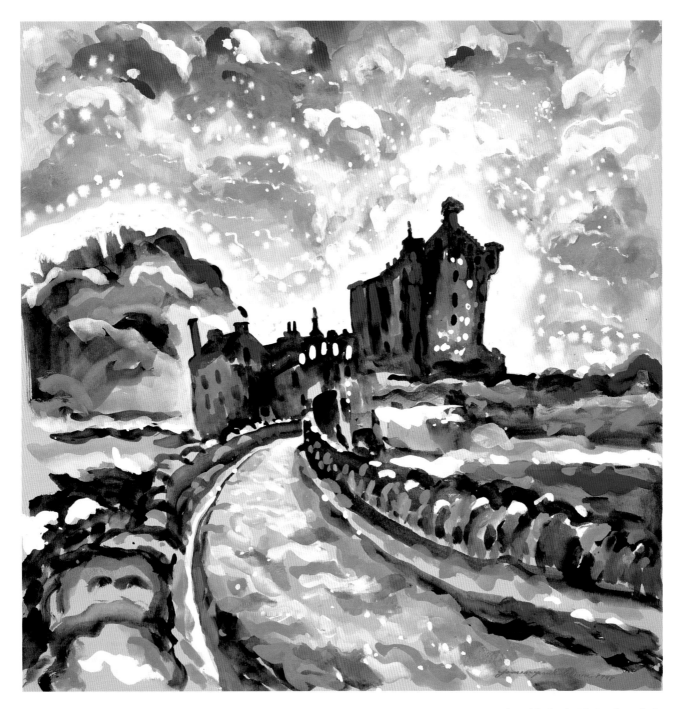

Scottish Castle I (mixed media)

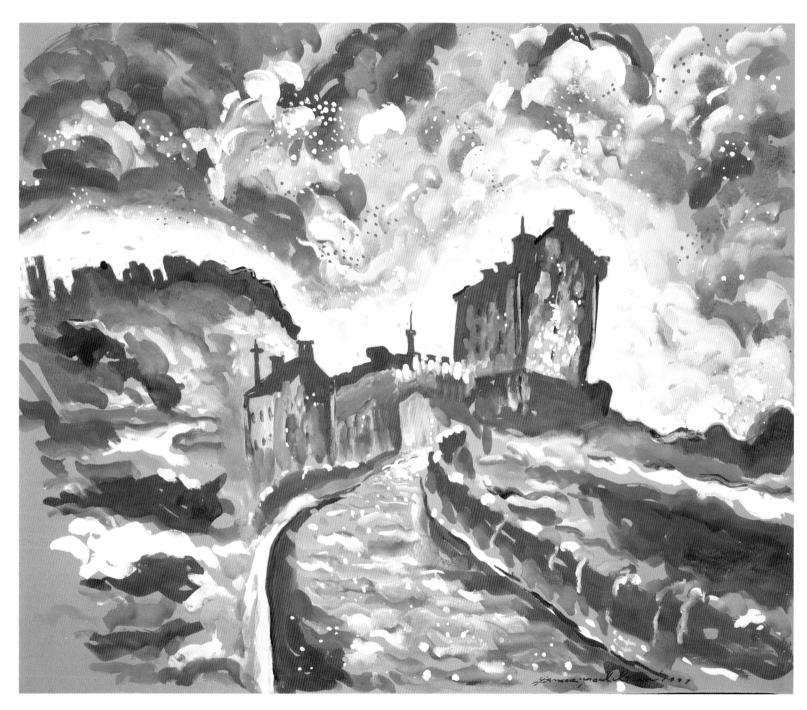

Scottish Castle II (mixed media)

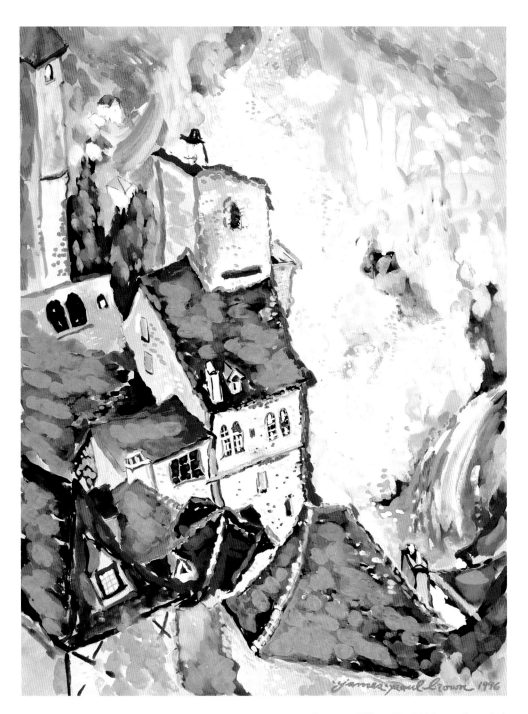

Provence Village II, 1996 (mixed media)

69

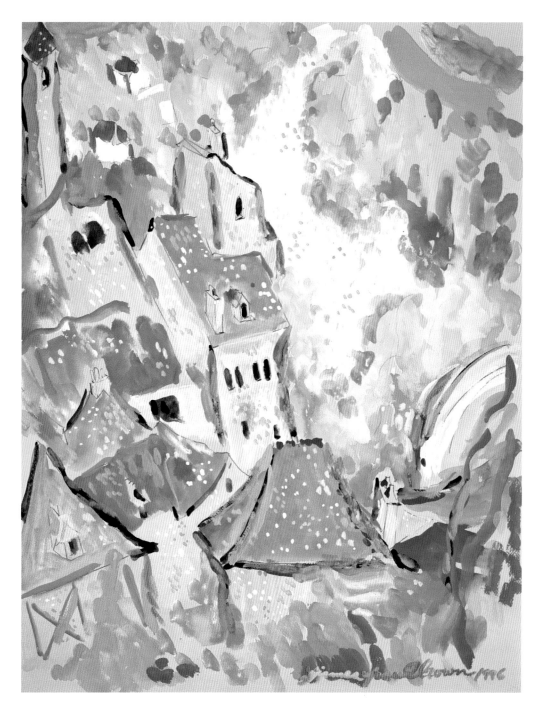

Provence Village III, 1996 (mixed media)

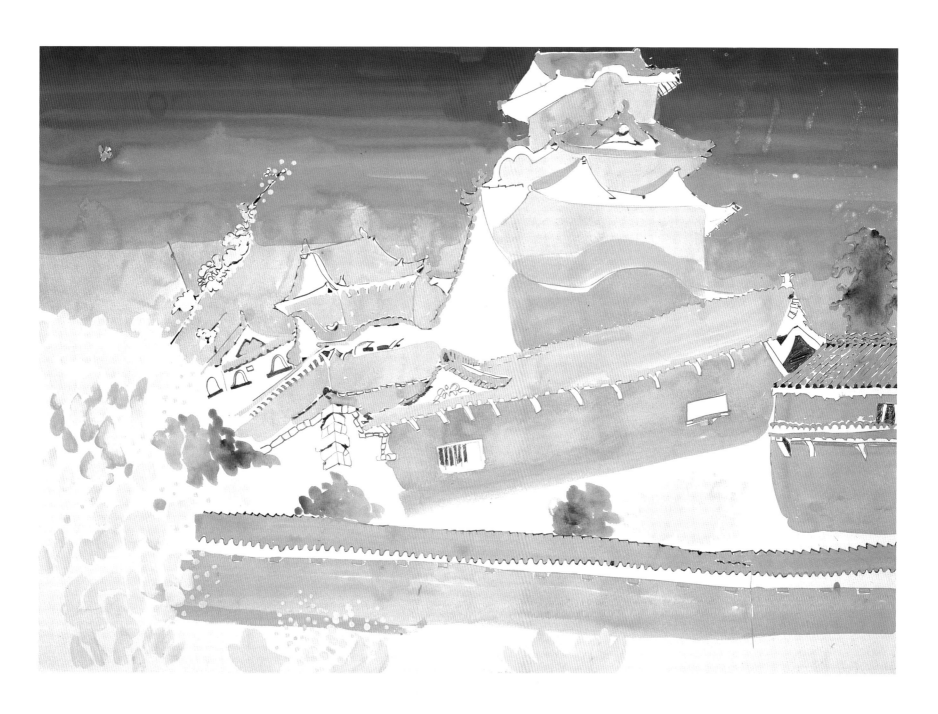

Japanese Temple, 1998 (mixed media)

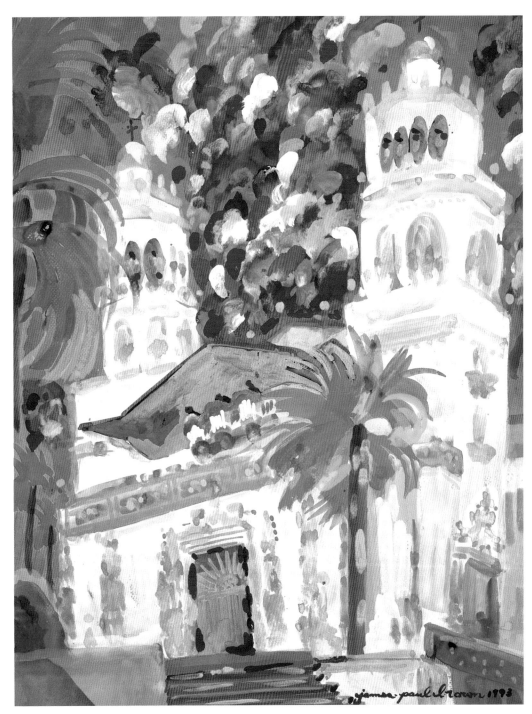

Hearst Castle II, 1993 (mixed media)

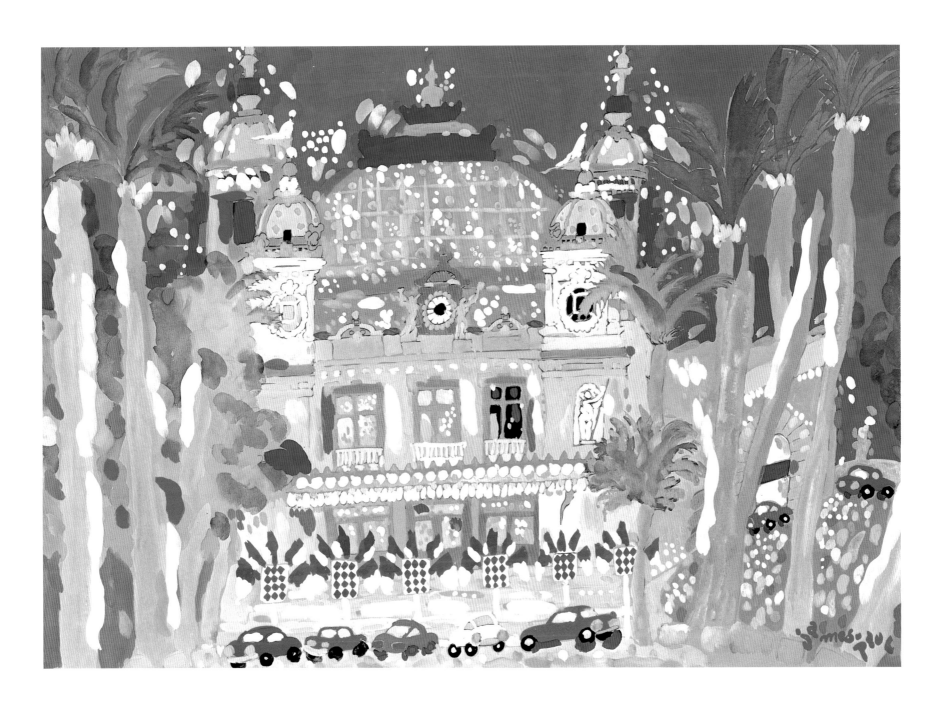

Monte Carlo (mixed media)

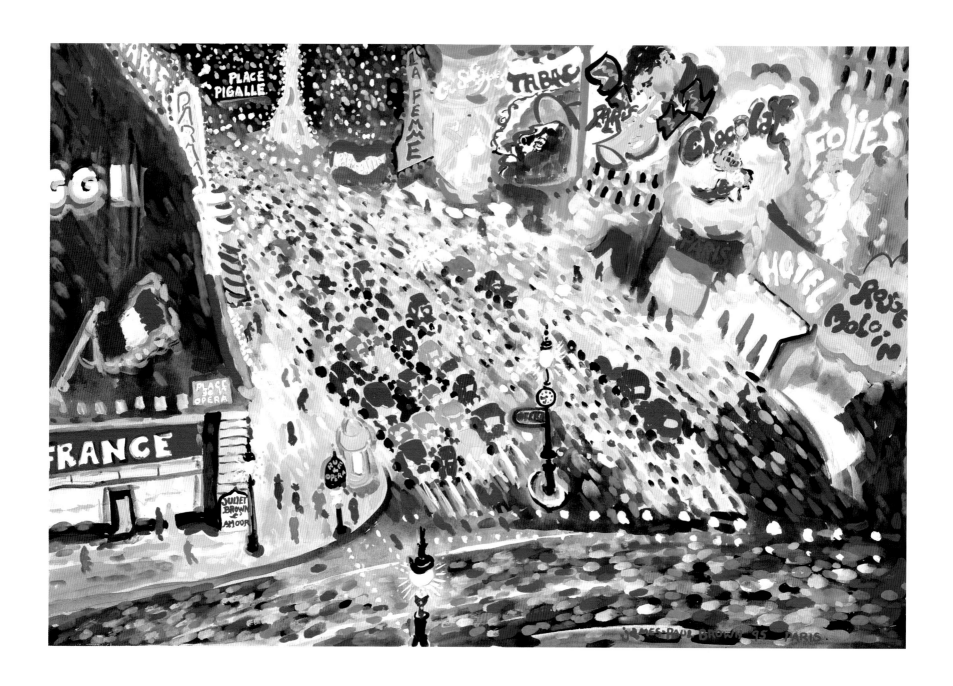

Streets of Paris I, 1995 (mixed media)

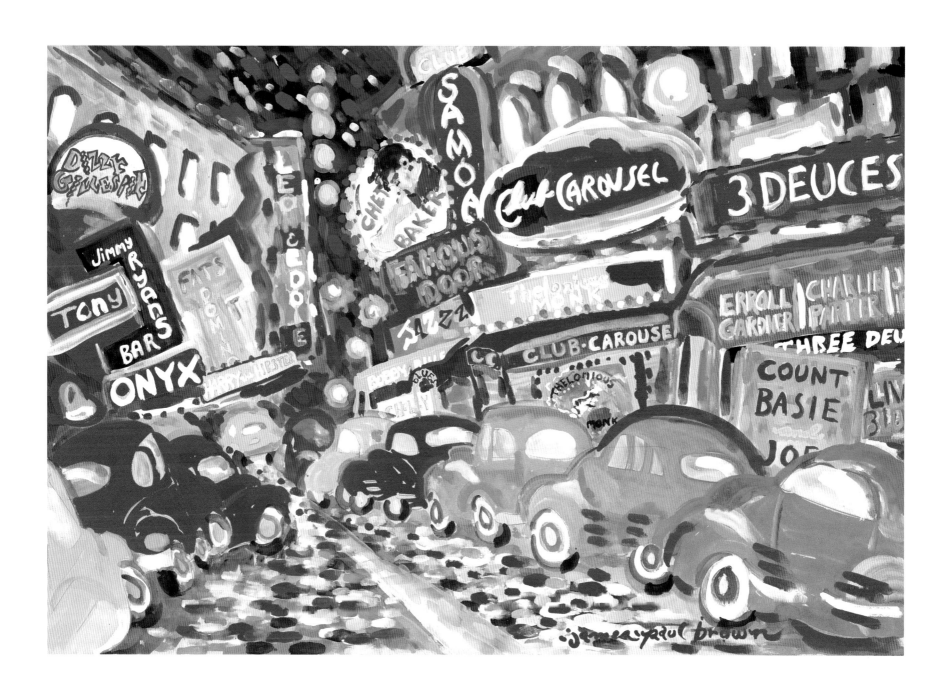

Streets of New York, 1995 (mixed media)

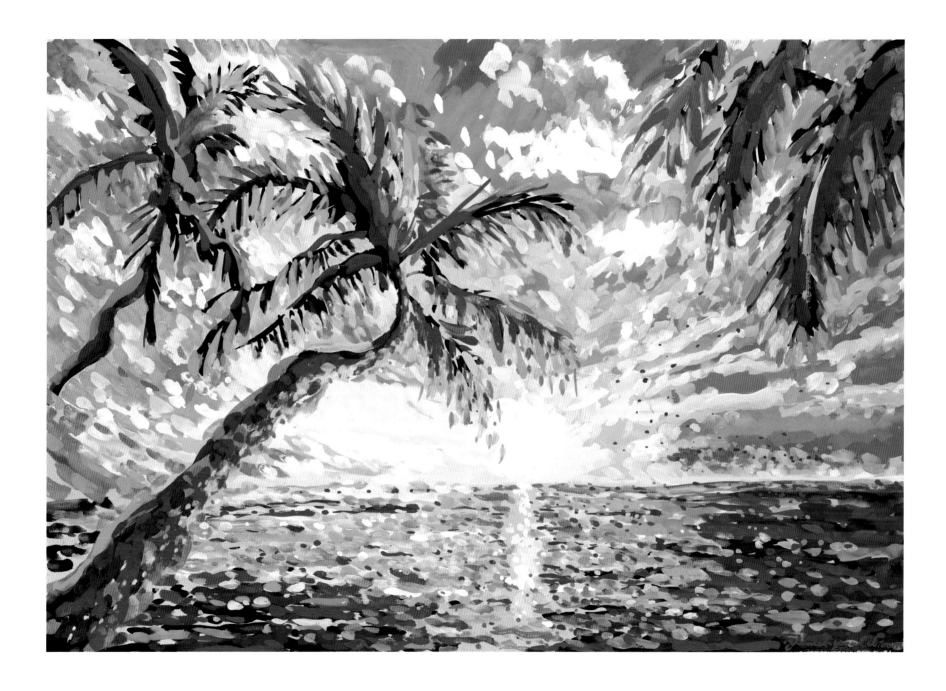

Island Sunset I, 1996 (mixed media)

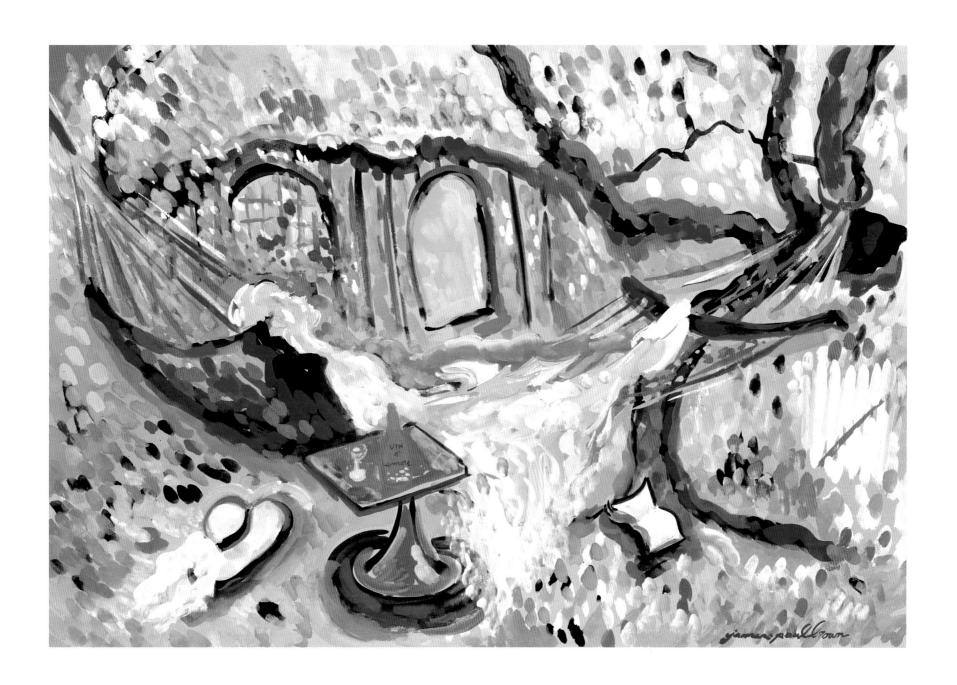

Island Bungalow (mixed media)

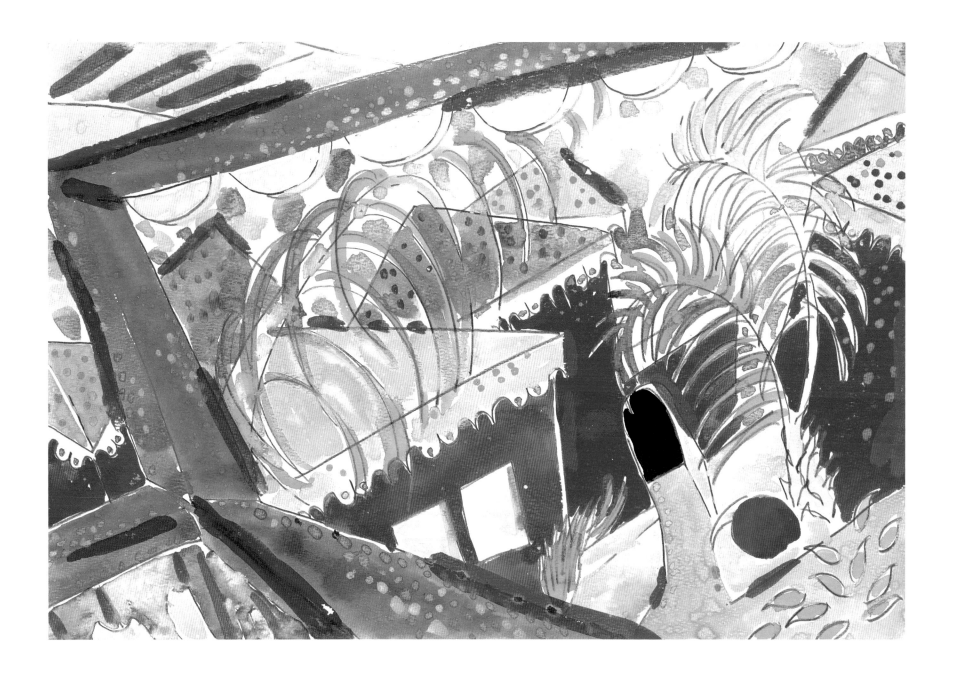

Caribbean (mixed media)

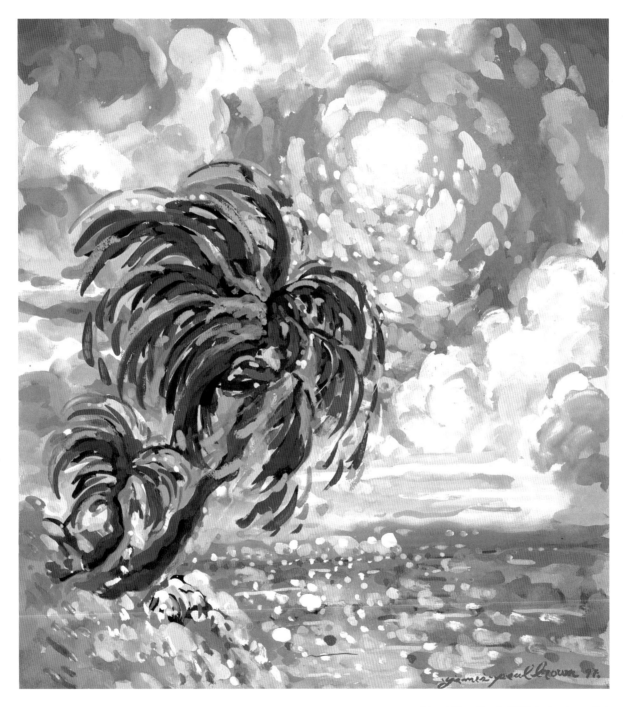

Island Shoreline I, 1997 (mixed media)

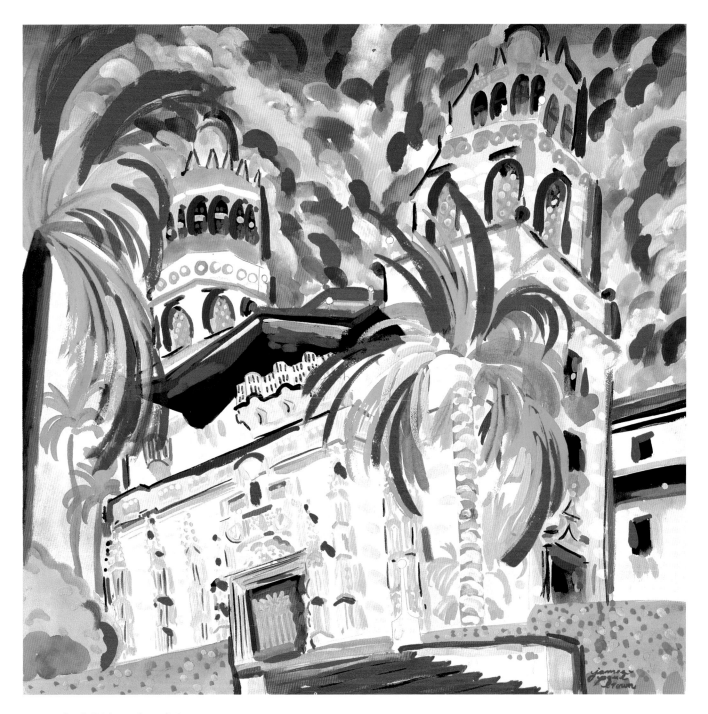

Hearst Castle III (mixed media)

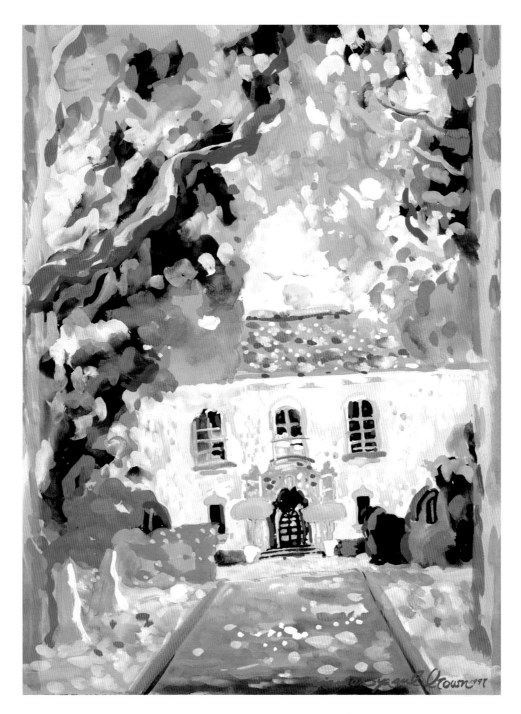

Music Academy of the West, 1997 (mixed media)

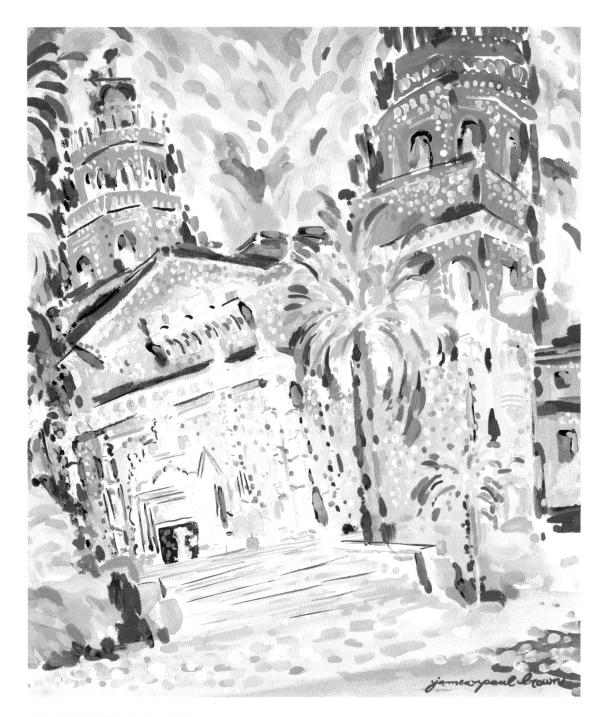

Hearst Castle IV (mixed media)

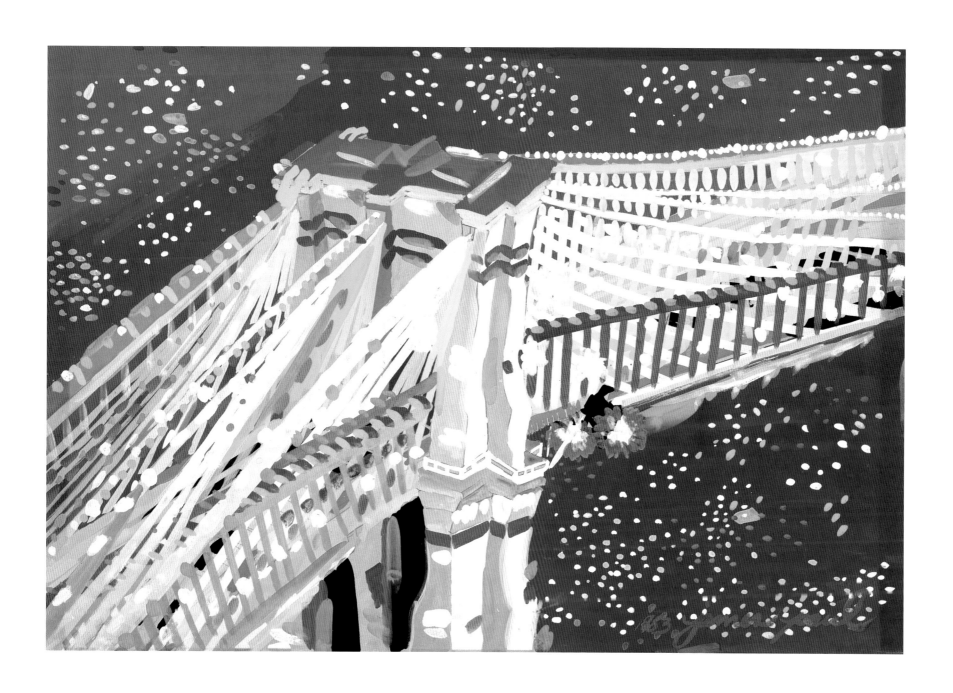

Brooklyn Bridge (mixed media)

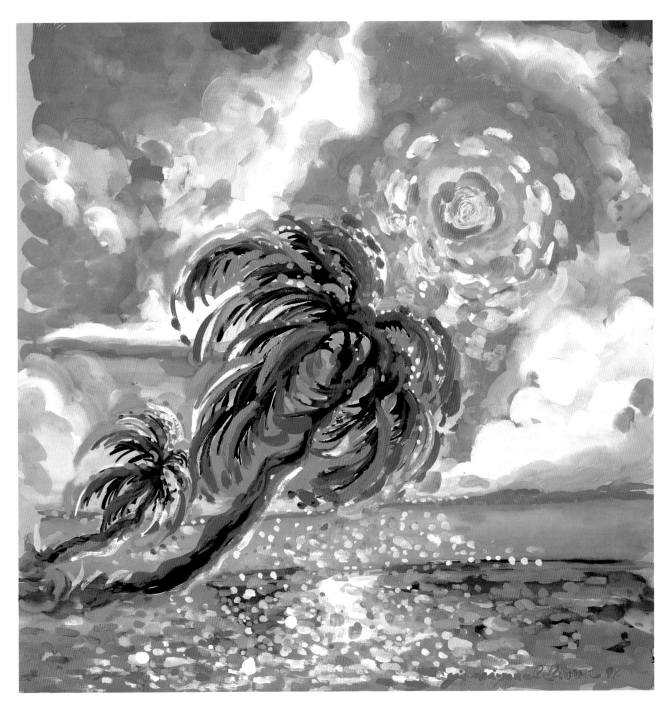

Island Shoreline II, 1997 (mixed media)

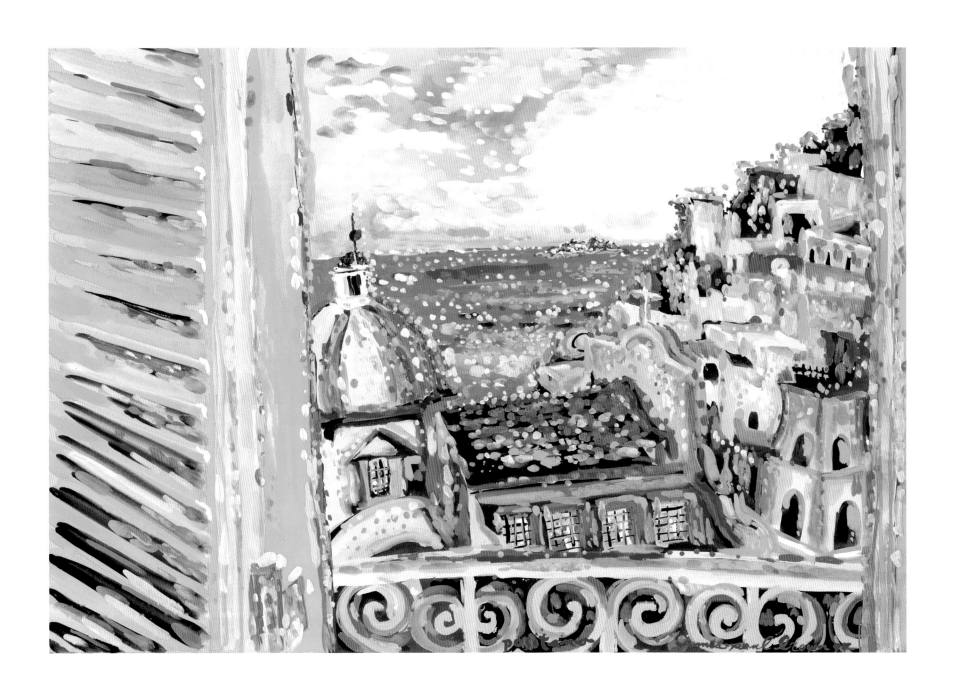

Positano View I (mixed media)

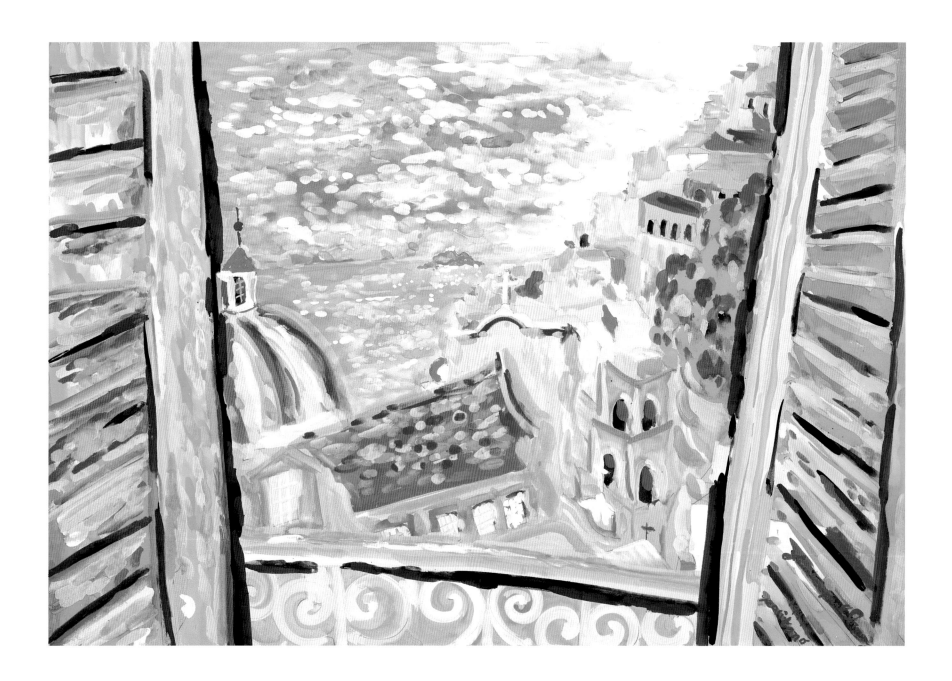

Positano View II, 1997 (mixed media)

Venice, Italy (mixed media)

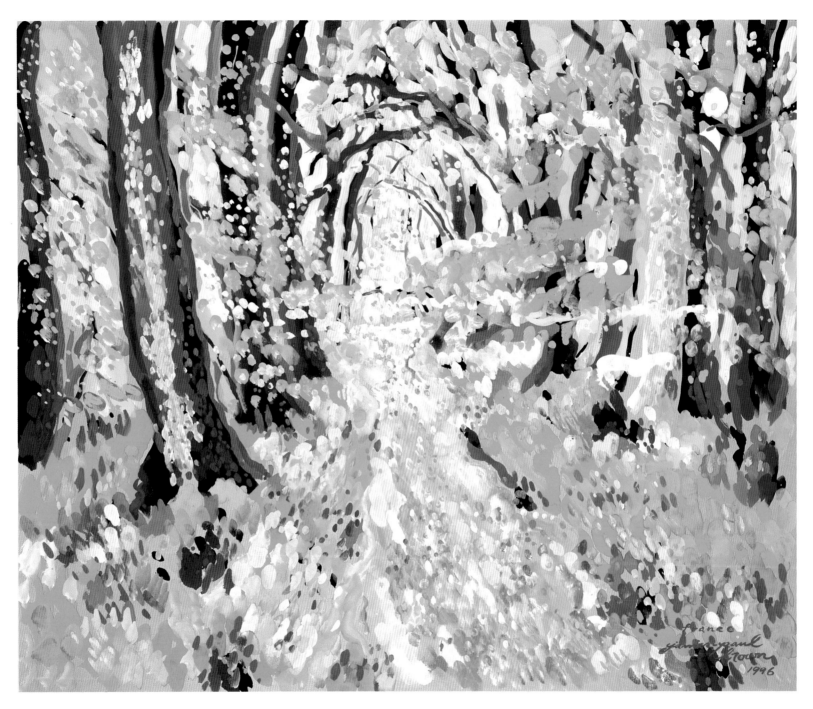

Secret Path II, 1996 (mixed media)

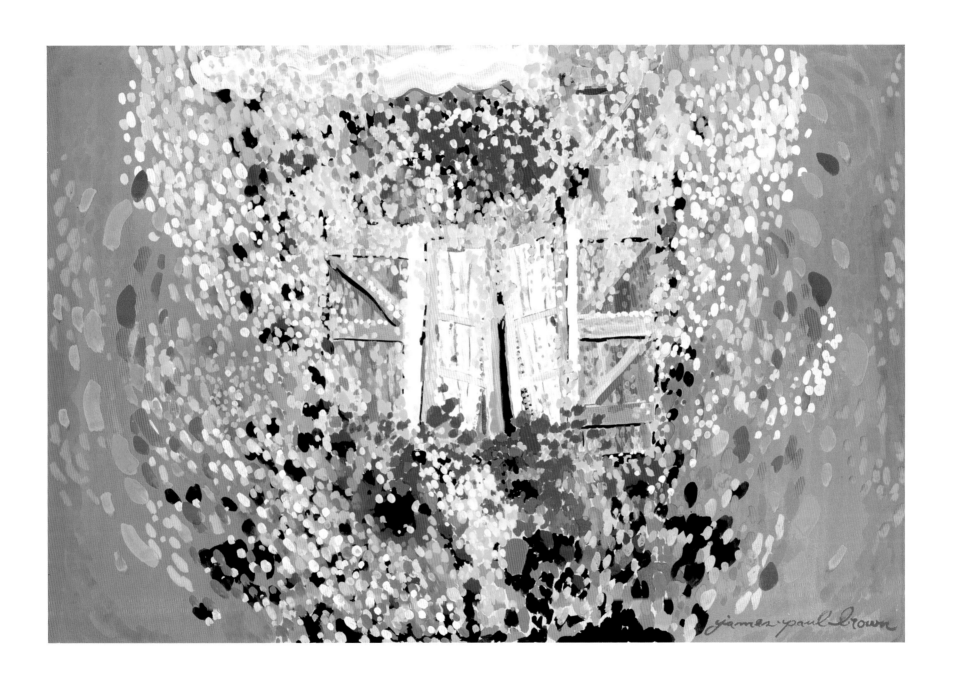

Secret Passage (mixed media)

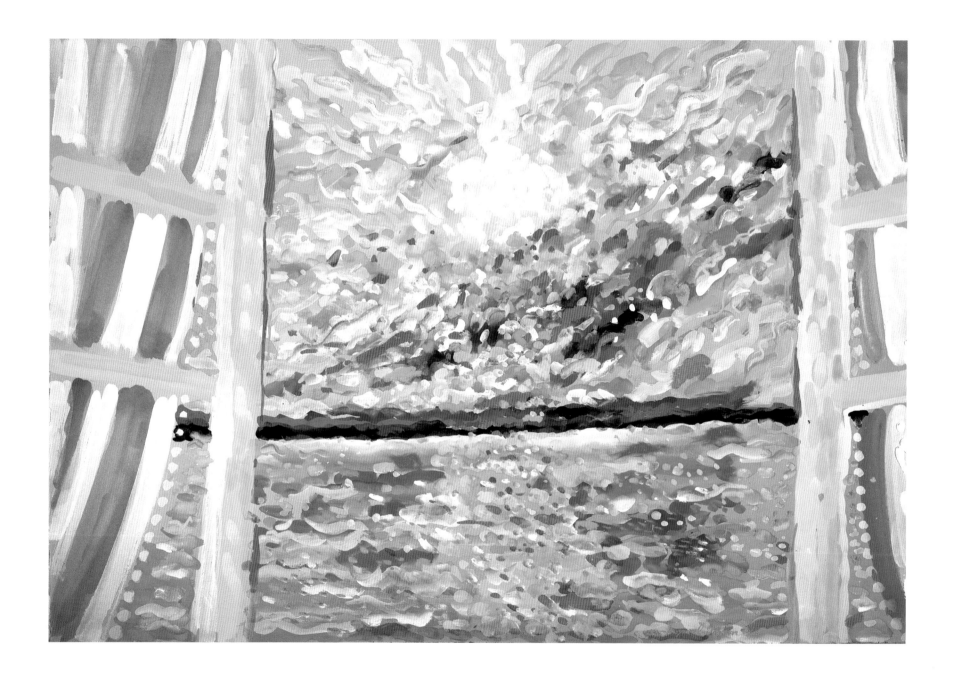

Sunset (mixed media)

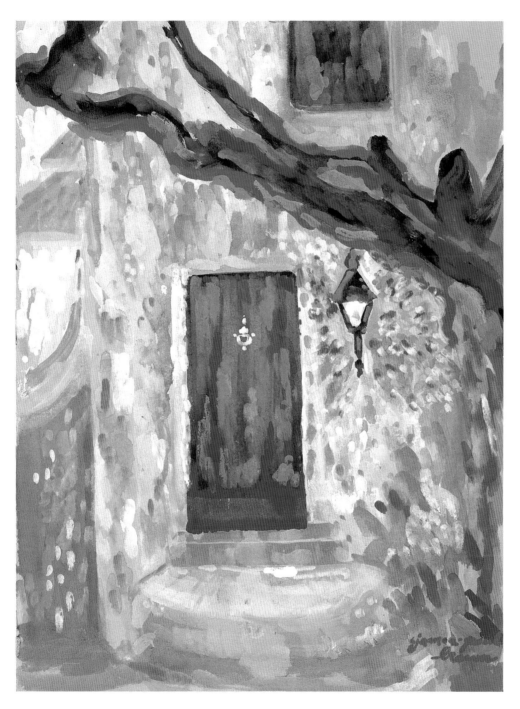

Secret Door (mixed media)

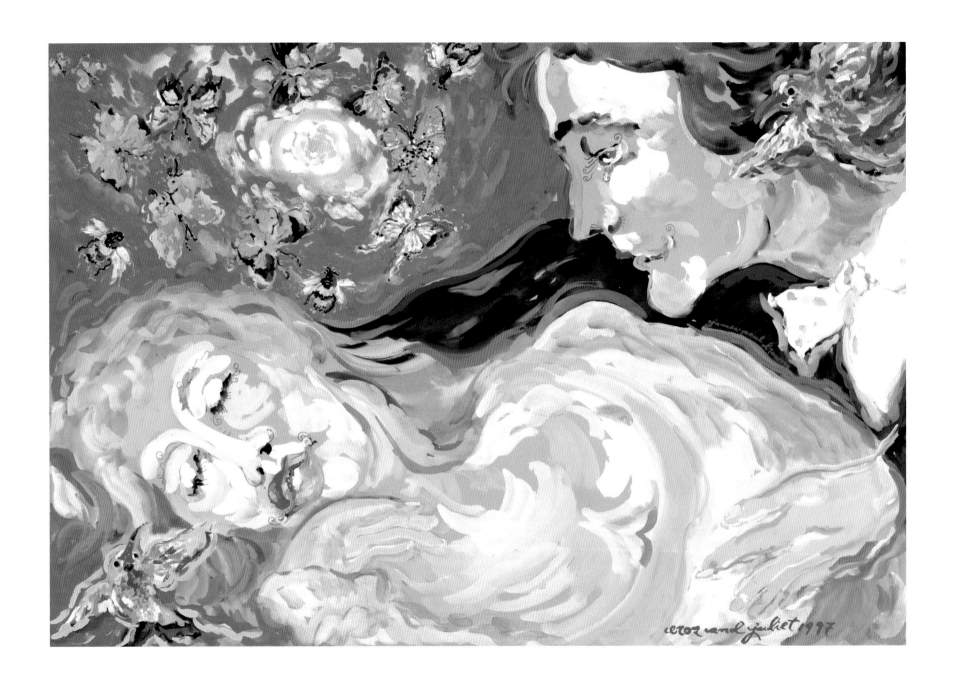

Amore, 1997 (mixed media)

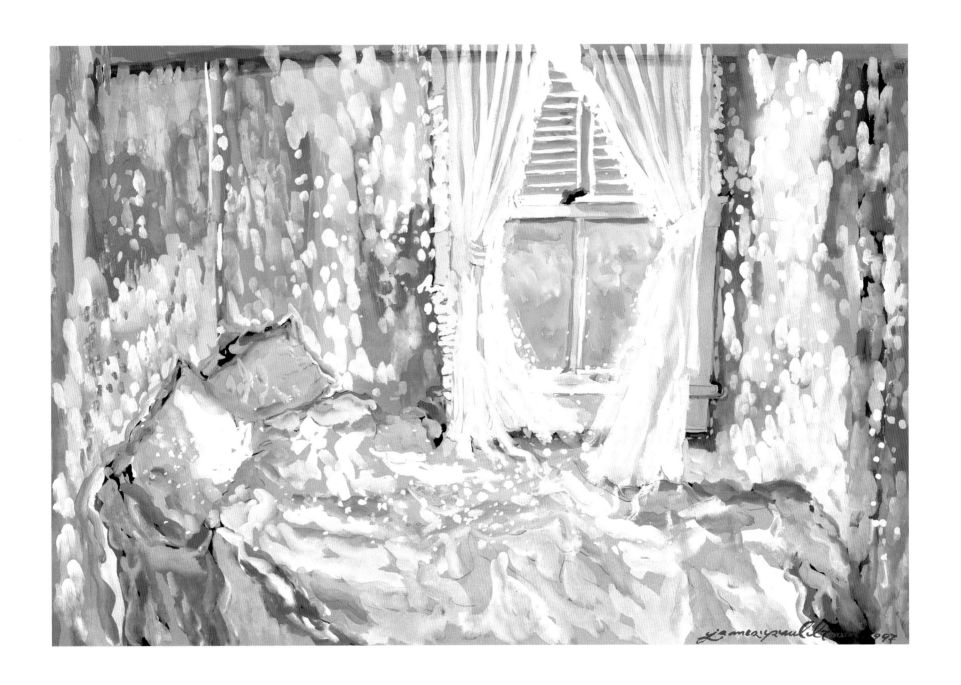

Maine I (mixed media)

Maine II, 1997 (mixed media)

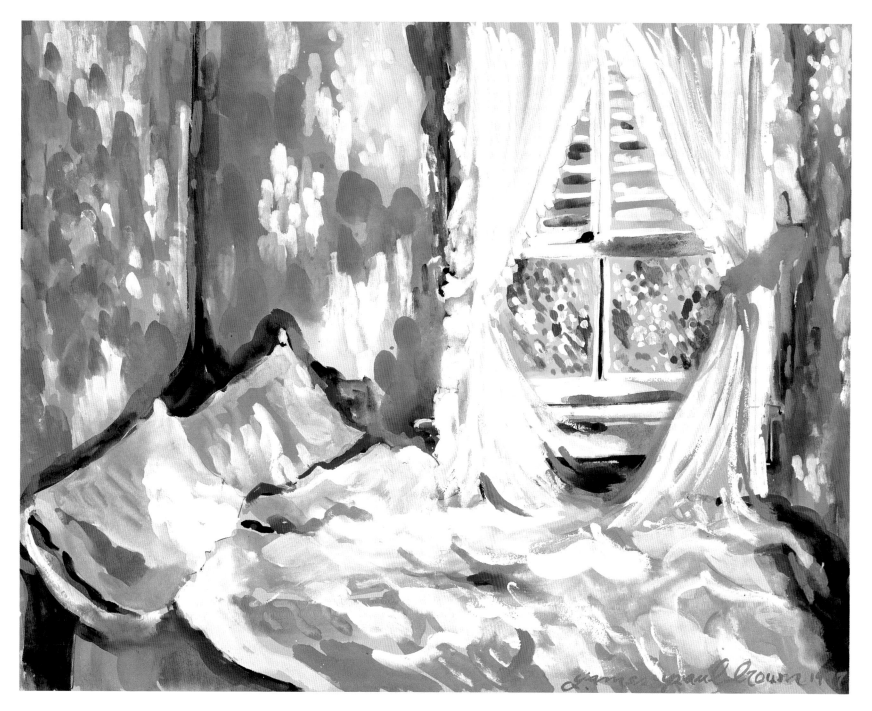

Maine III, 1997 (mixed media)

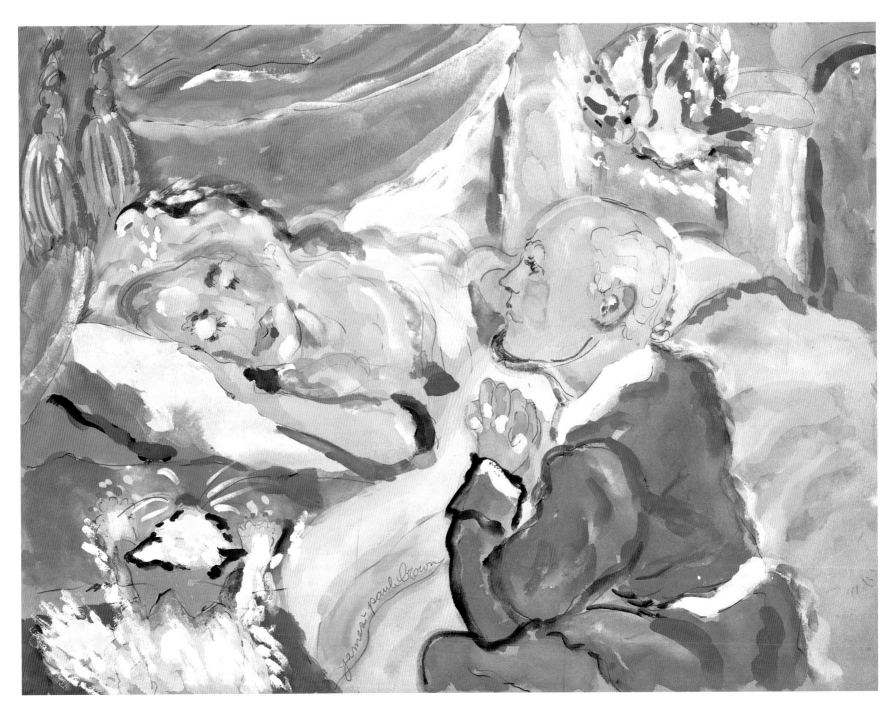

More Than the Greatest Love the World Has Known (mixed media)

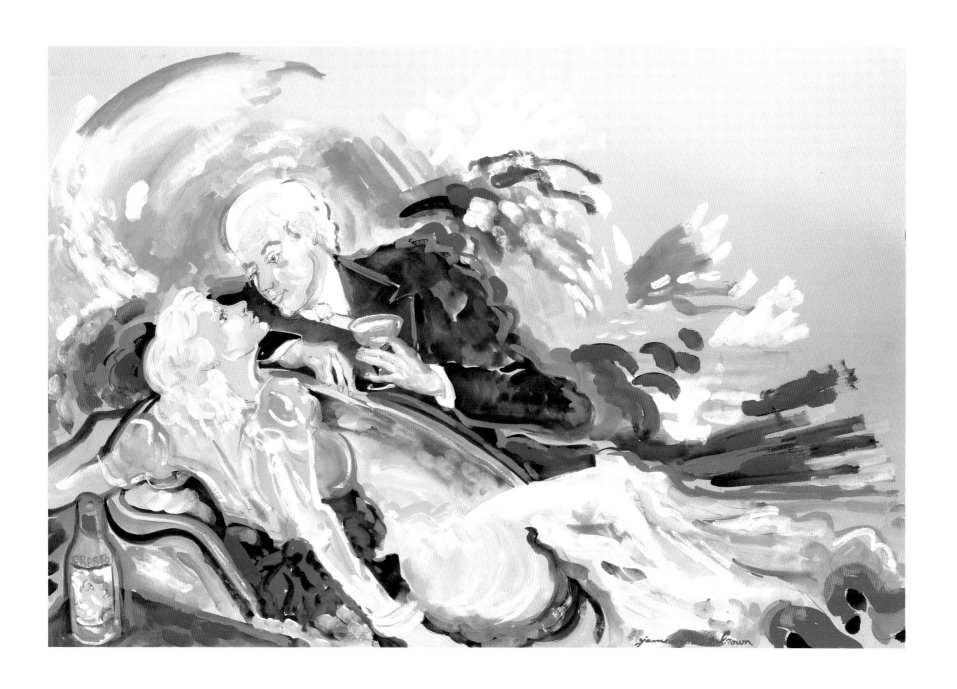

This Is the Love I Give to You Alone (mixed media)

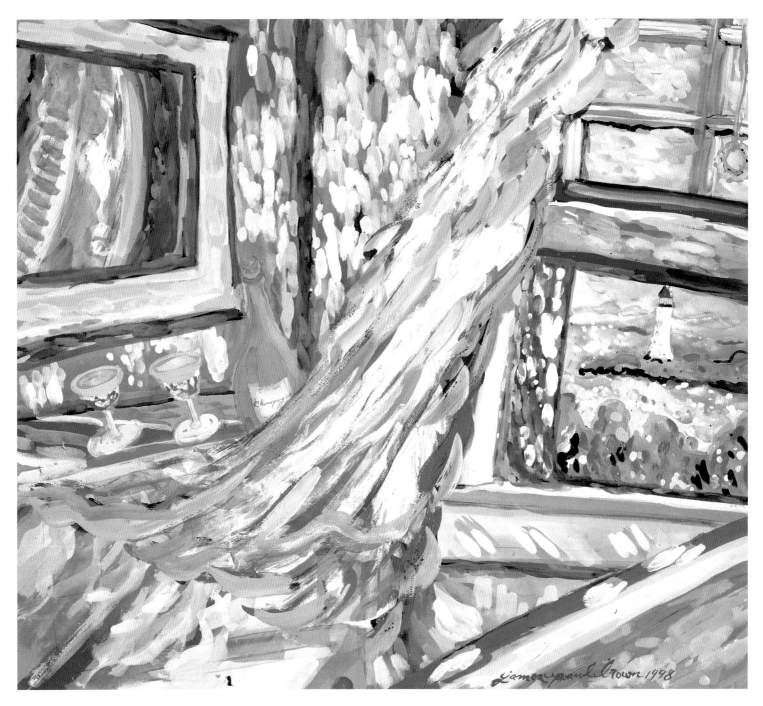

Maine IV, 1998 (mixed media)

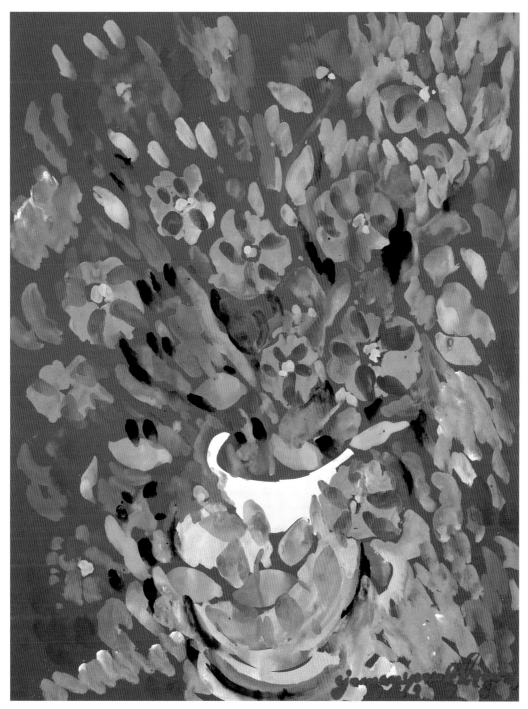

More, 1998 (mixed media)

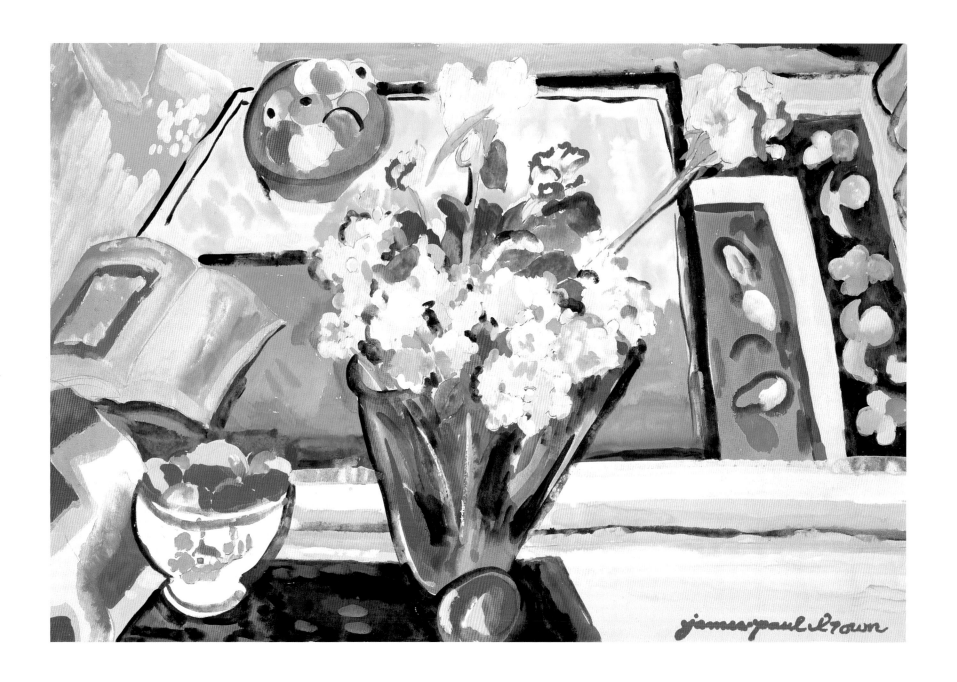

Painter's Table II (mixed media)

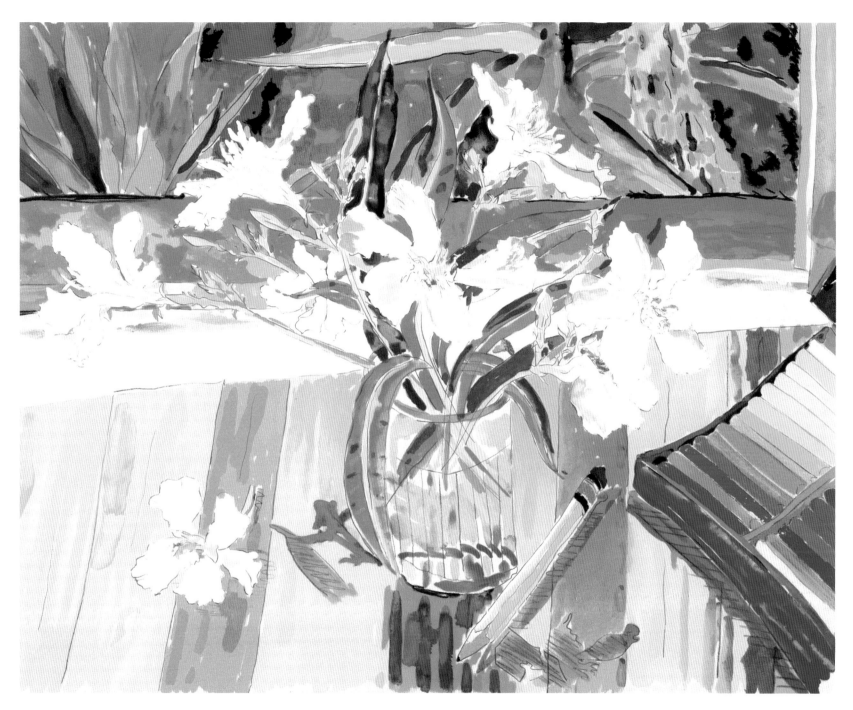

Artist's Table (oil on paper)

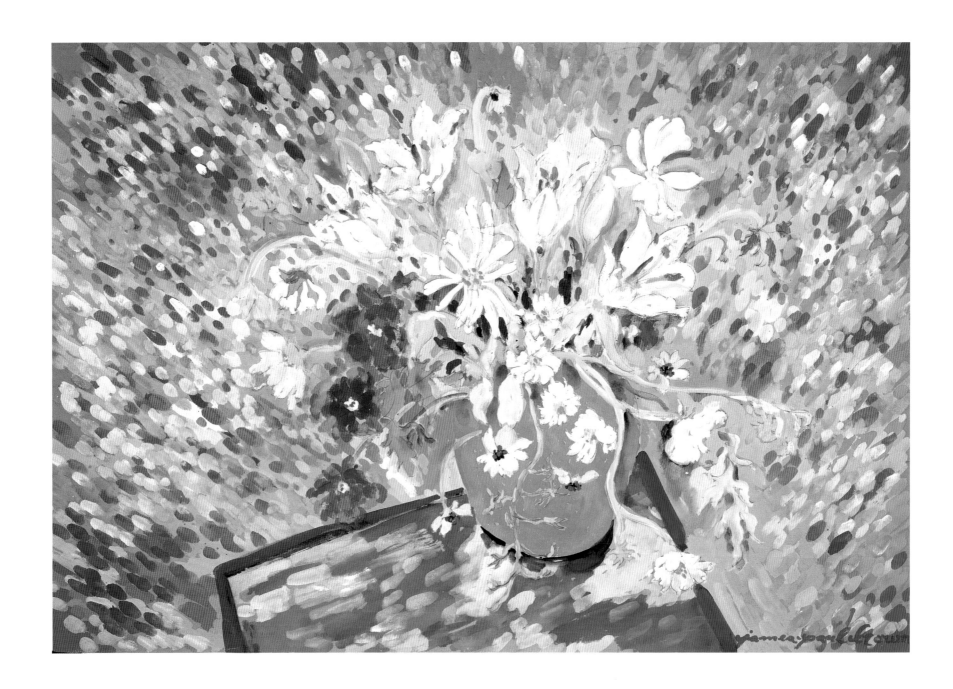

Blooming Flowers(mixed media)

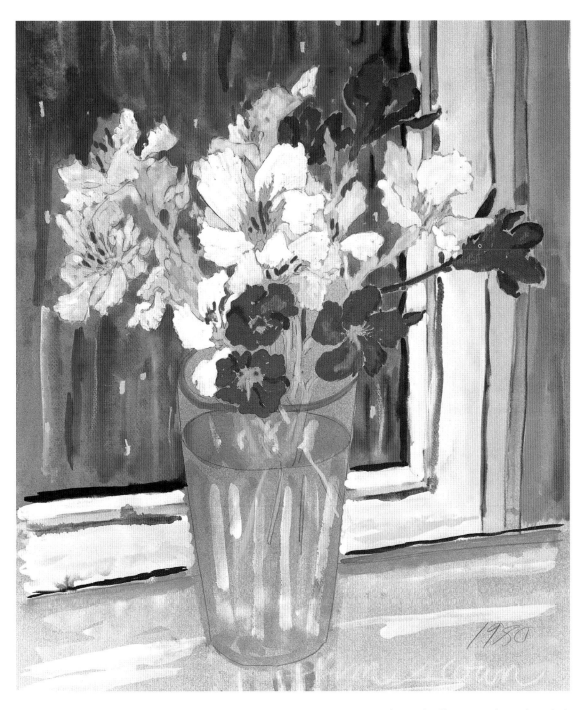

Flowers in Glass, 1980 (mixed media)

103

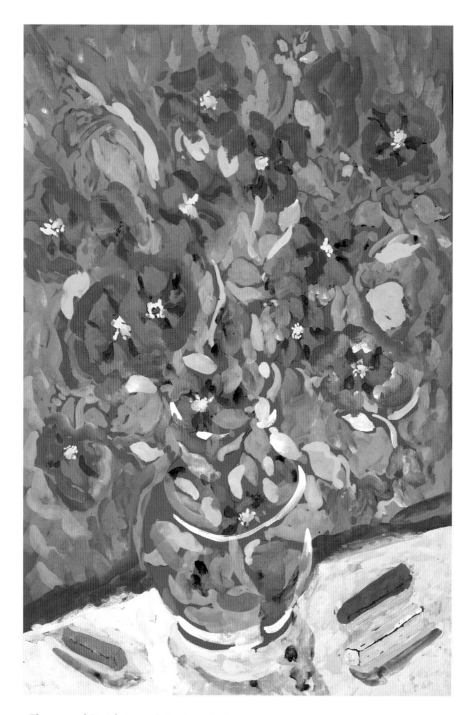

Flowers and Pastels, 1998 (mixed media)

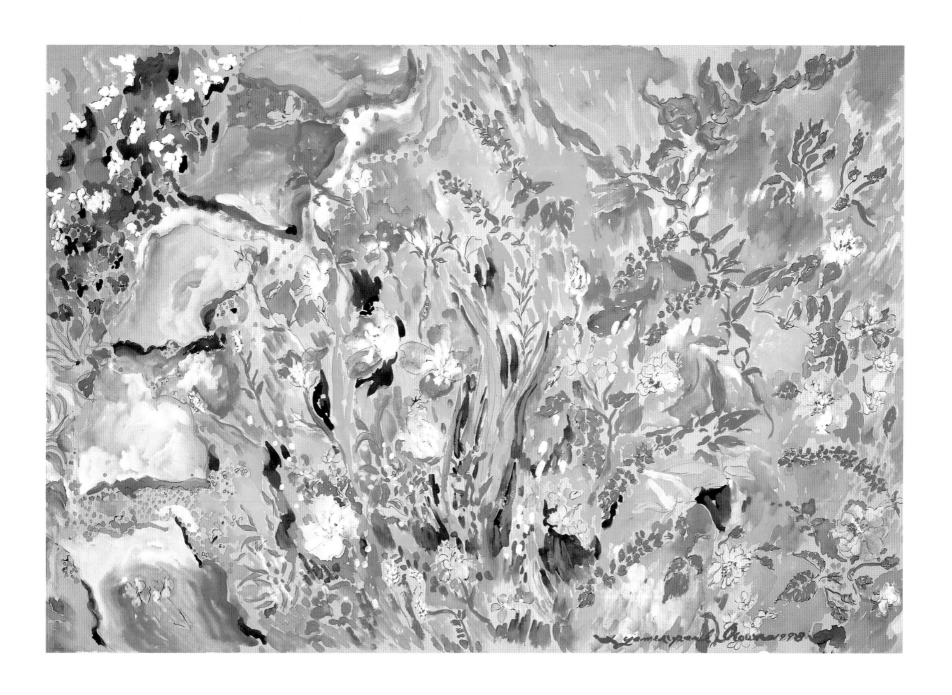

Flower Path, 1998 (mixed media)

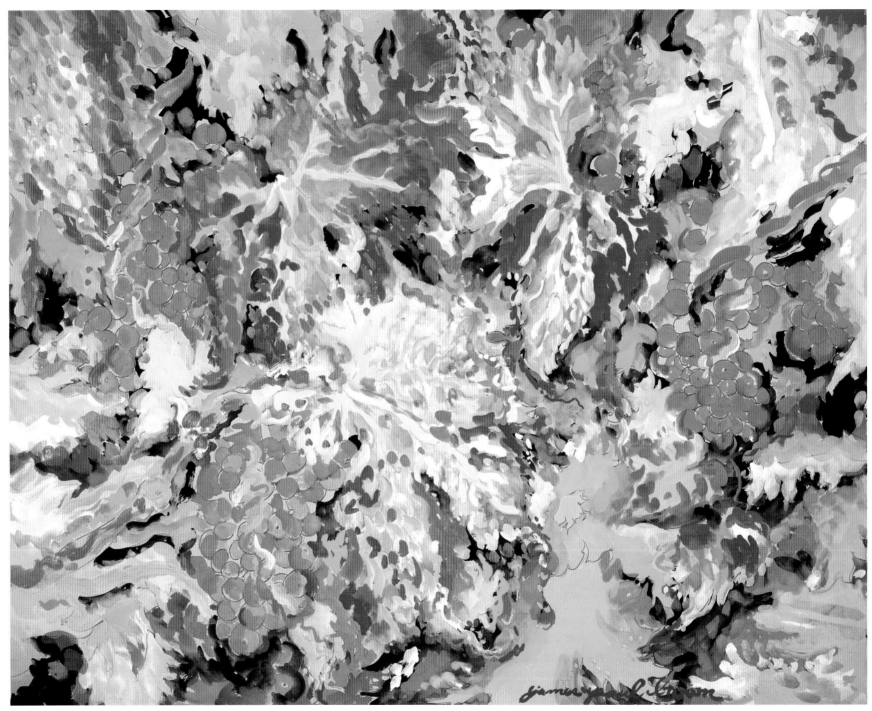

Grapes and Leaves, 1997 (mixed media)

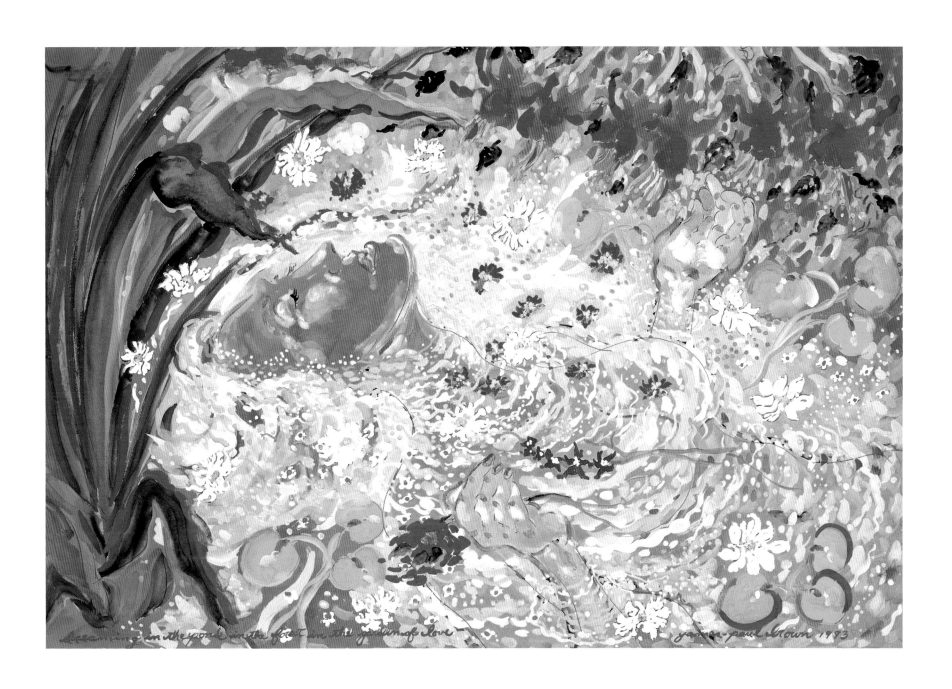

Ophelia II—The Pool in the Garden of Love, 1993 (mixed media)

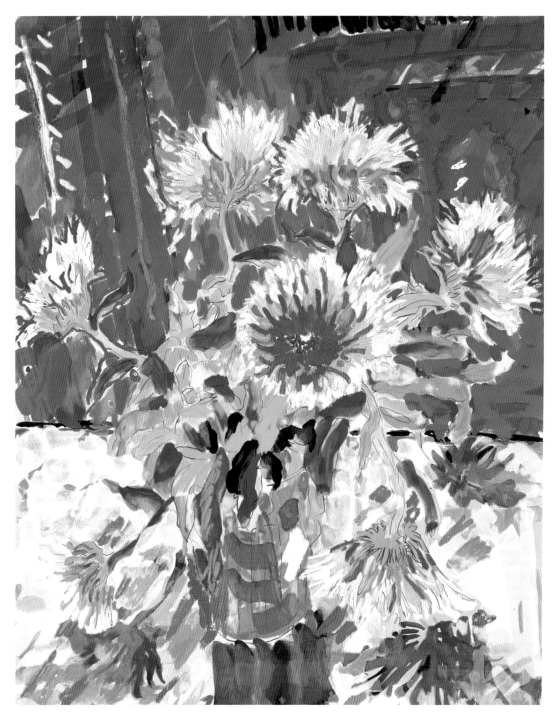

Chateau Julie, 1983 (mixed media)

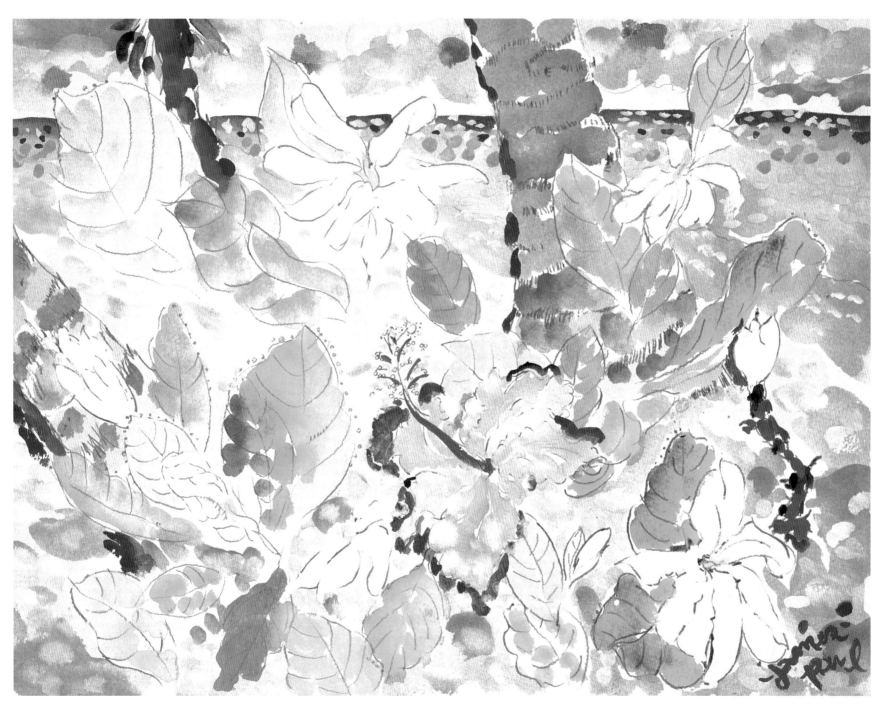

Caribbean Watercolor, 1983 (mixed media)

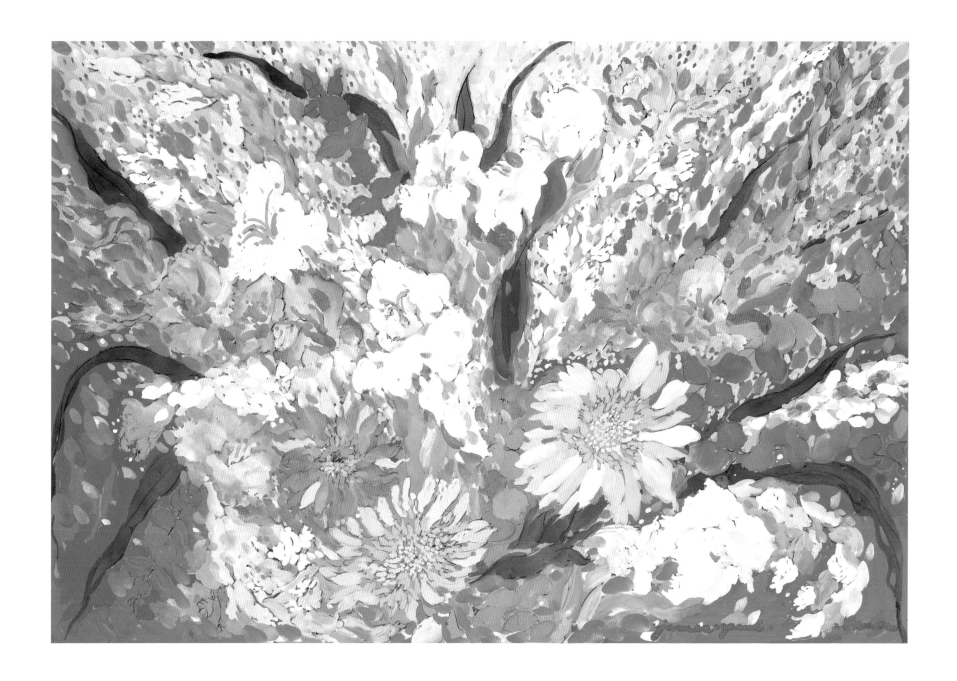

Flowers I, 1989 (mixed media)

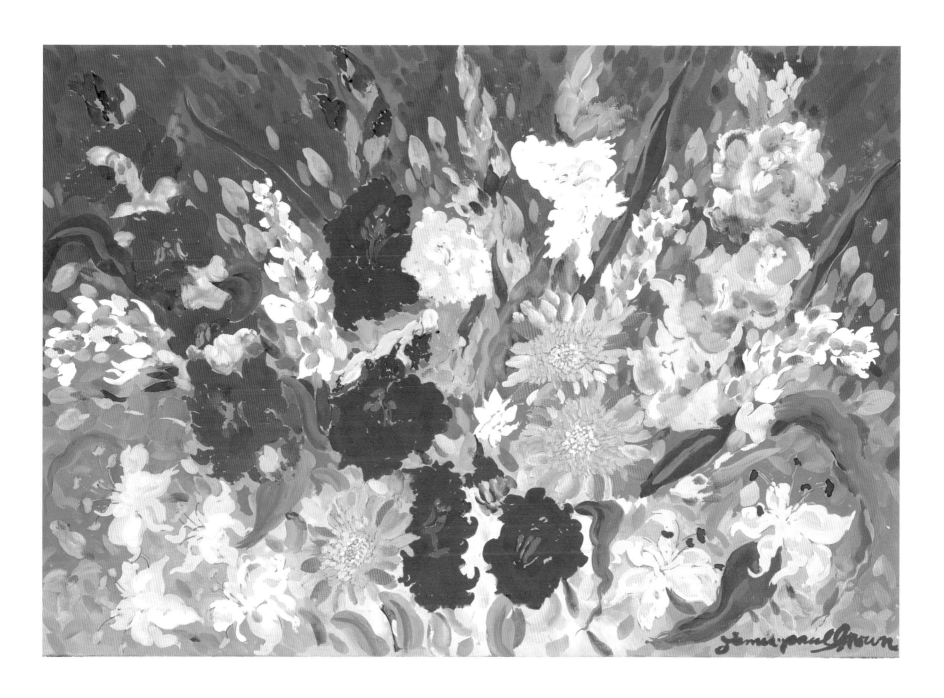

Flowers II, 1989 (mixed media)

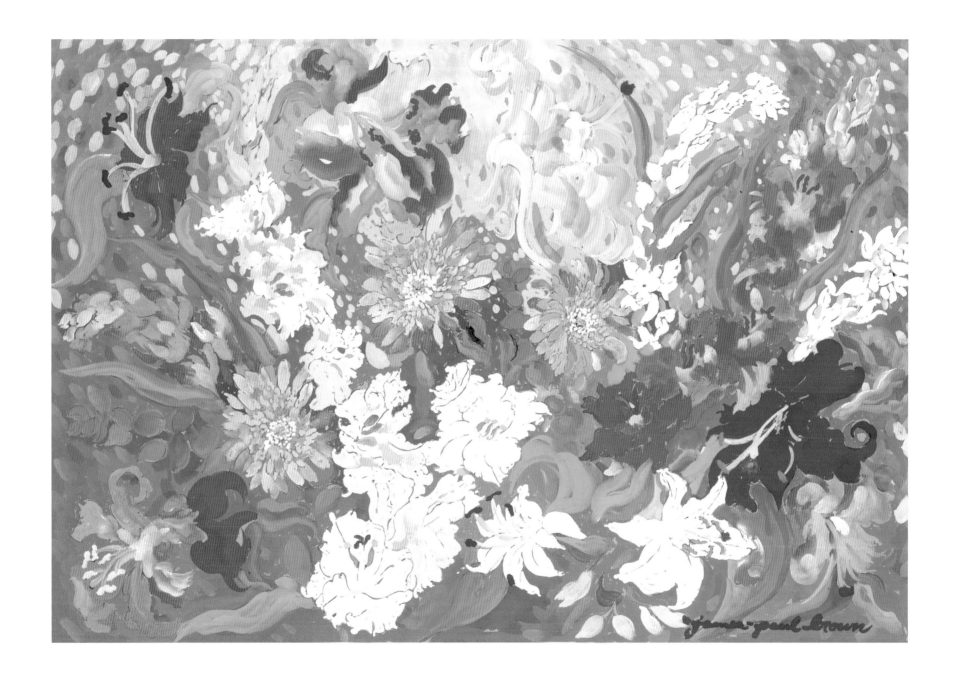

Flowers III, 1989 (mixed media)

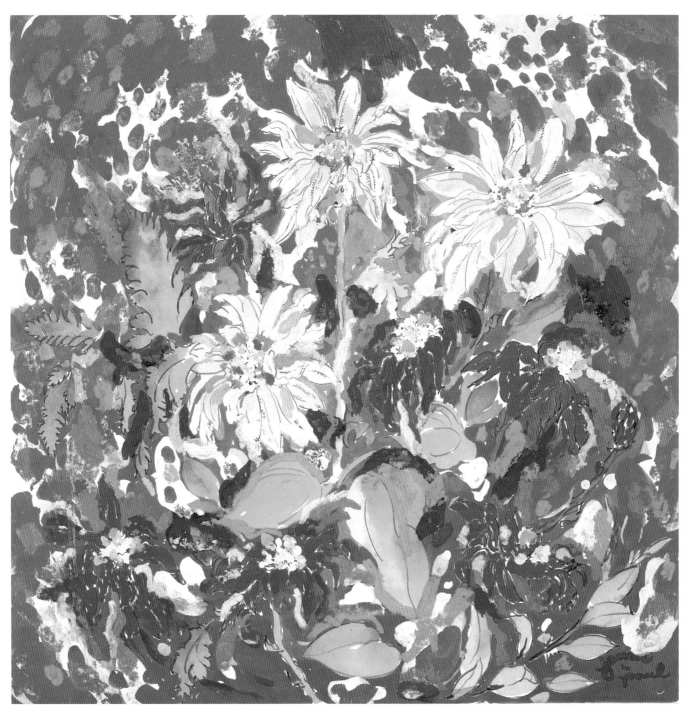

Flowers, 1986 (mixed media)

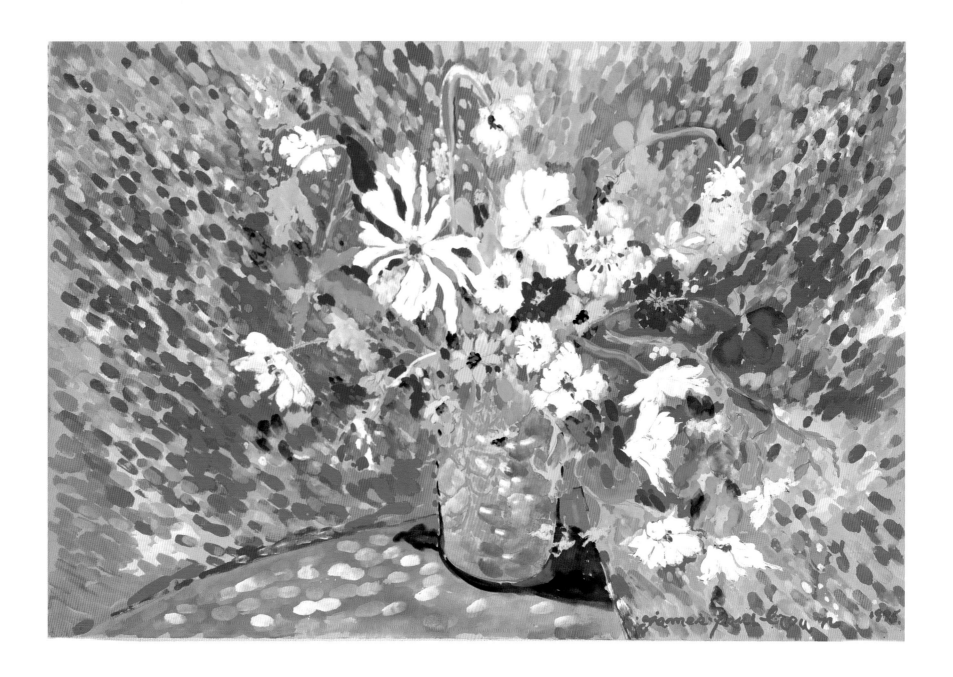

Flower Explosion (mixed media)

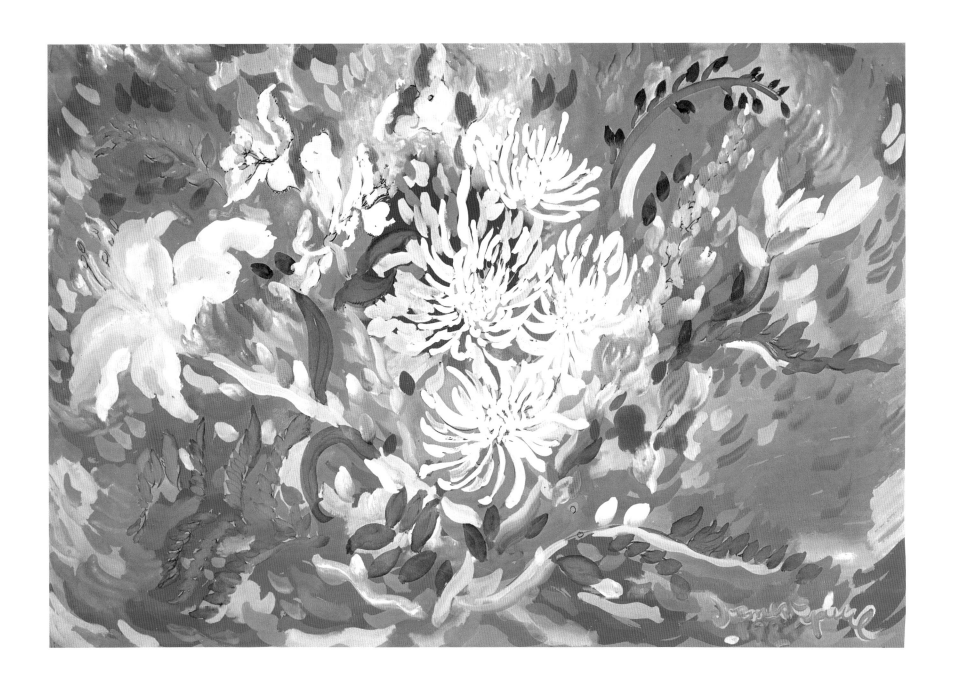

Flowers V, 1998 (mixed media)

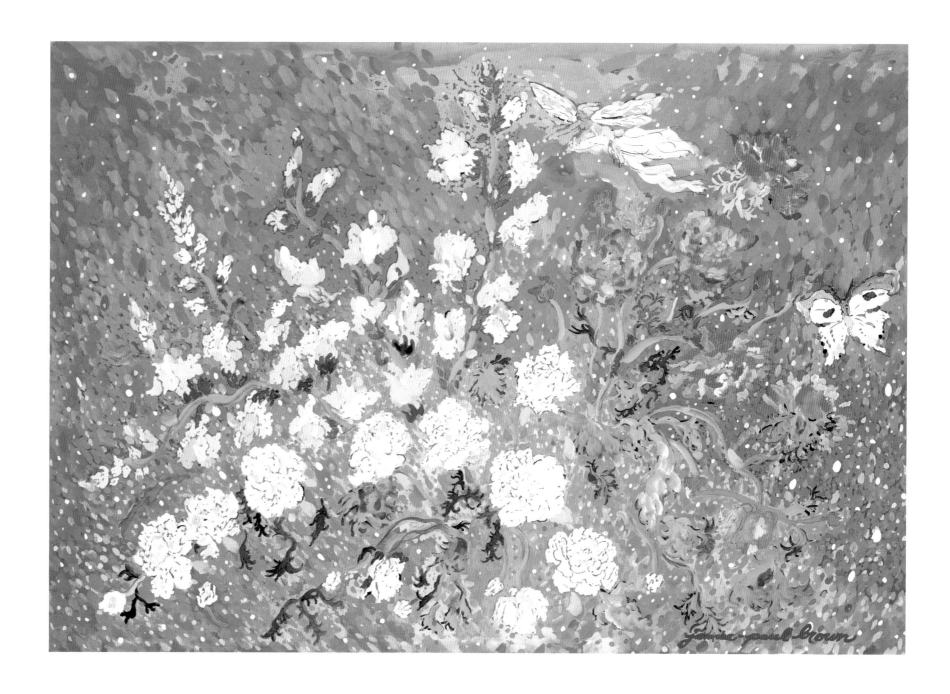

Juliet Pollinating Flowers (mixed media)

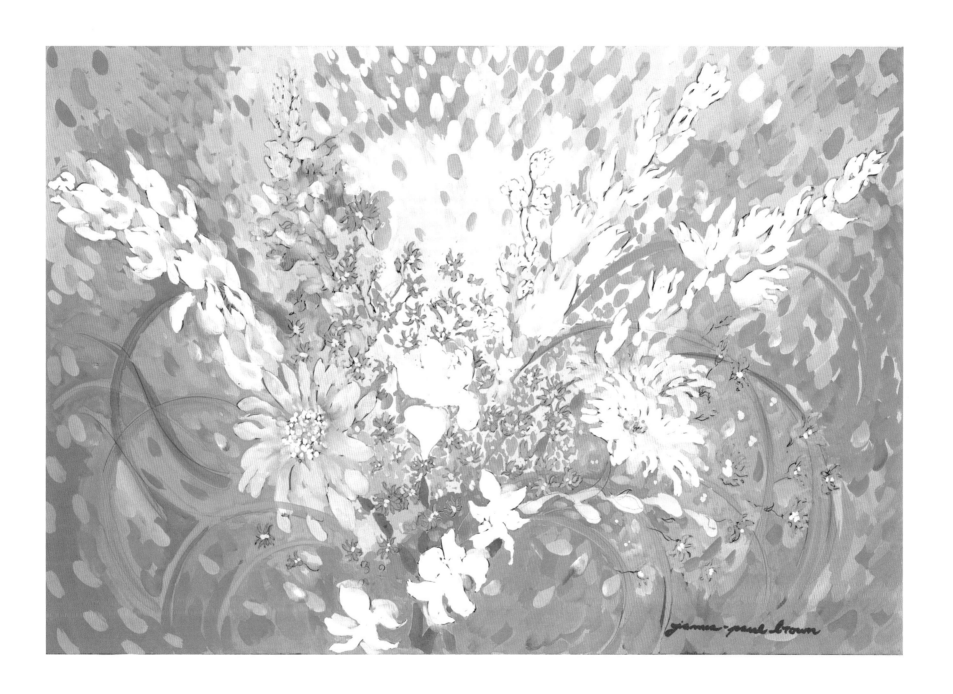

Bouquet (mixed media)

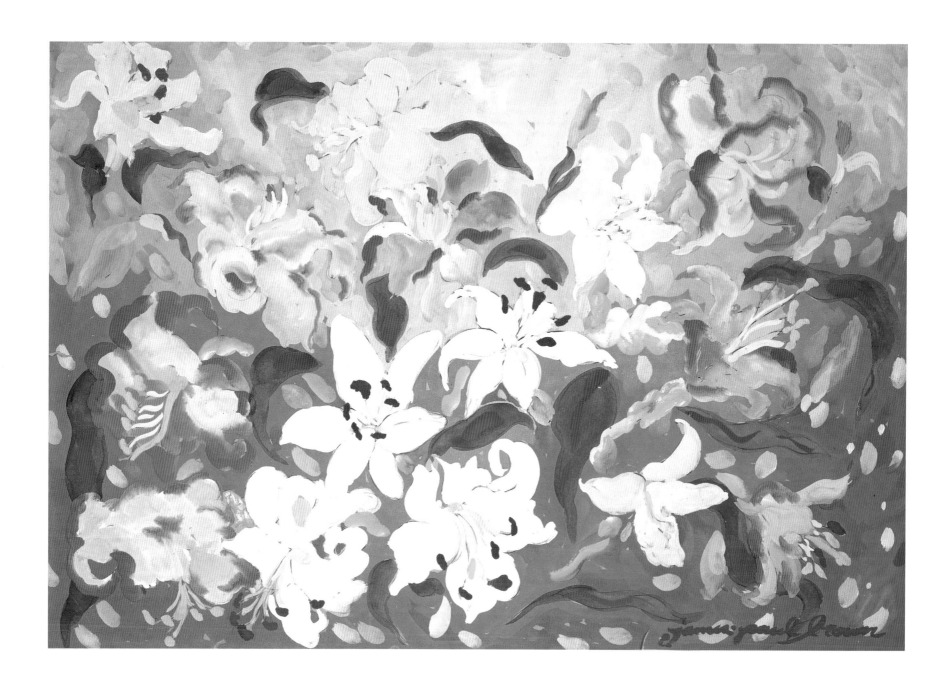

Lilies (mixed media)

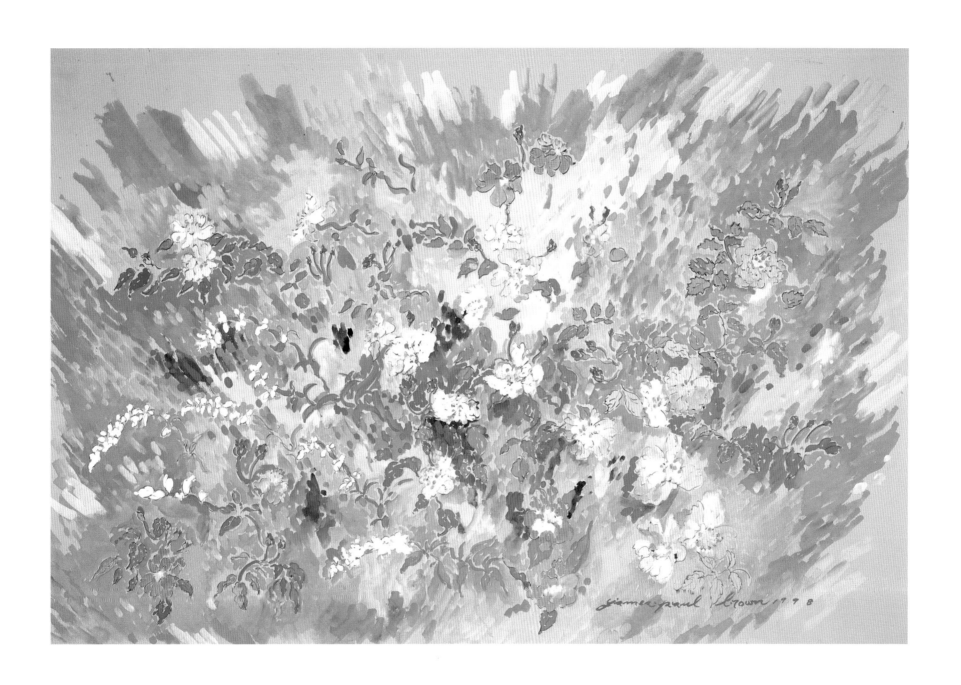

Montecito Flowers, 1998 (mixed media)

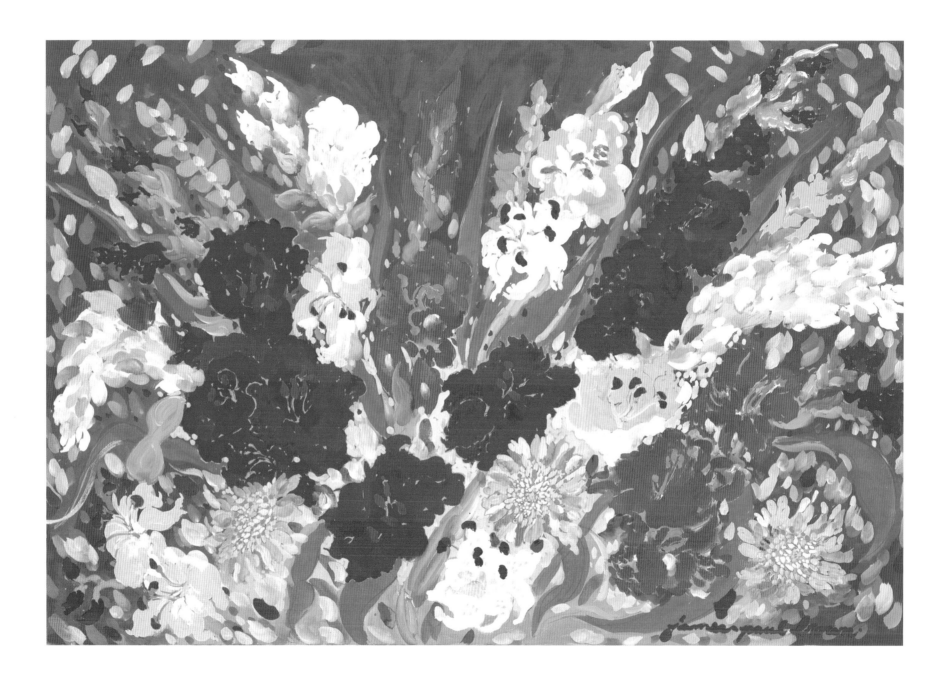

Flowers VI (mixed media)

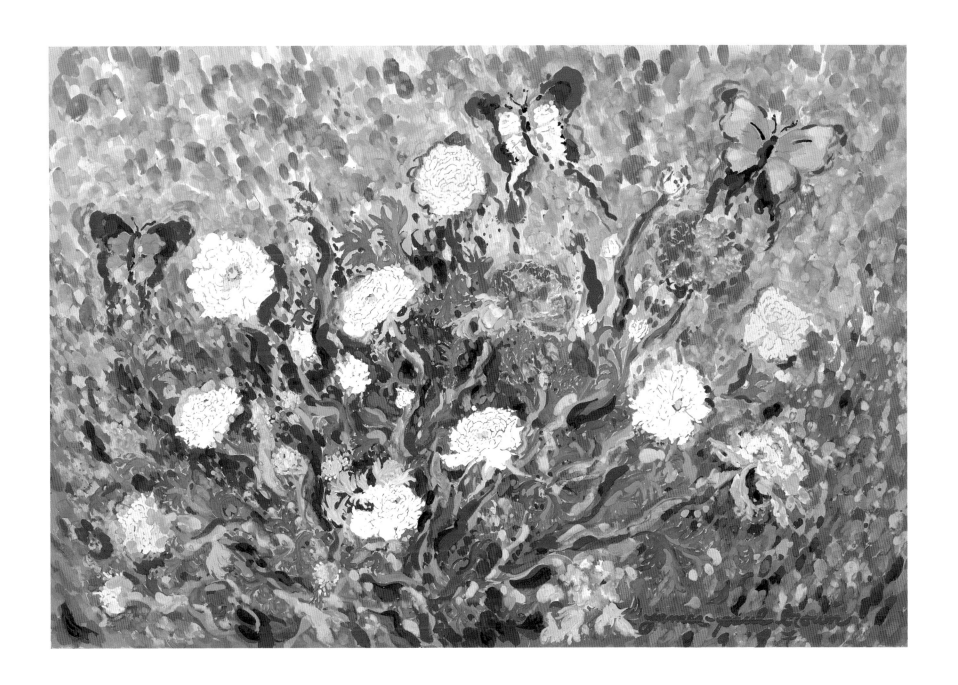

Montecito Garden, 1990-1998 (mixed media)

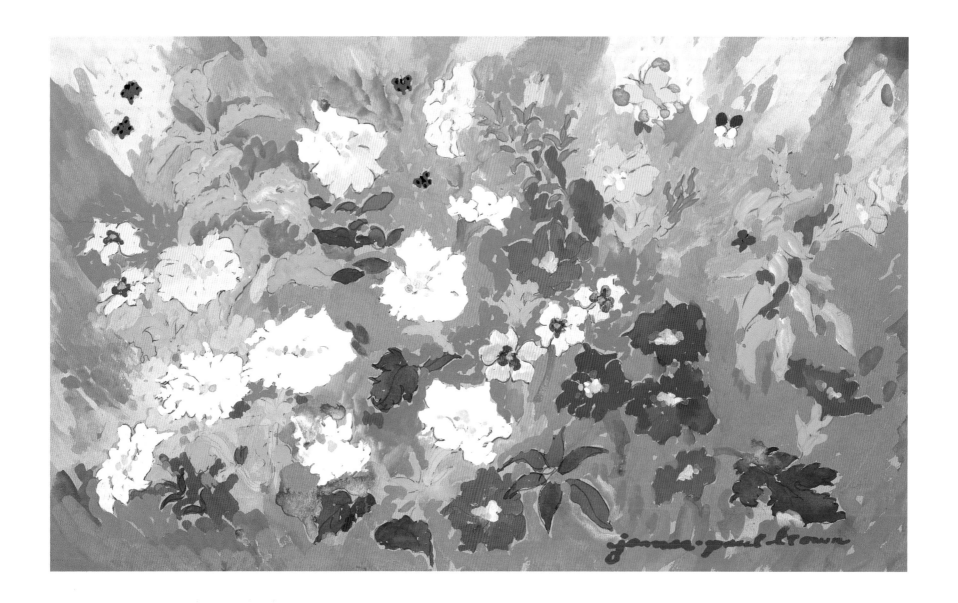

Flowers VII (mixed media)

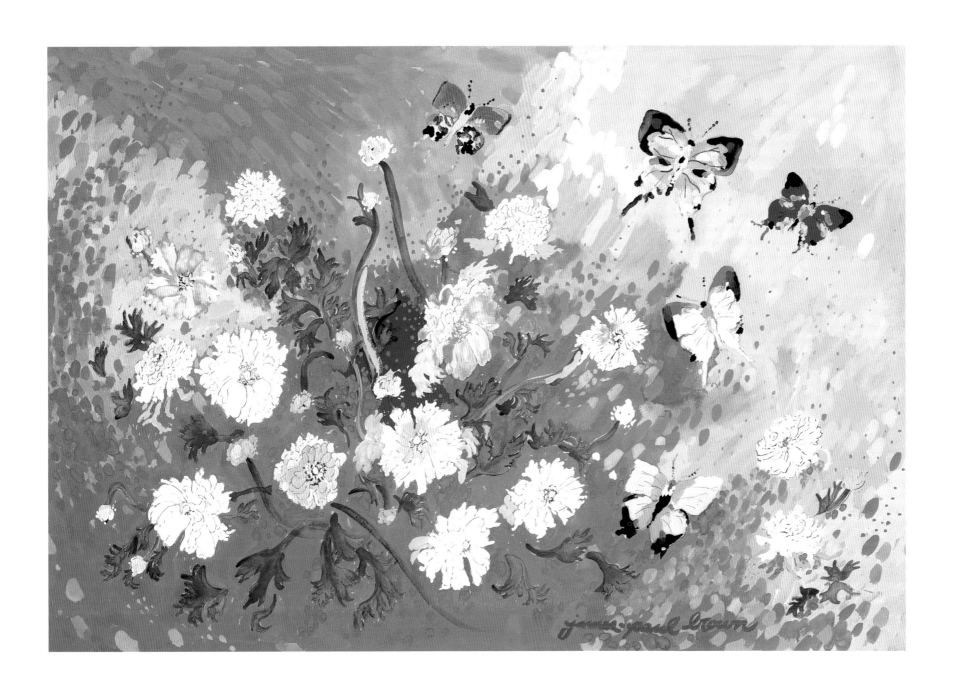

Flowers and Butterflies (mixed media)

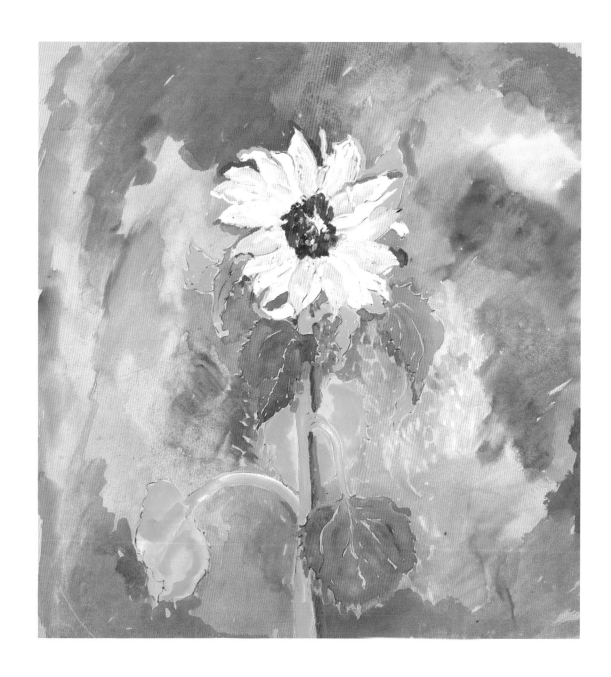

Sunflower (mixed media)

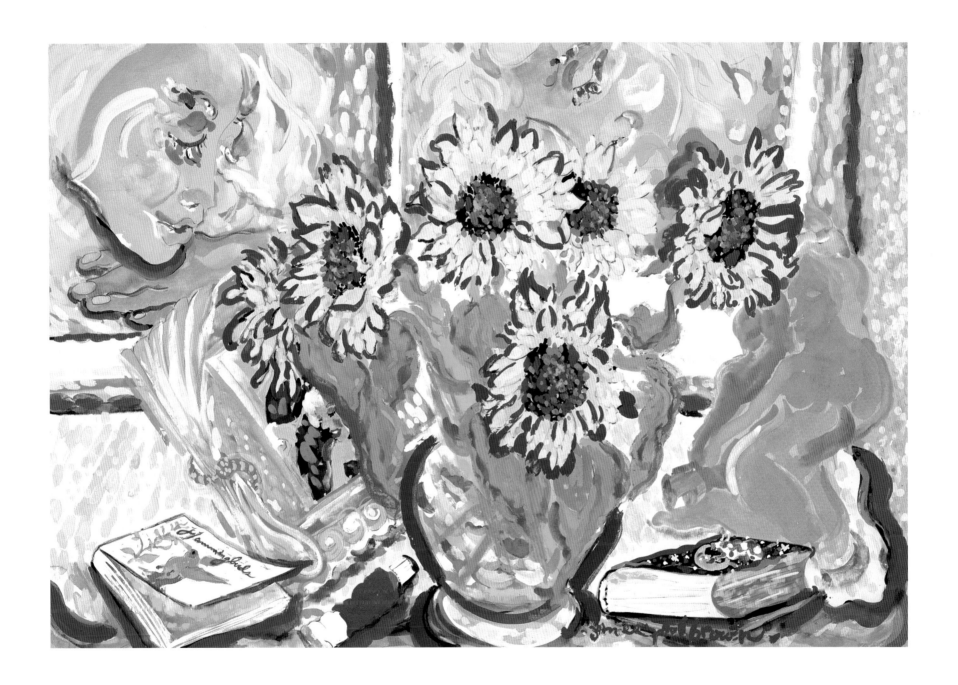

Sunflowers (mixed media)

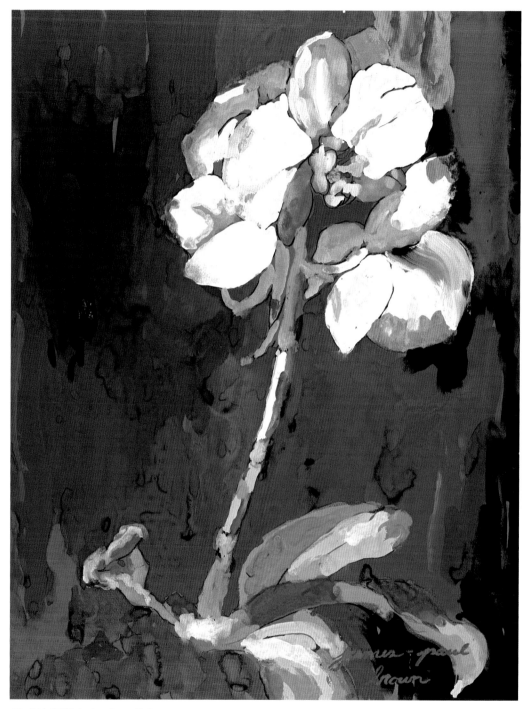

Orchid, 1982 (mixed media)

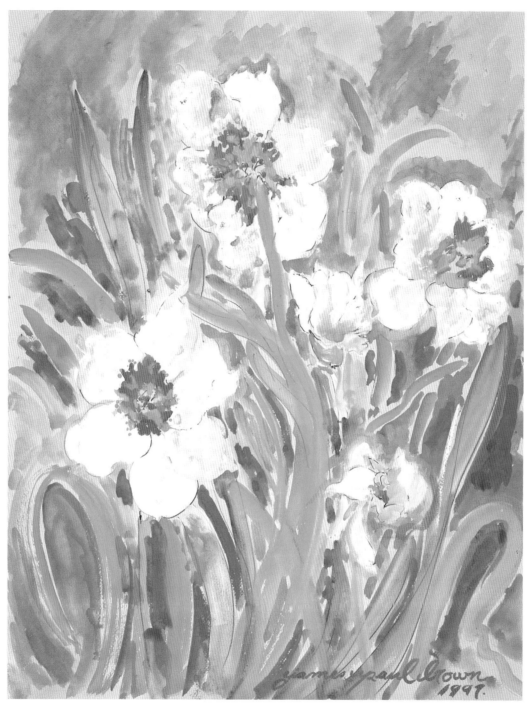

Daffodils, 1997 (mixed media)

127

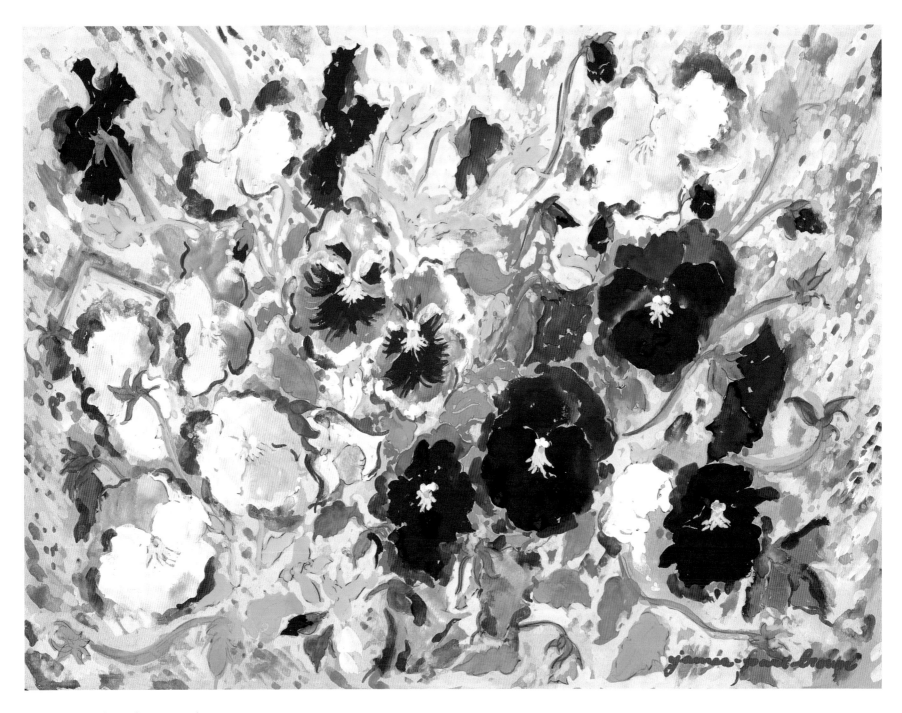

Pansies I, 1993 (gouache on paper)

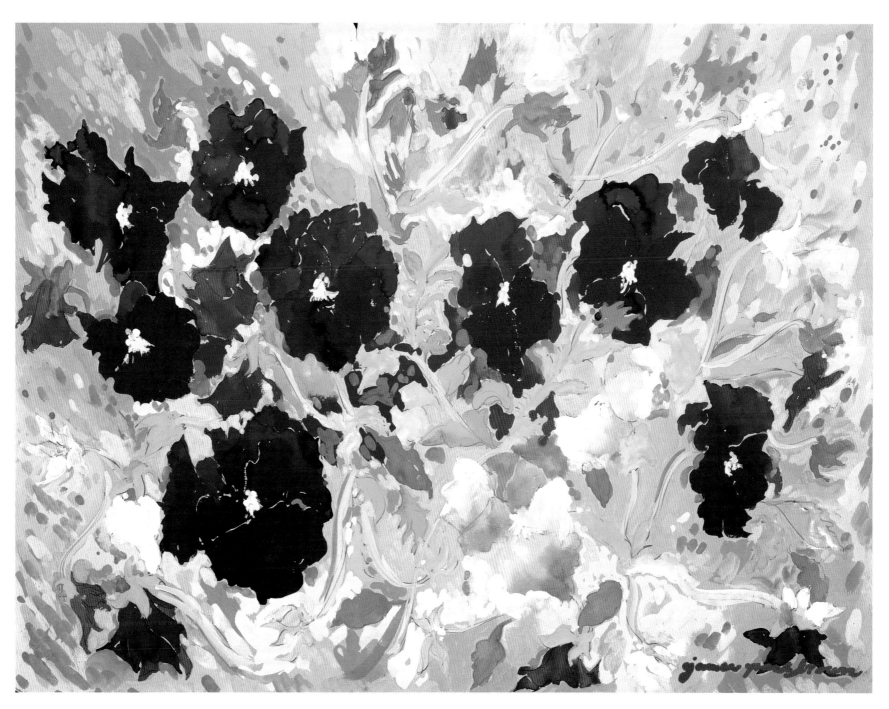

Pansies II, 1993 (gouache on paper)

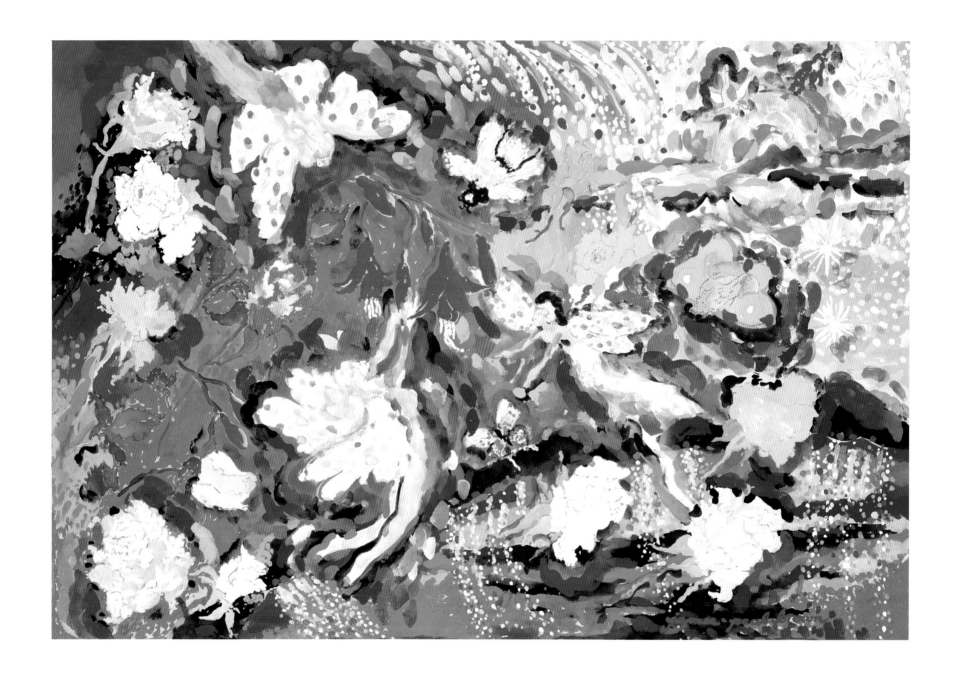

Fairies in the Garden, 1995 (mixed media)

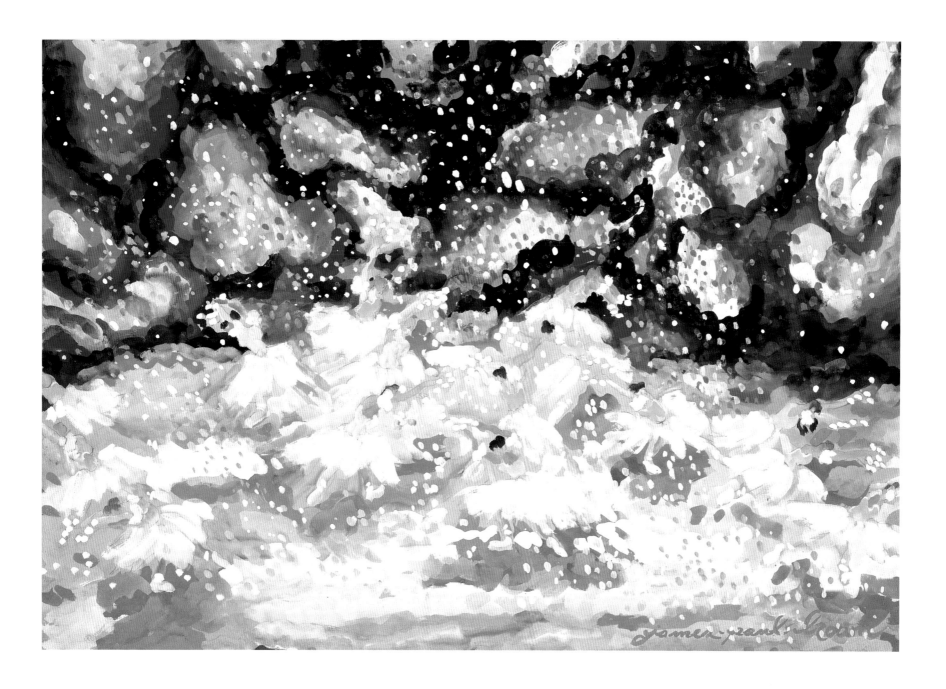

Nutcracker Suite II, 1992 (mixed media)

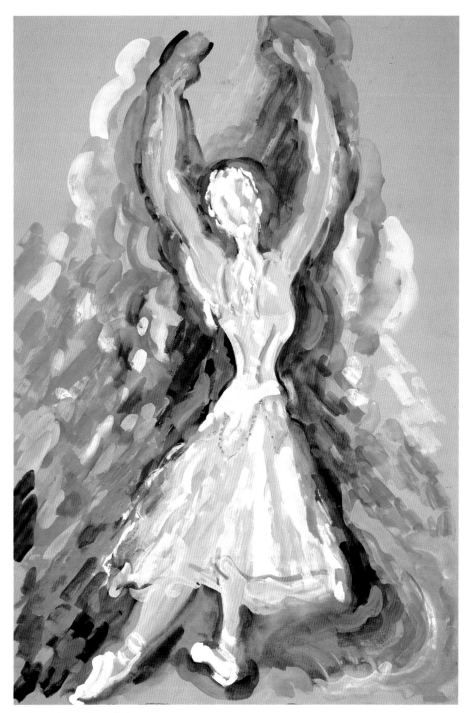

Pointe I (mixed media)

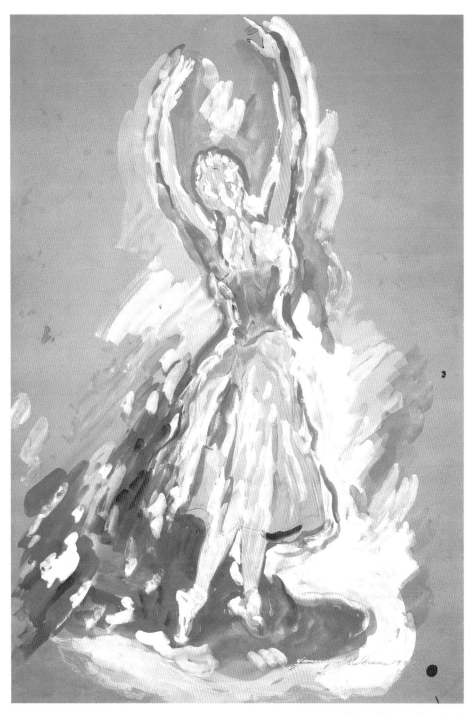

Pointe II (mixed media)

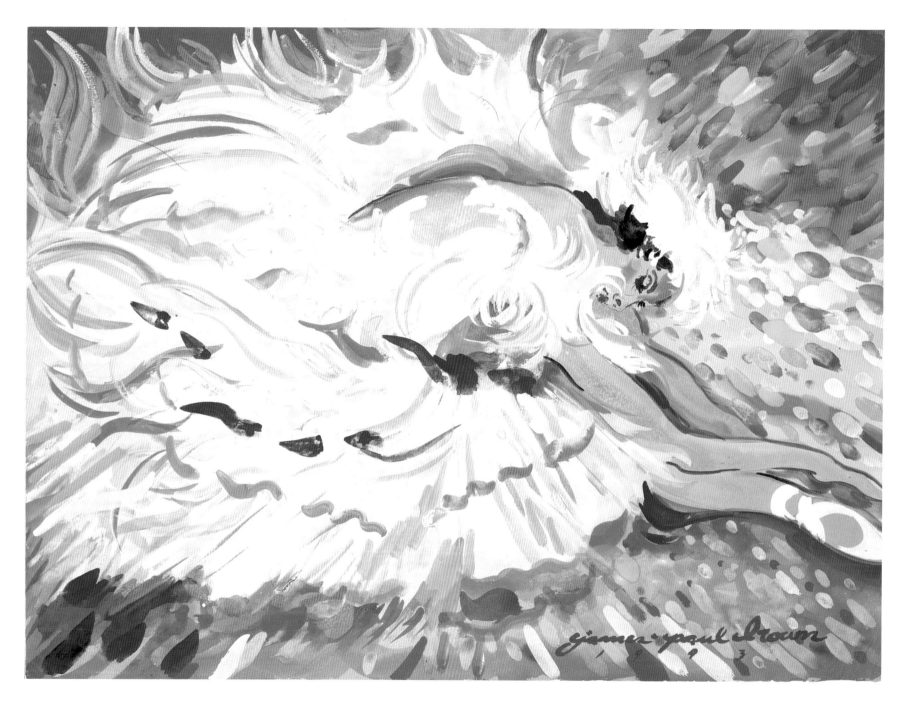

Ballet III (mixed media)

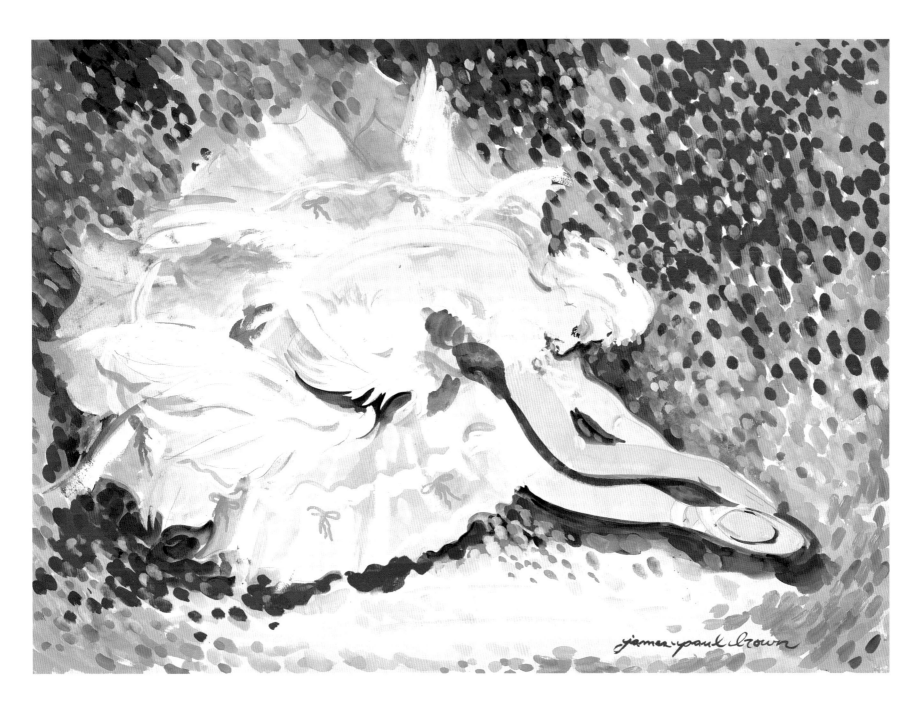

Ballet IV (mixed media)

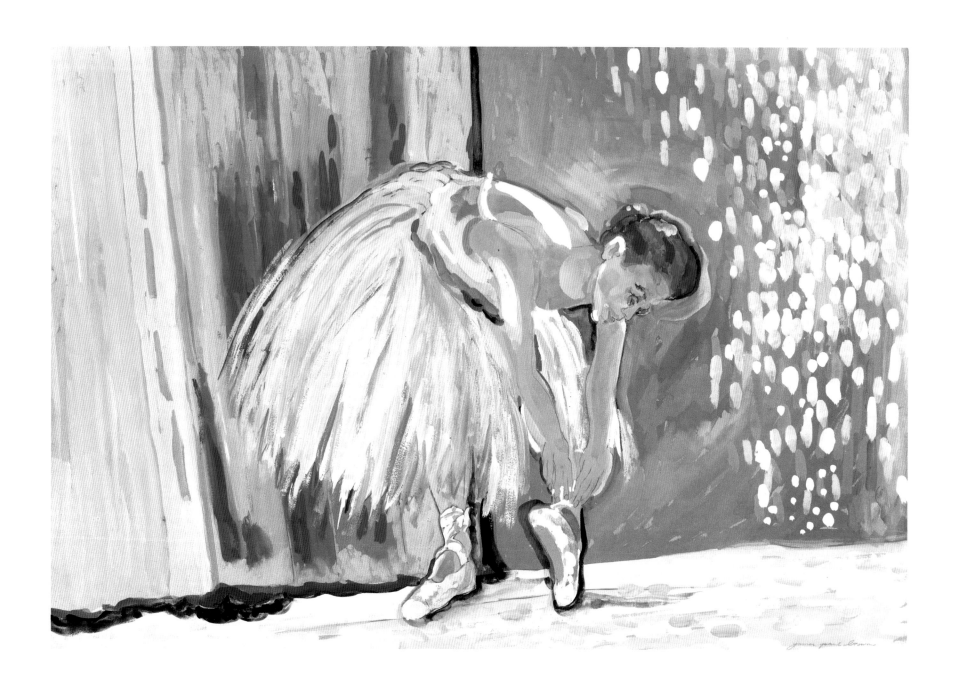

Ballet V (mixed media)

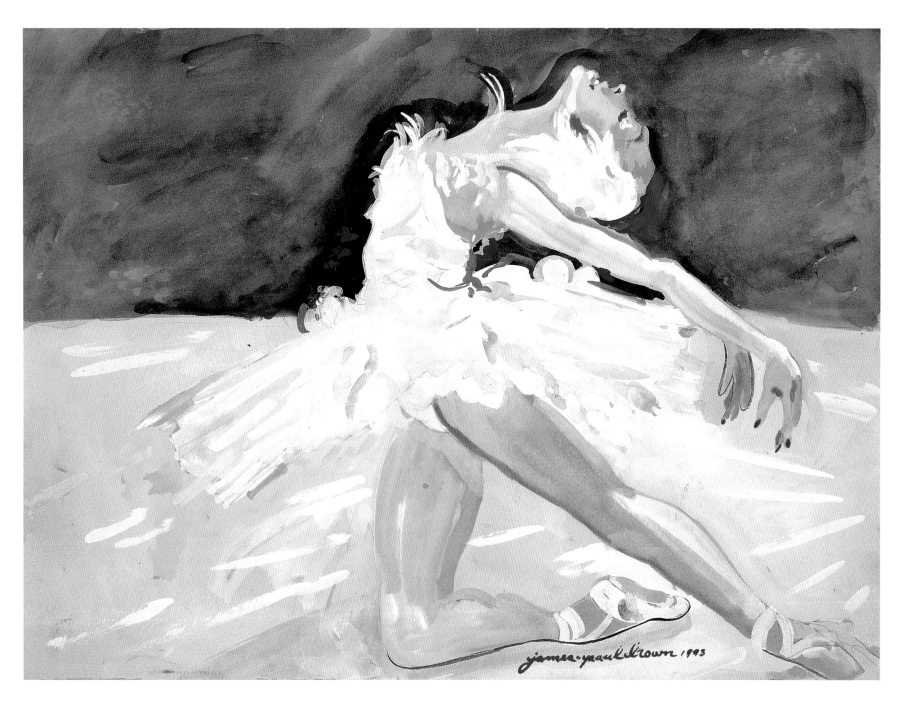

Ballet VI (mixed media)

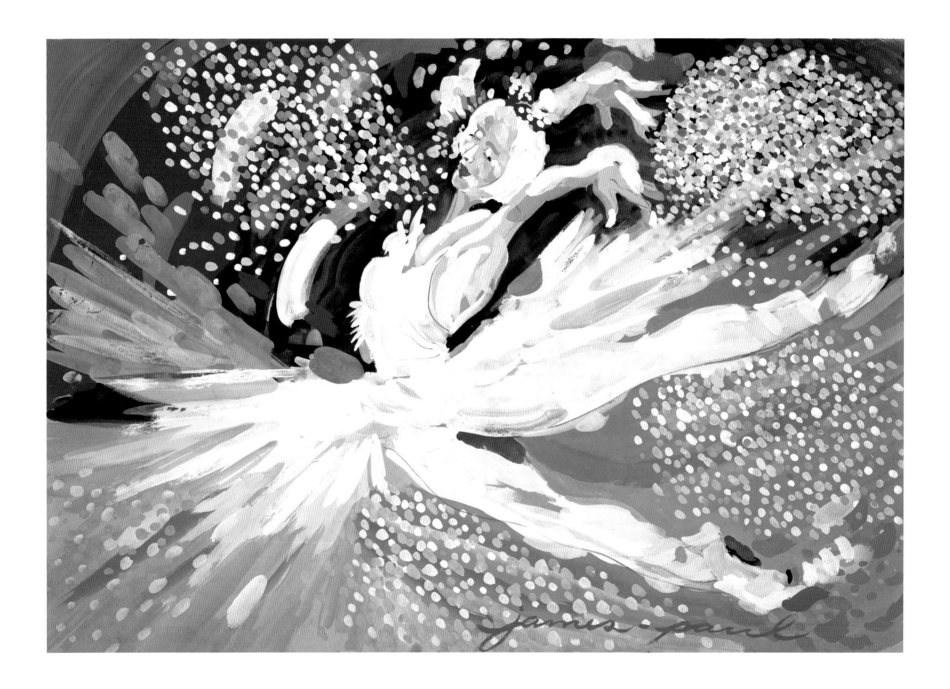

Ballet VII (mixed media)

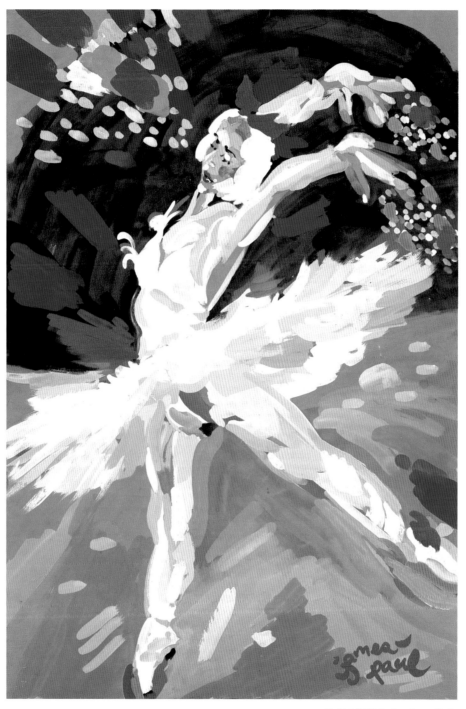

Ballet VIII (mixed media)

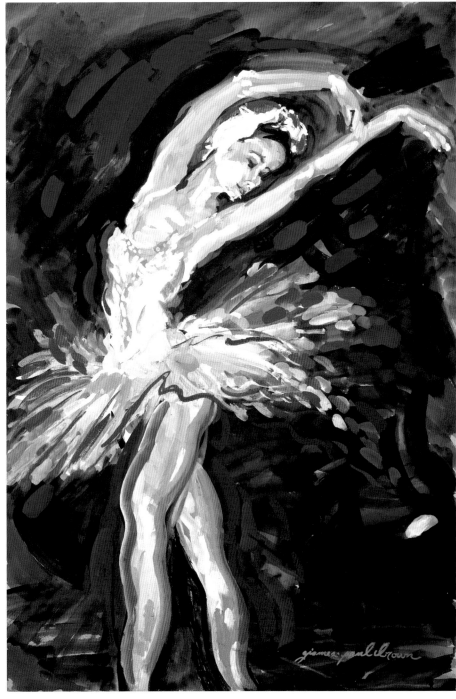

Ballet IX (mixed media)

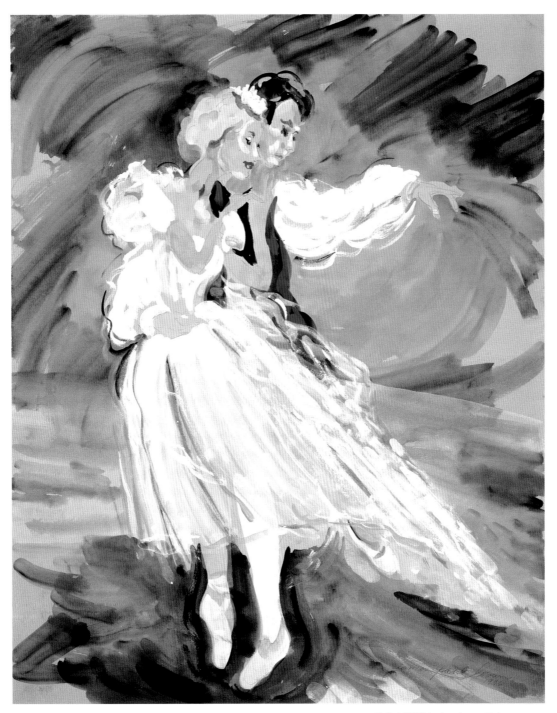

Ballet XIII (mixed media)

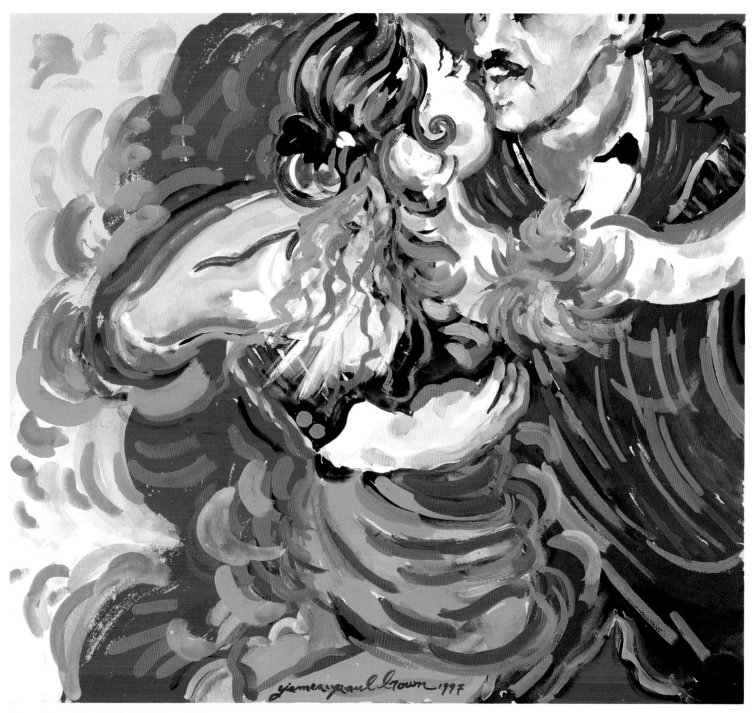

Dance Romantica, 1997 (mixed media)

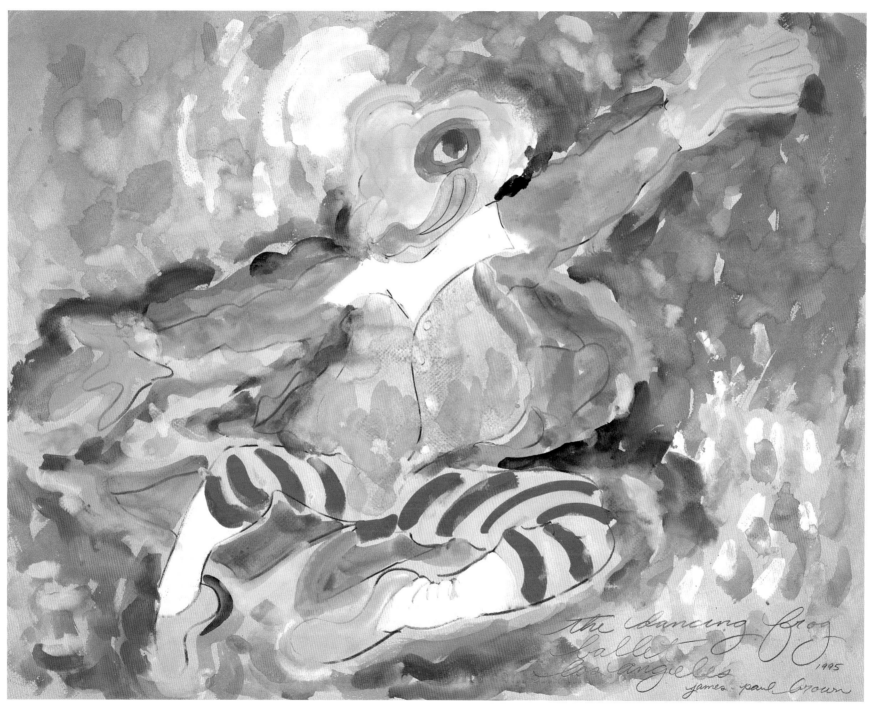

The Dancing Frog (mixed media)

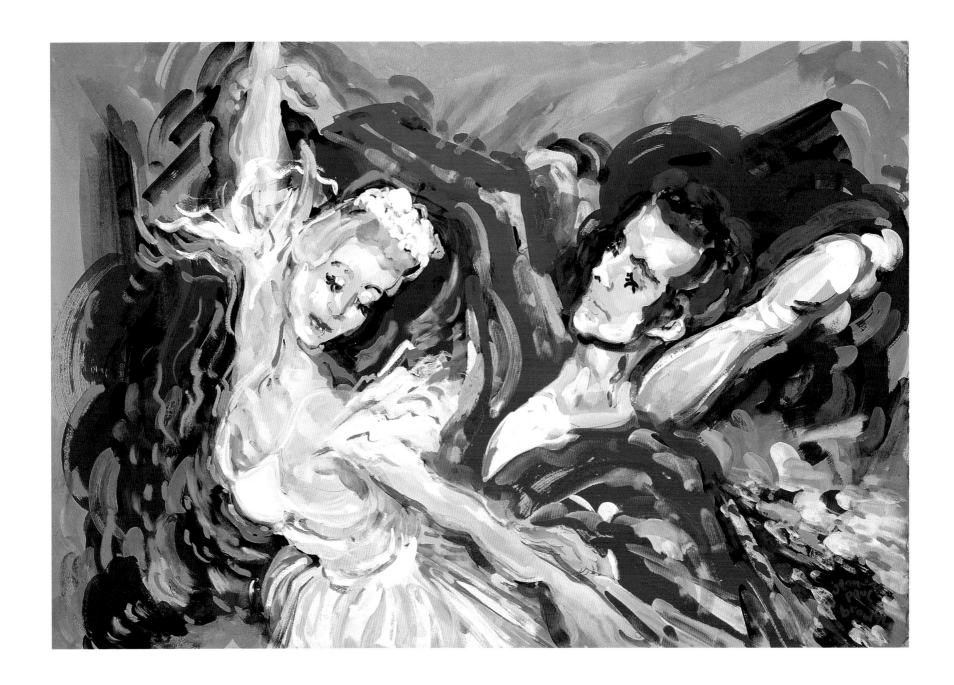

Ballet XIV (mixed media)

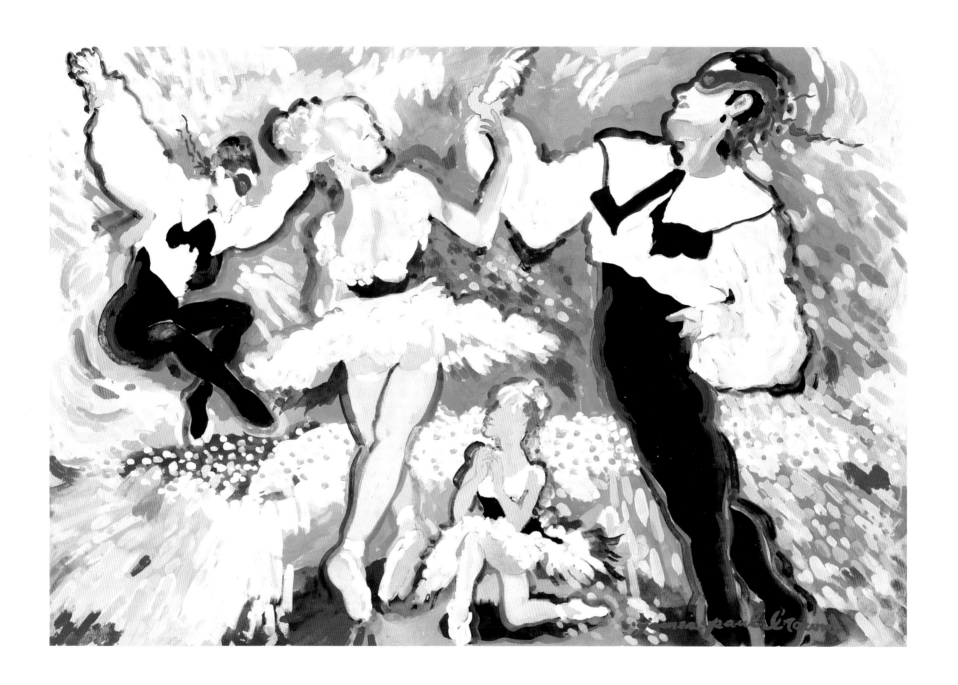

Ballet XV (mixed media)

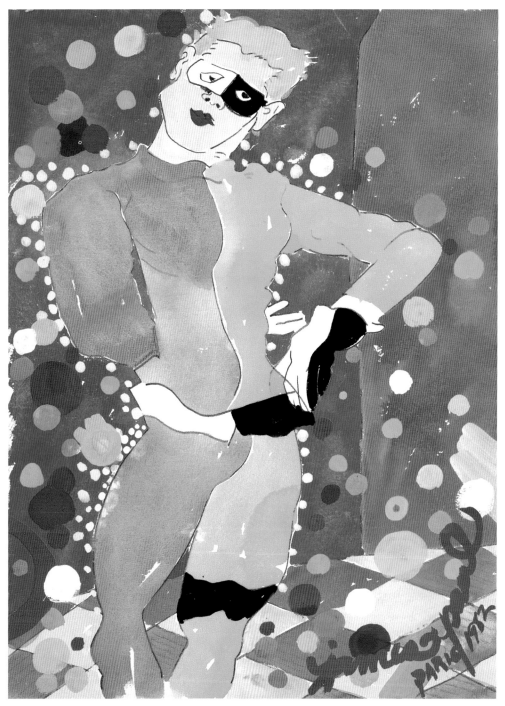

Paris Dancer, 1982 (mixed media)

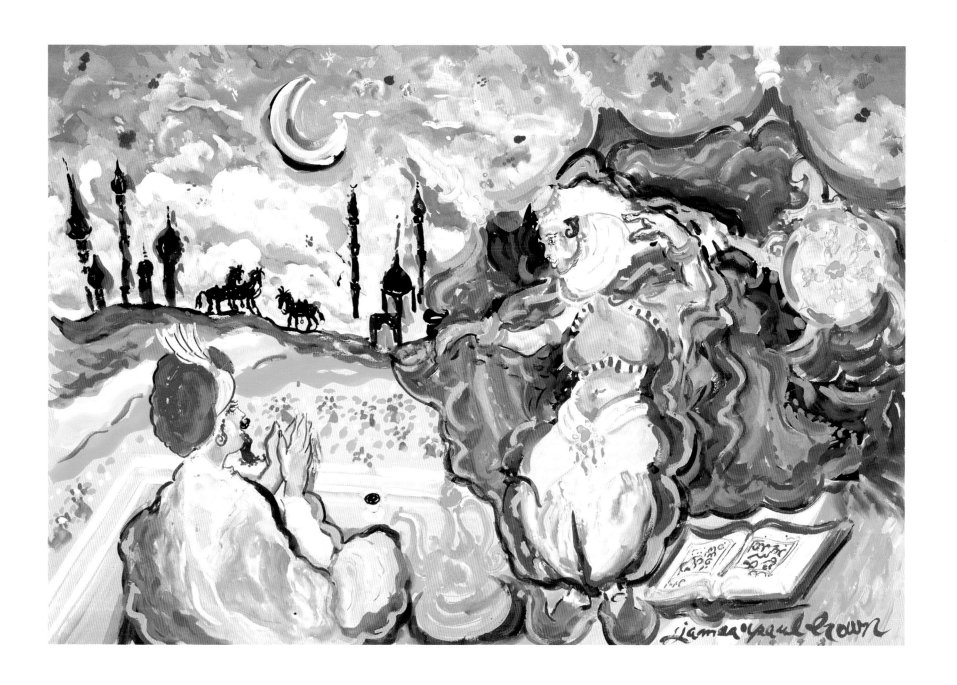

Belly Dance, 1998 (mixed media)

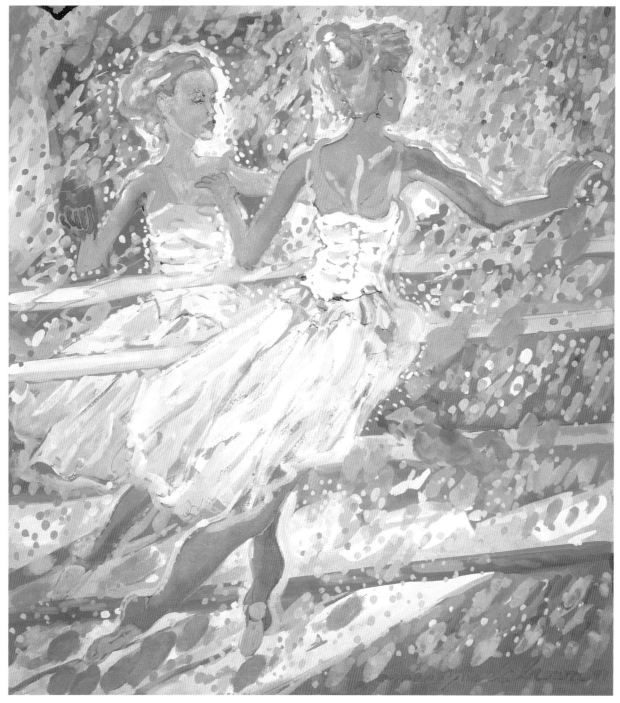

French Ballerina, 1997 (mixed media)

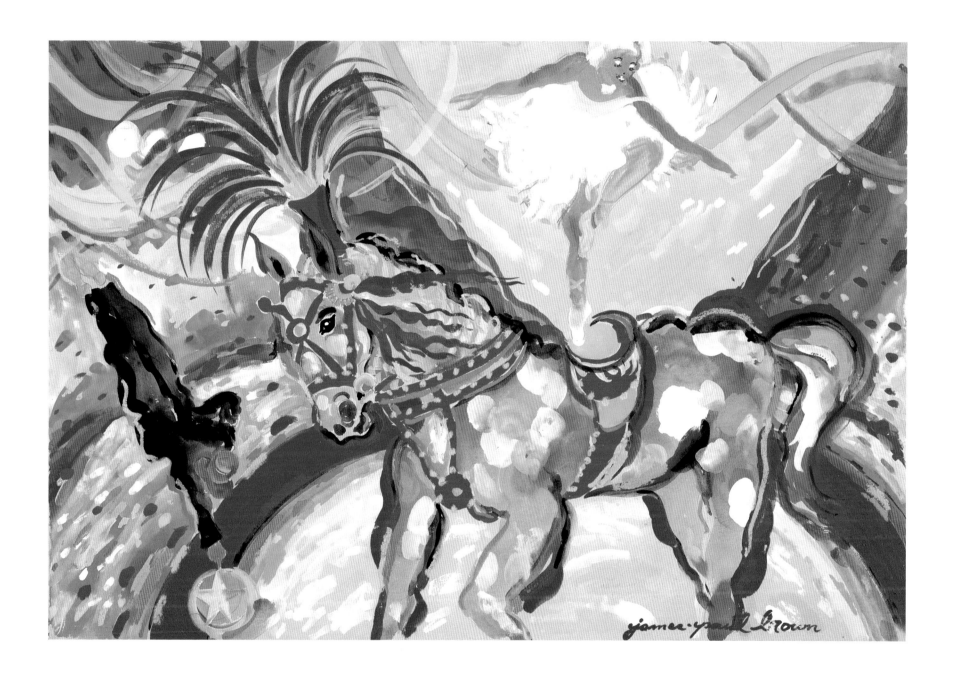

Circus Ballerina, 1997 (mixed media)

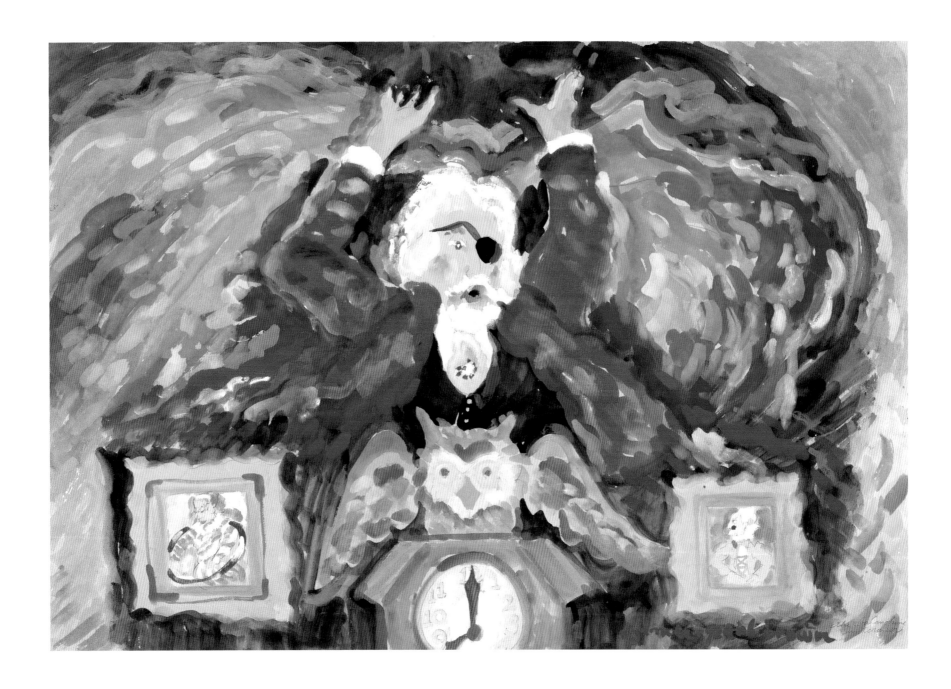

Ringleader, 1993 (mixed media)

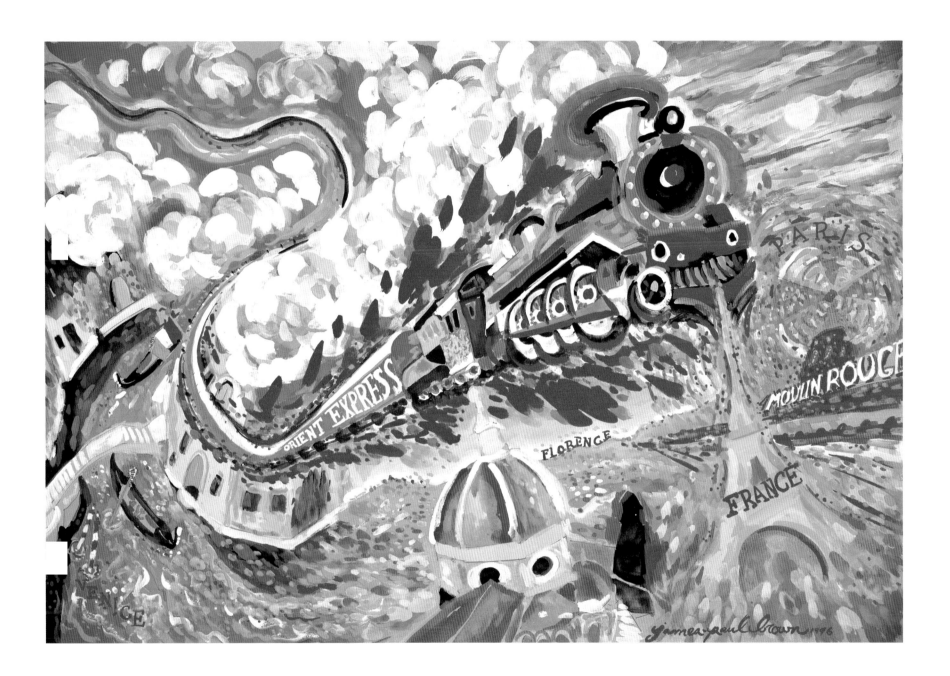

Orient Express I (mixed media)

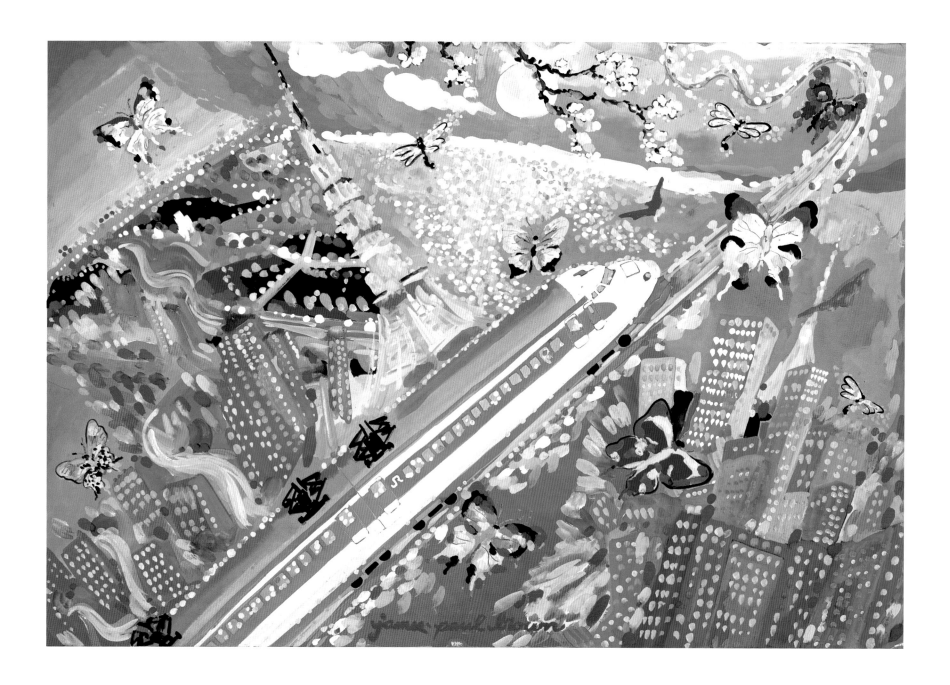

Japan's Bullet Train I, 1986 (mixed media)

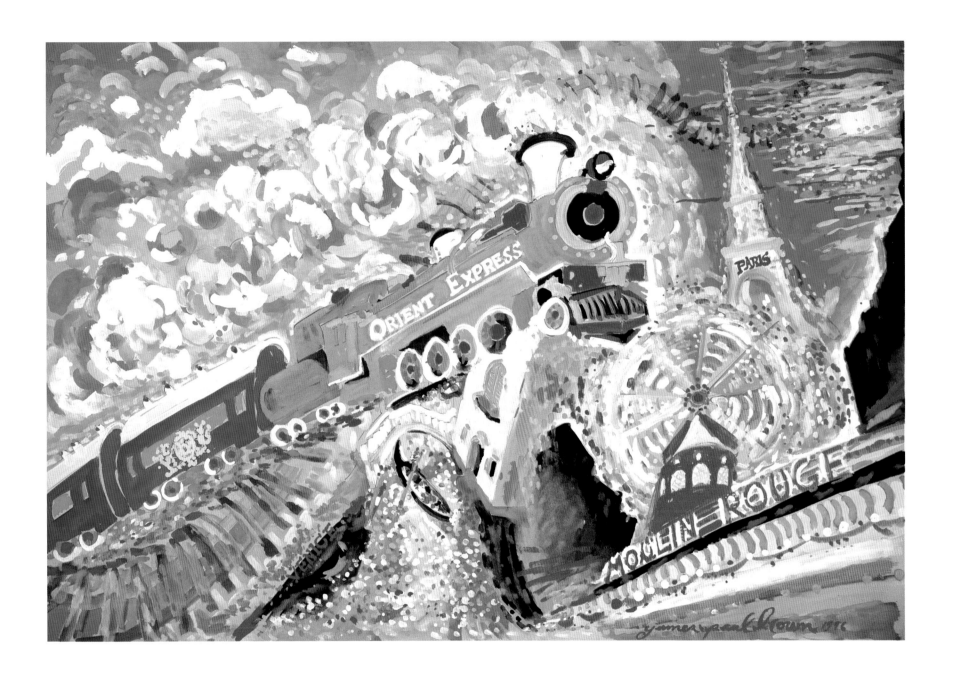

Orient Express II, 1996 (mixed media)

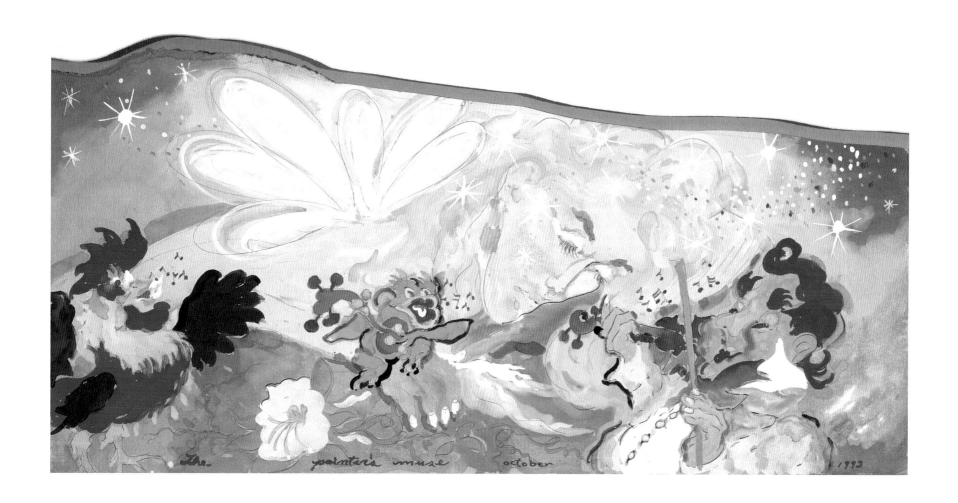

Angel Juliet and Her Merry Men, 1993 (mixed media)

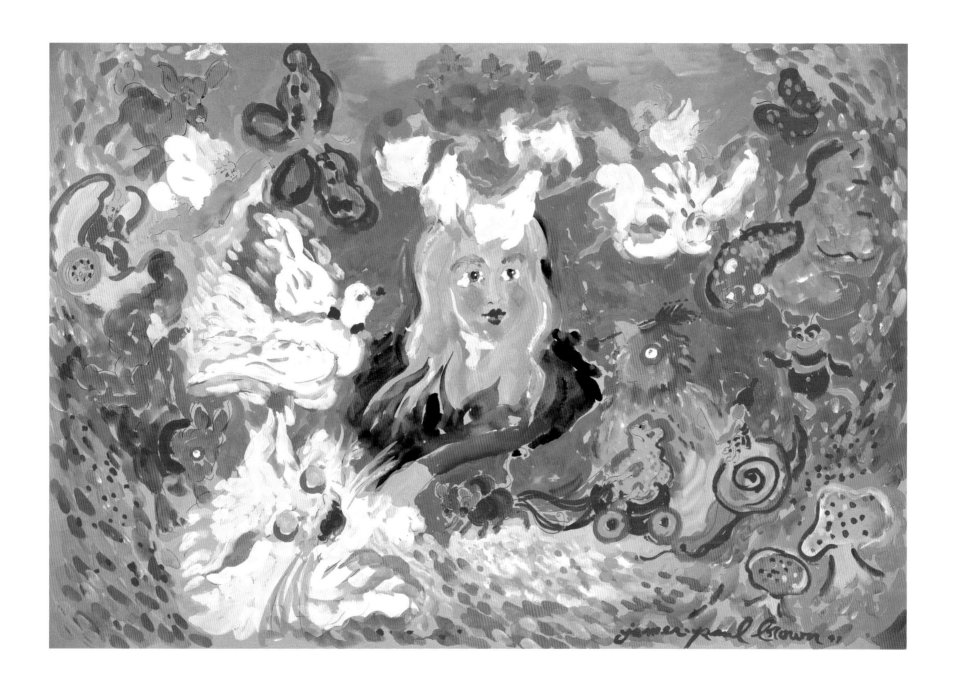

Young Princess Juliet and Friends, 1997 (mixed media)

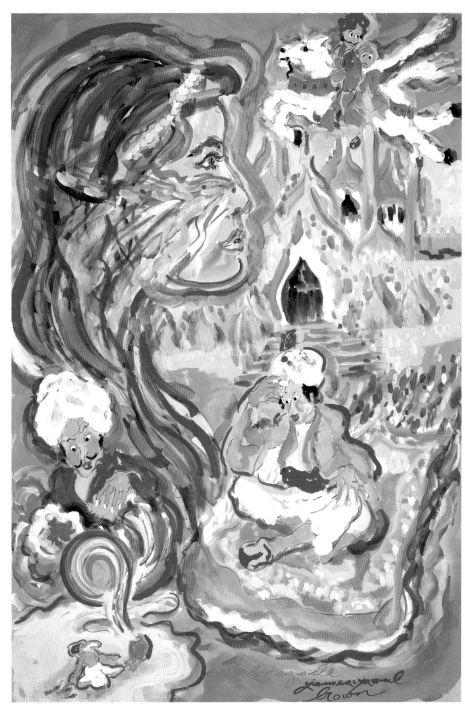

Princess Juliet Scheherazade, 1997 (mixed media)

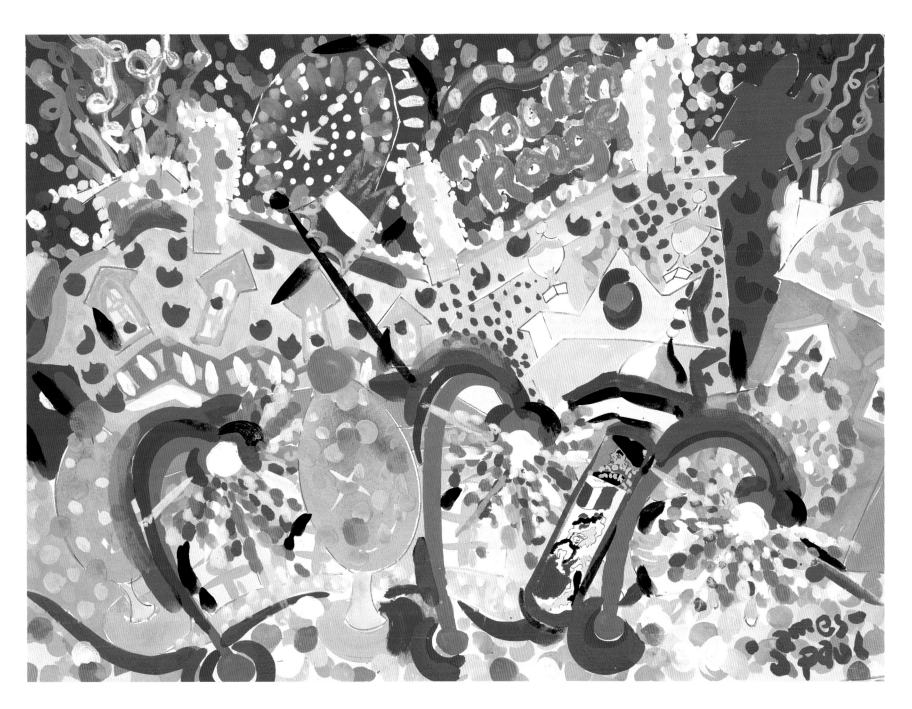

Moulin Rouge (mixed media)

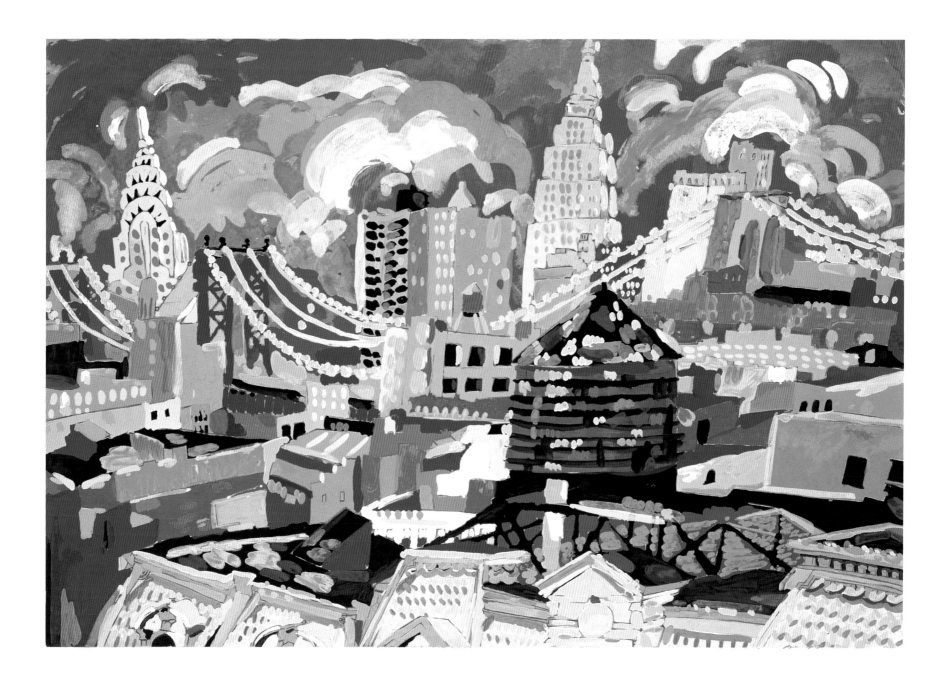

Manhattan Skyline (mixed media)

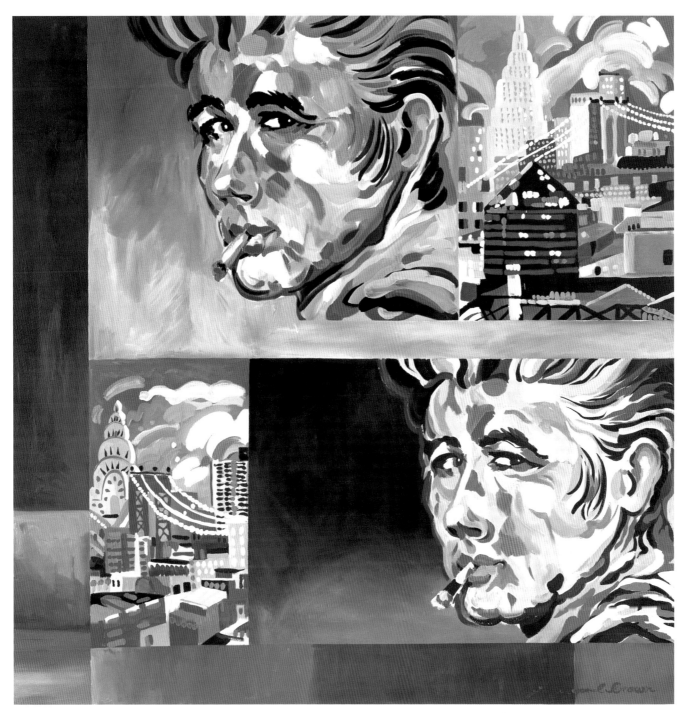

Dean Takes New York, 1995 (mixed media)

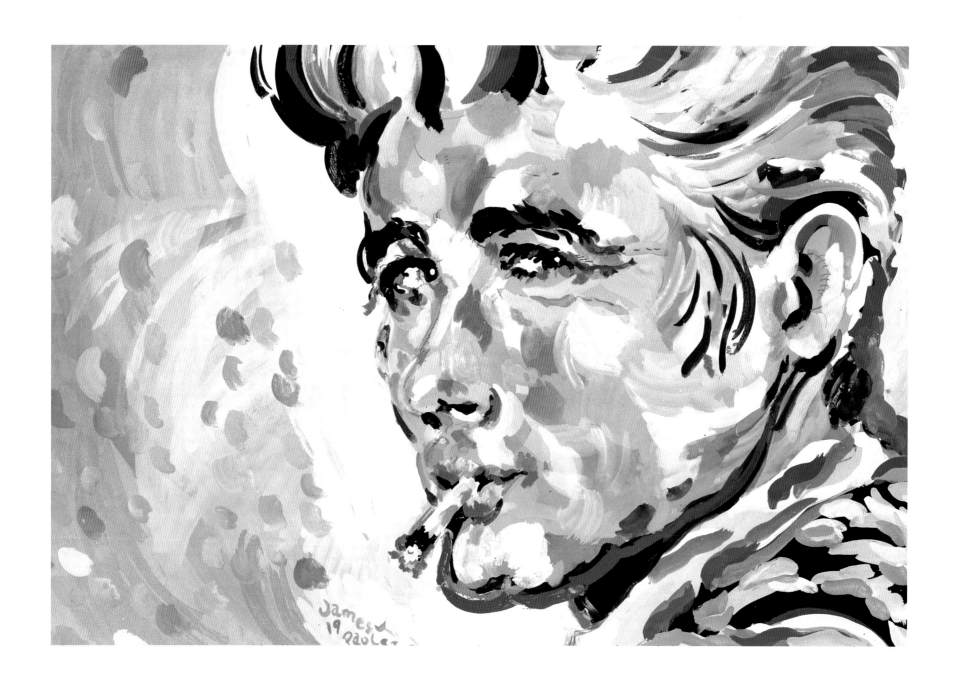

James Dean I, 1987 (mixed media)

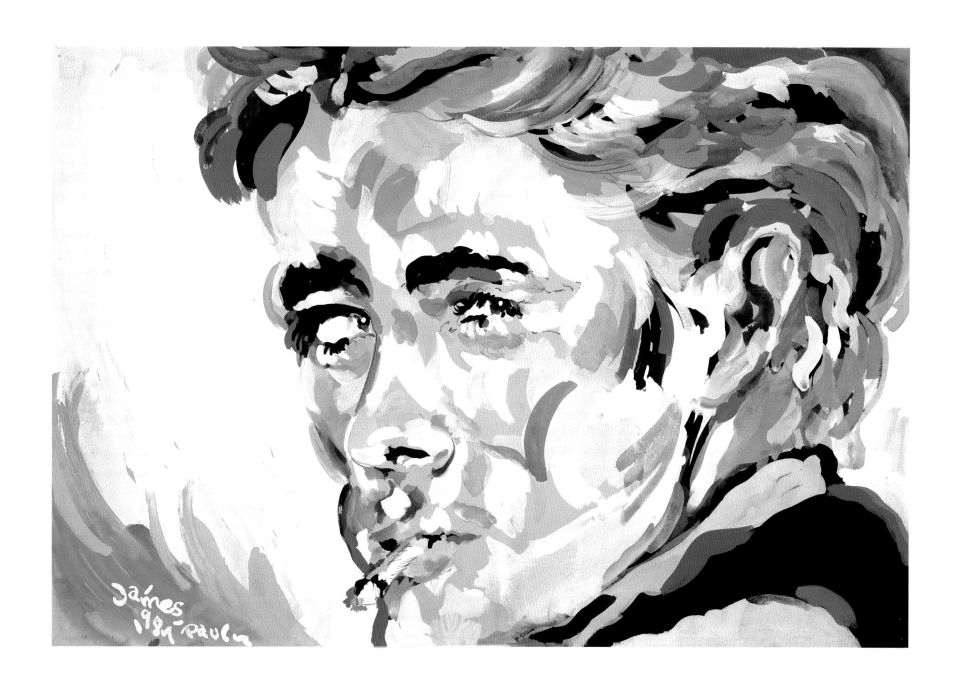

James Dean II, 1987 (mixed media)

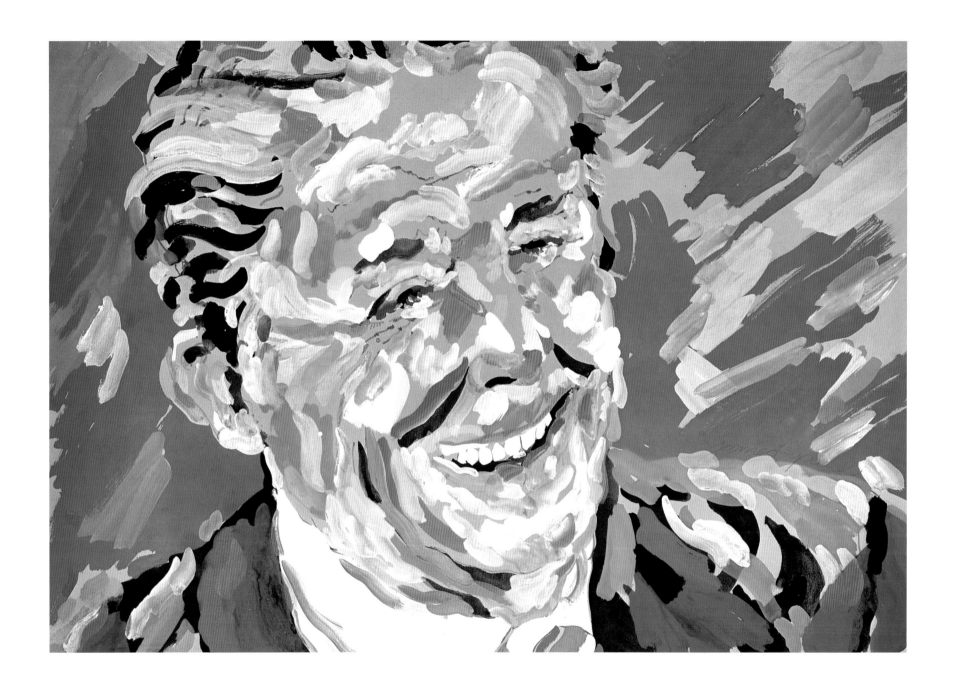

Inaugural Portrait, Ronald Reagan (mixed media)

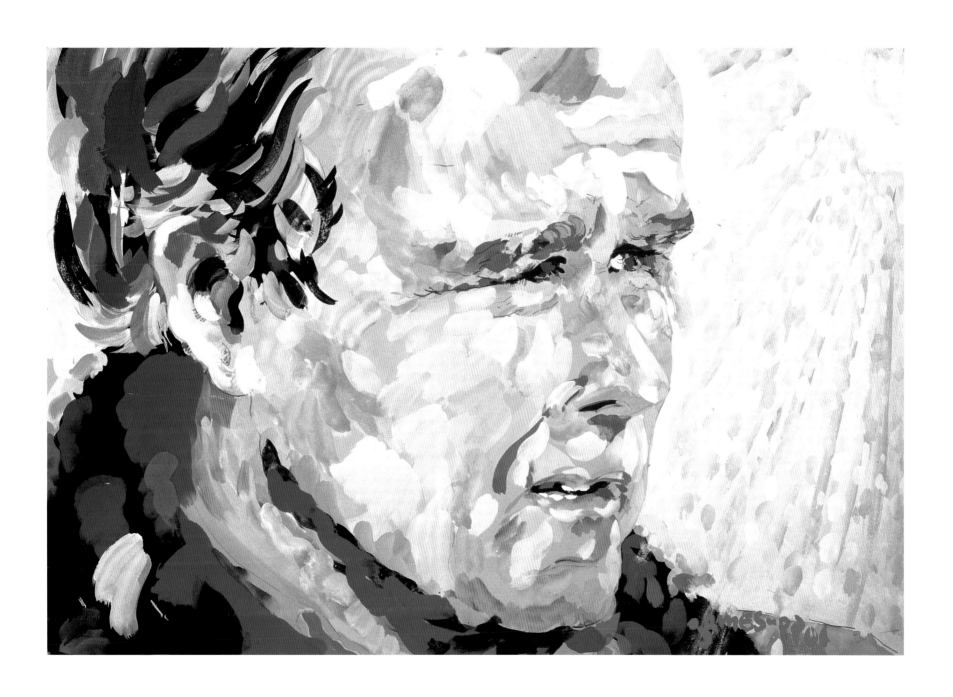

Inaugural Portrait, George Bush (mixed media)

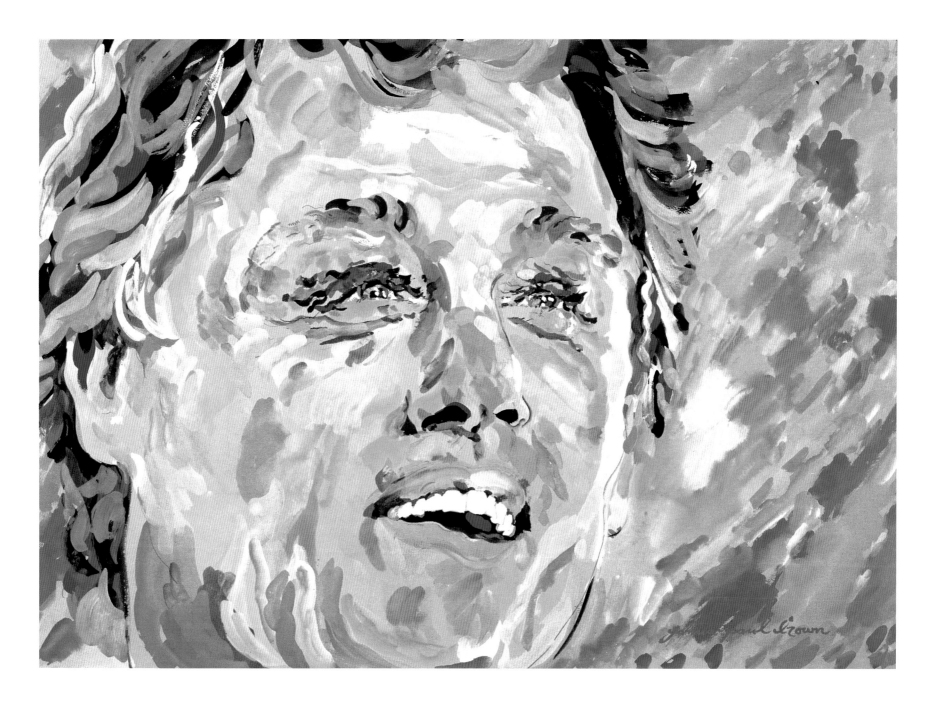

Inaugural Portrait, William Clinton (mixed media)

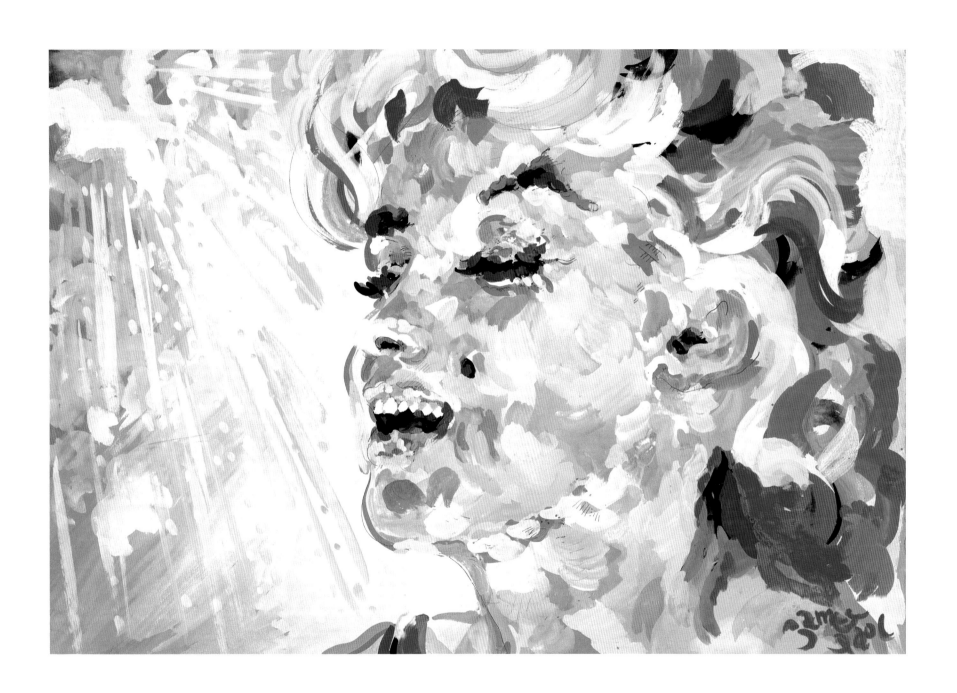

Marilyn Monroe (mixed media)

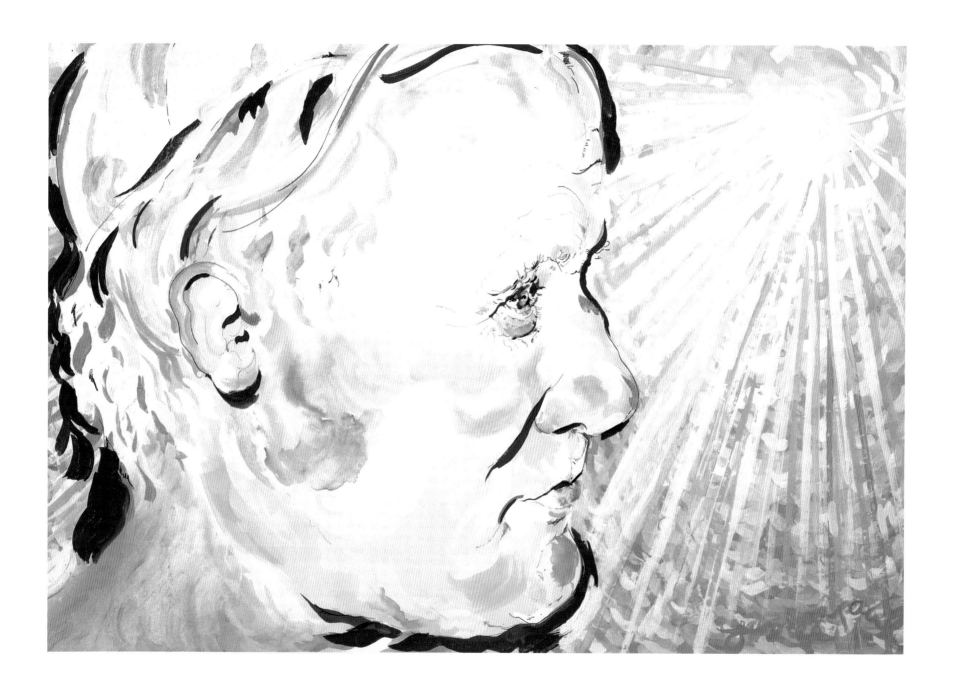

Pope John Paul's American Visit I (mixed media)

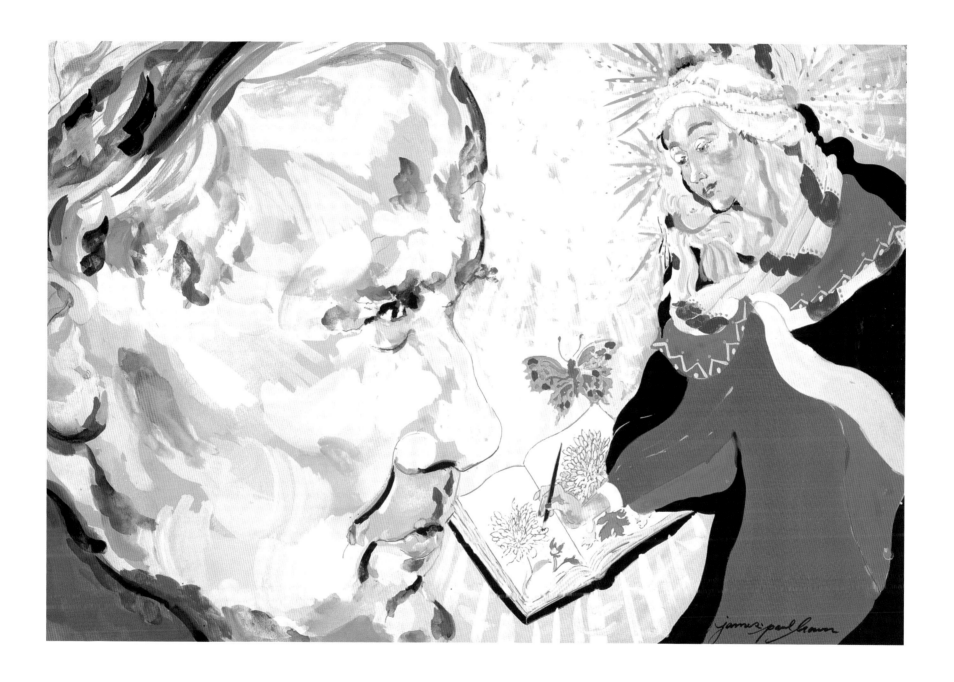

Pope John Paul's American Visit II (mixed media)

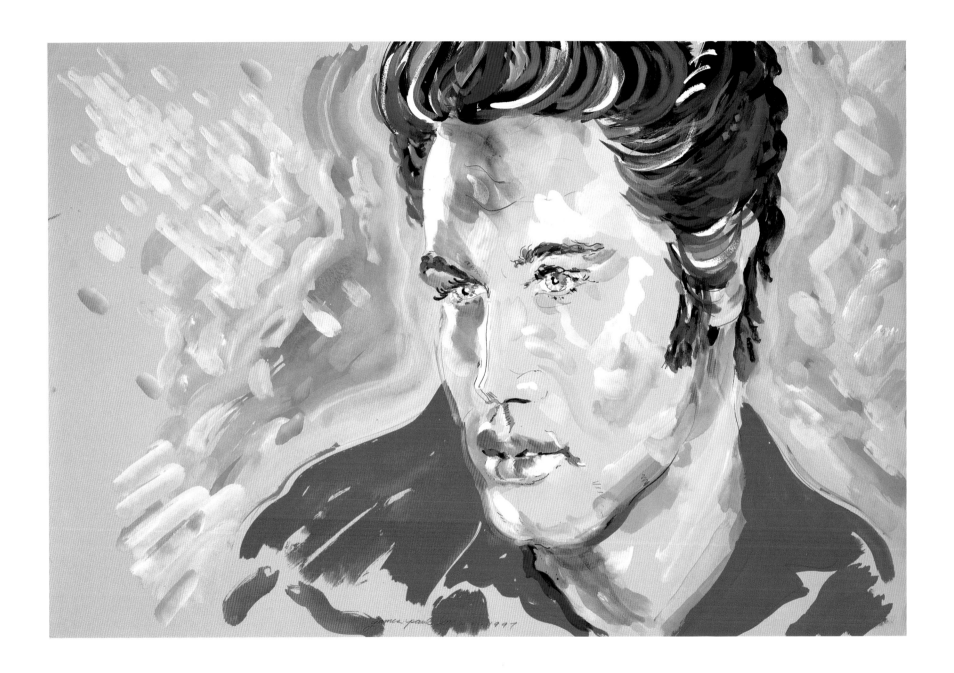

The Idol, 1997 (mixed media)

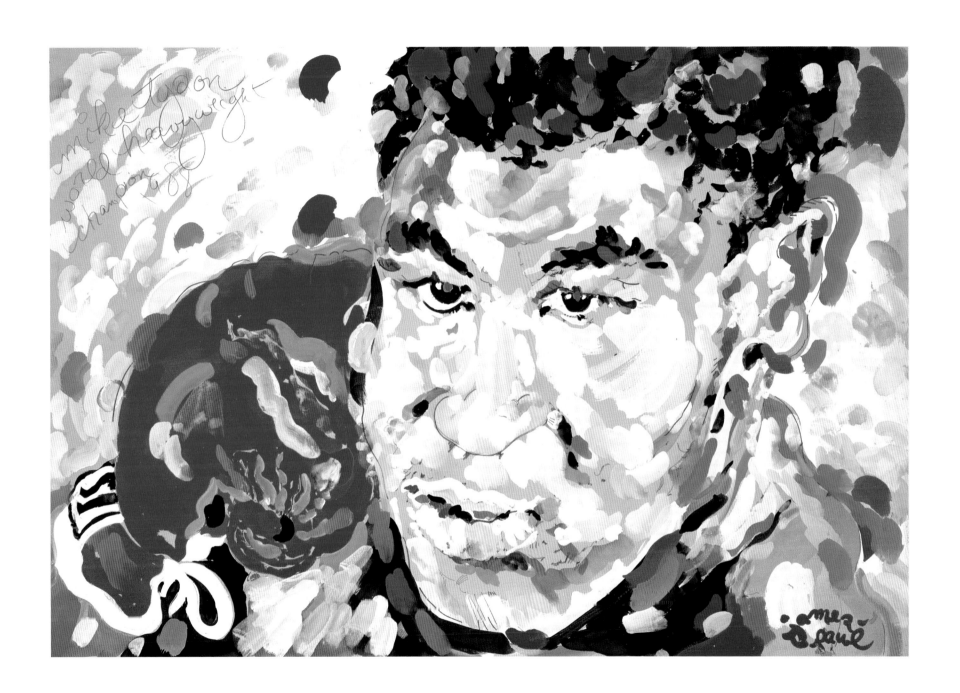

The Boxer (gouache)

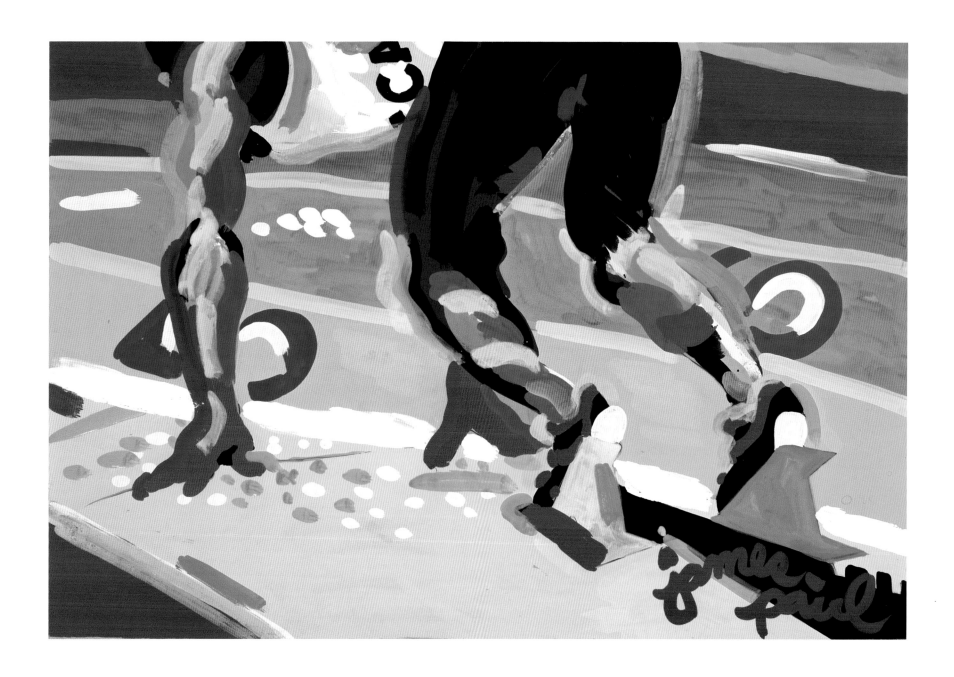

L.A. Olympics I, 1984 (mixed media)

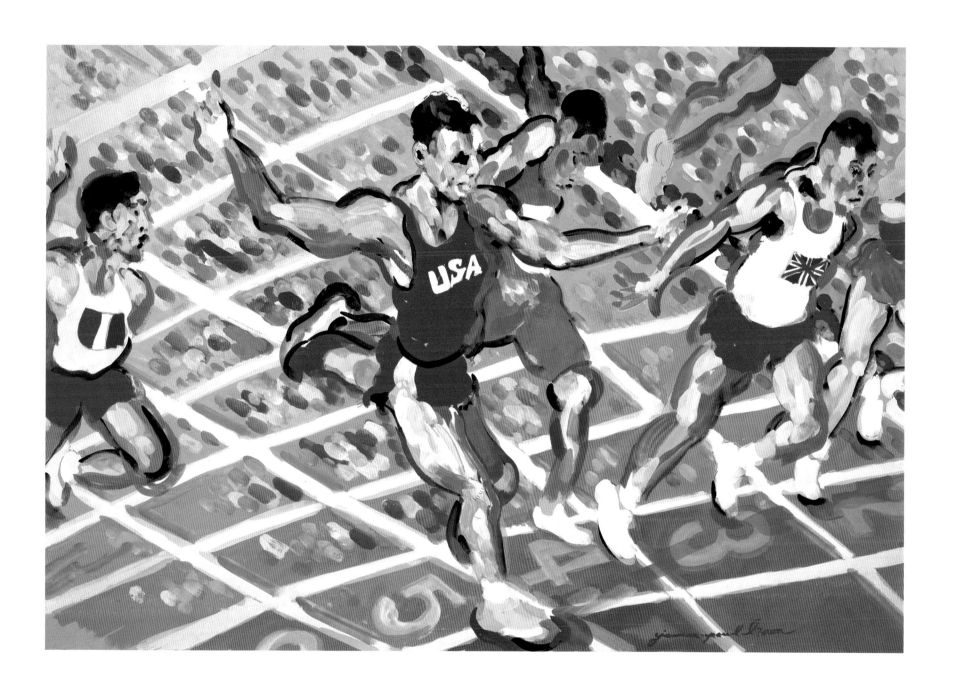

Atlanta Olympics I, 1996 (gouache)

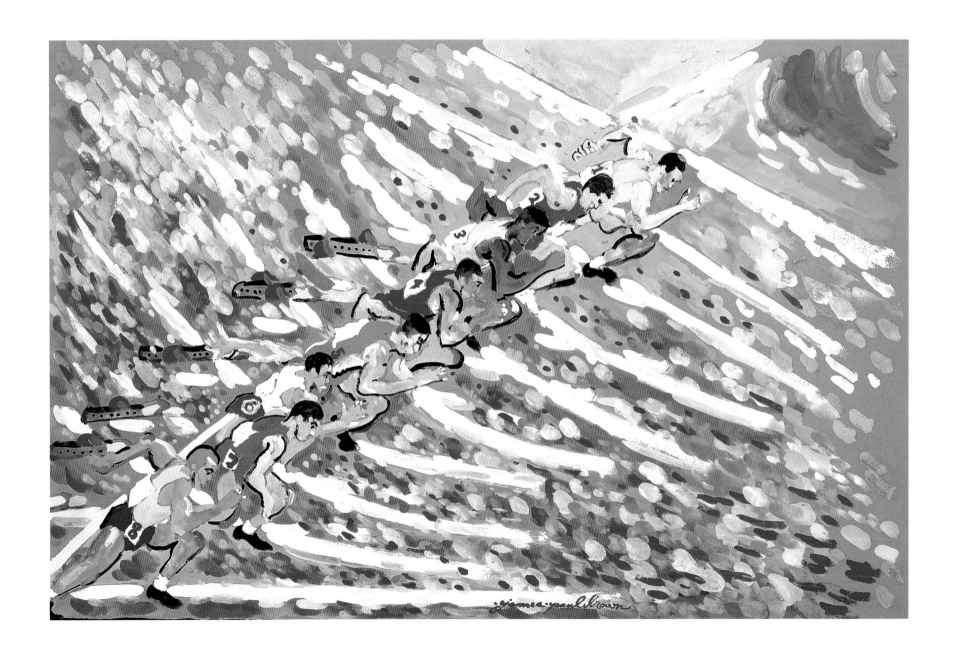

Atlanta Olympics II, 1996 (mixed media)

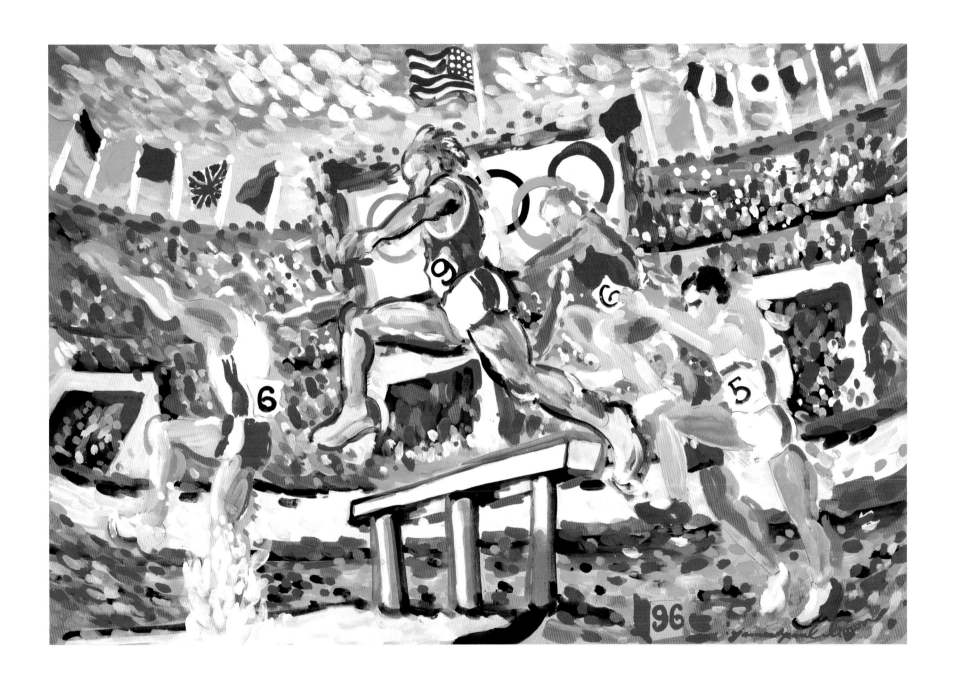

Atlanta Olympics III, 1996 (mixed media)

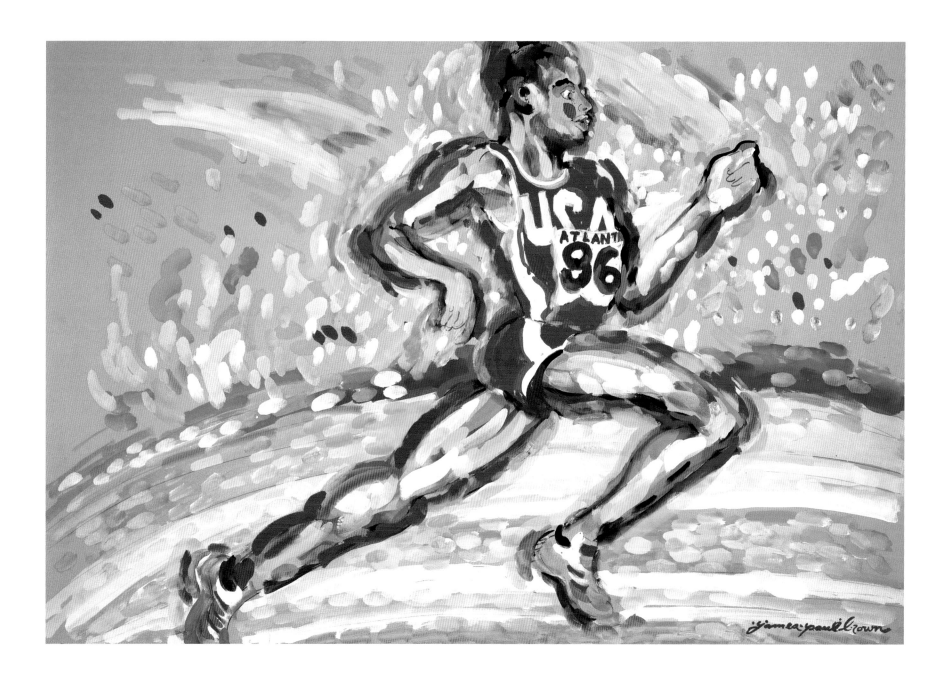

Atlanta Olympics IV, 1996 (mixed media)

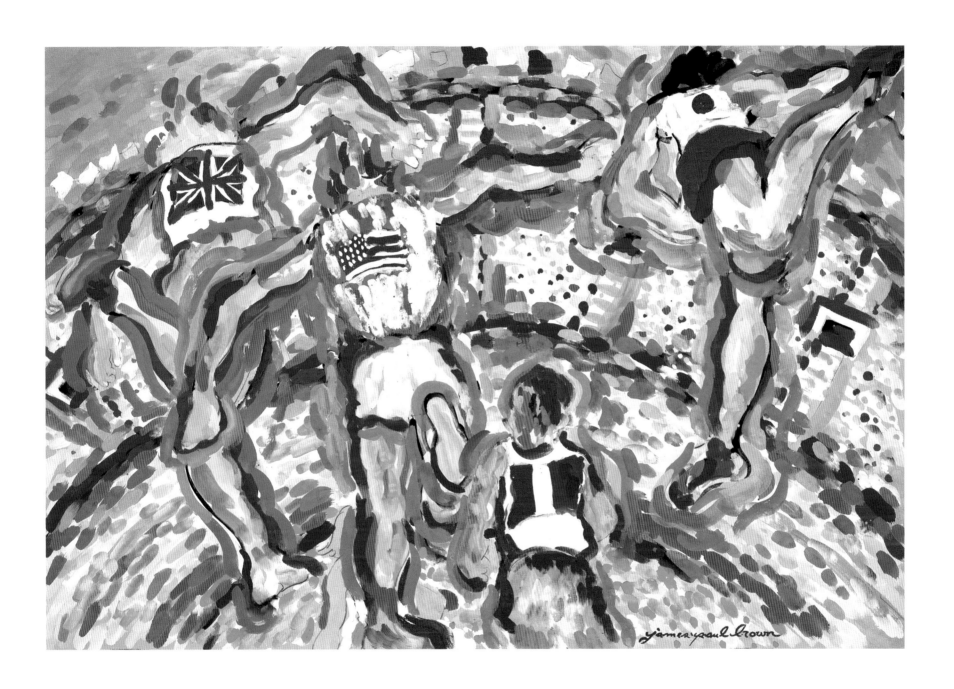

Atlanta Olympics V, 1996 (mixed media)

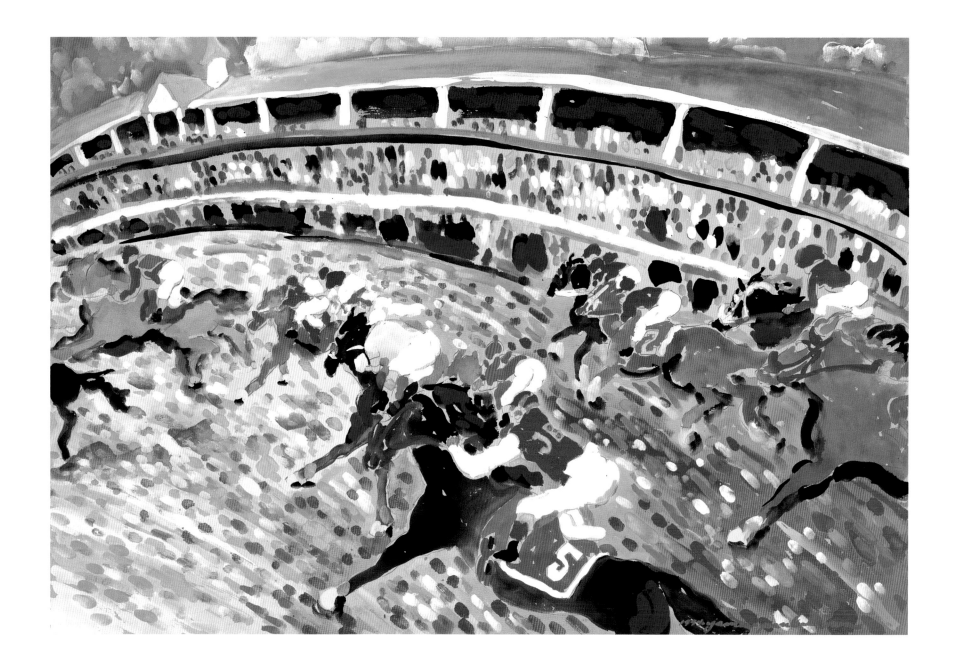

Kentucky Derby I (mixed media)

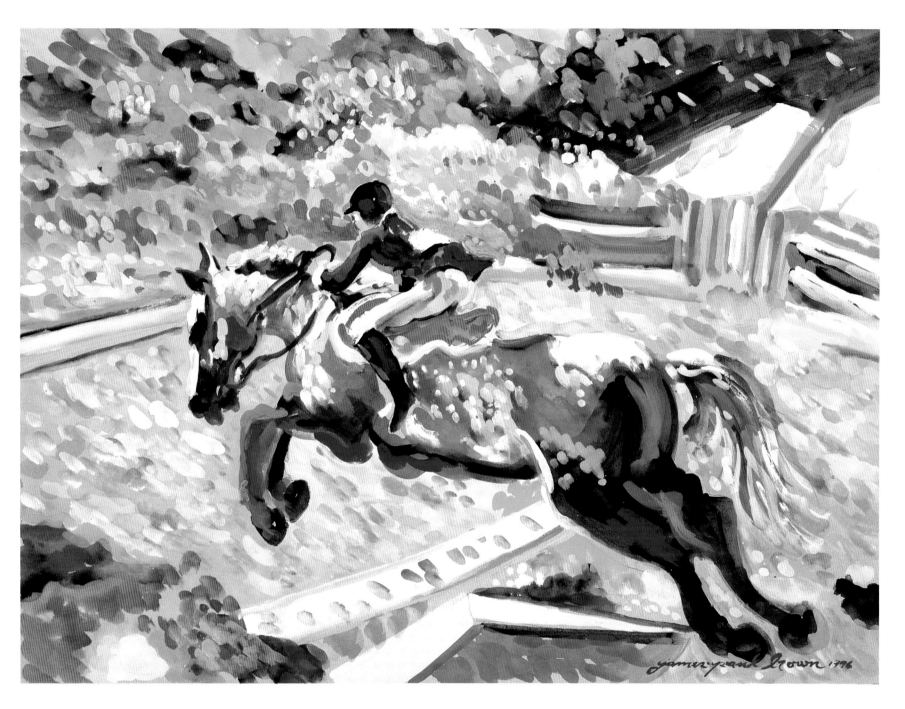

The Jumper I (mixed media)

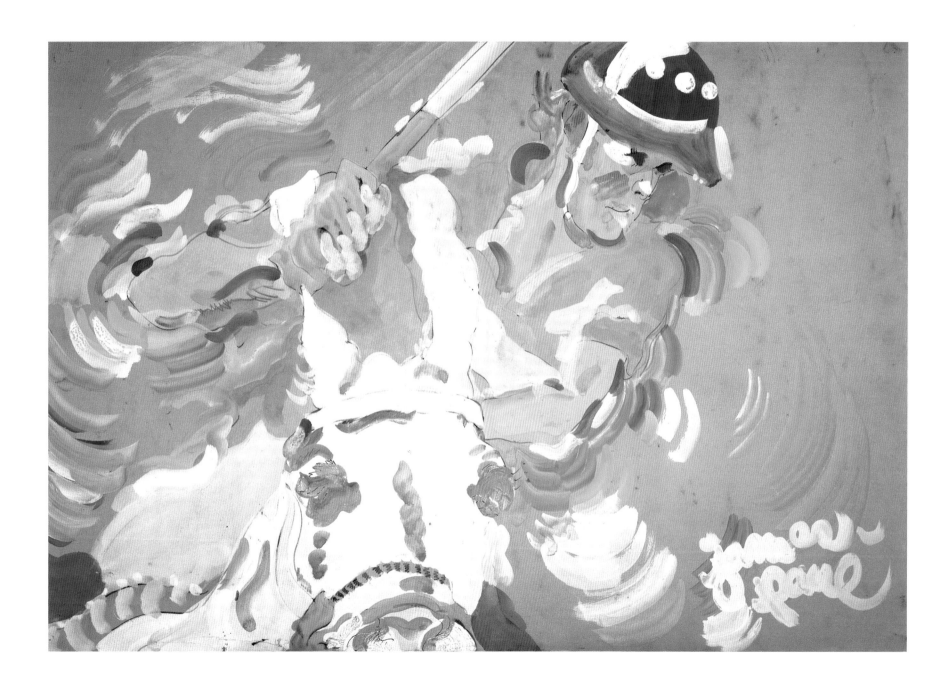

Polo (gouache)

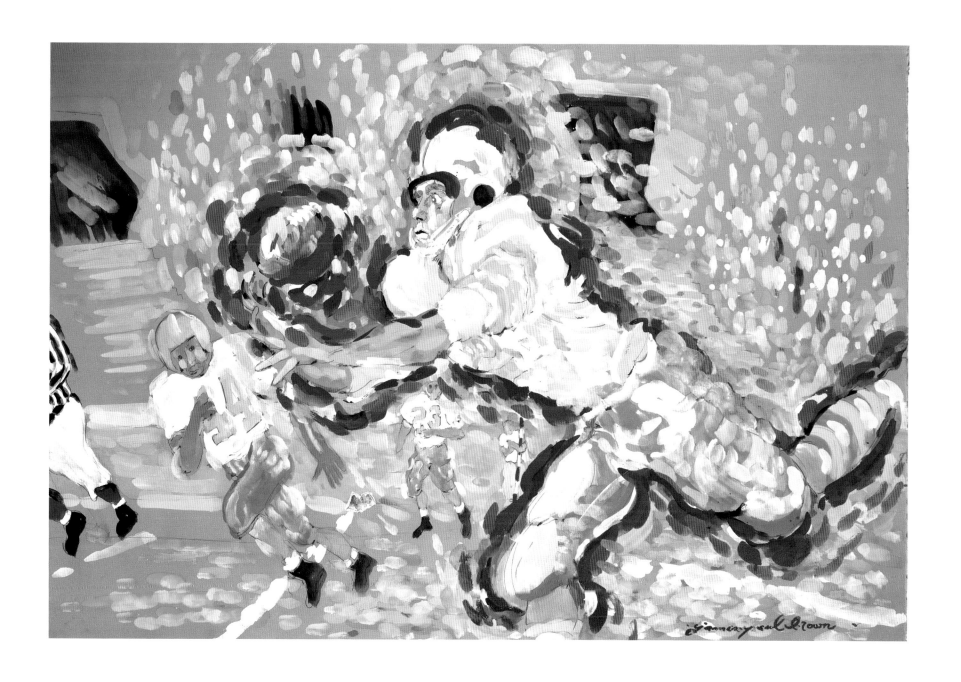

Super Bowl I (mixed media)

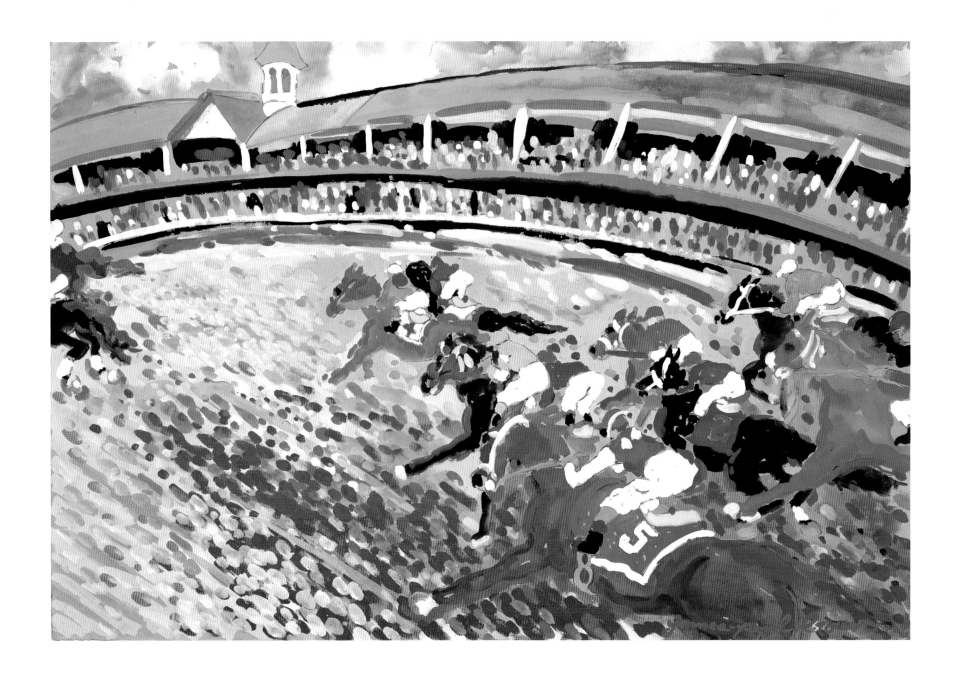

Kentucky Derby II (mixed media)

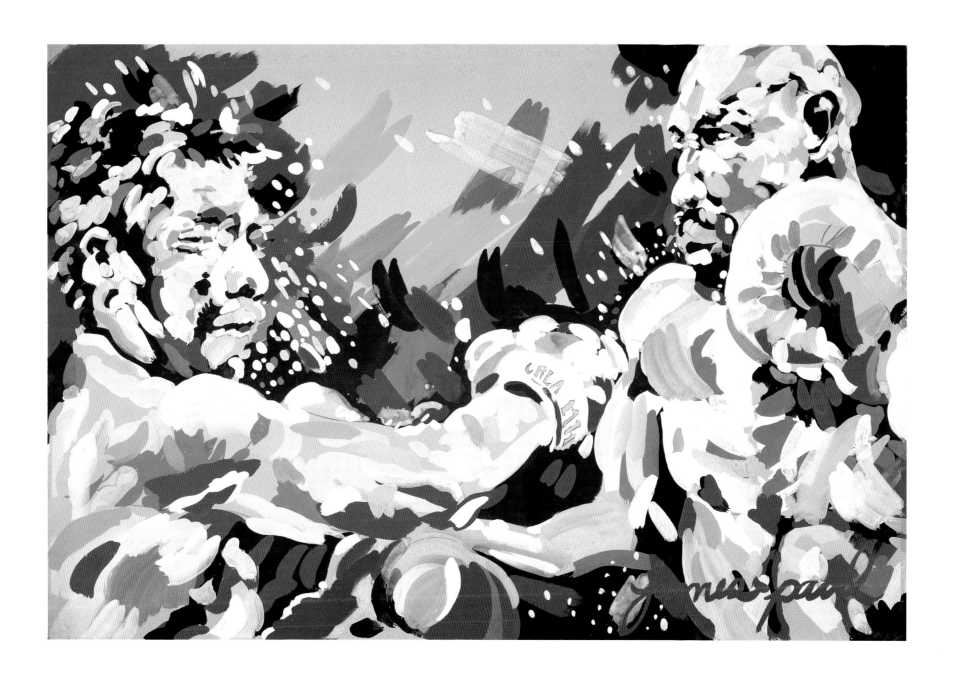

The Championship (gouache)

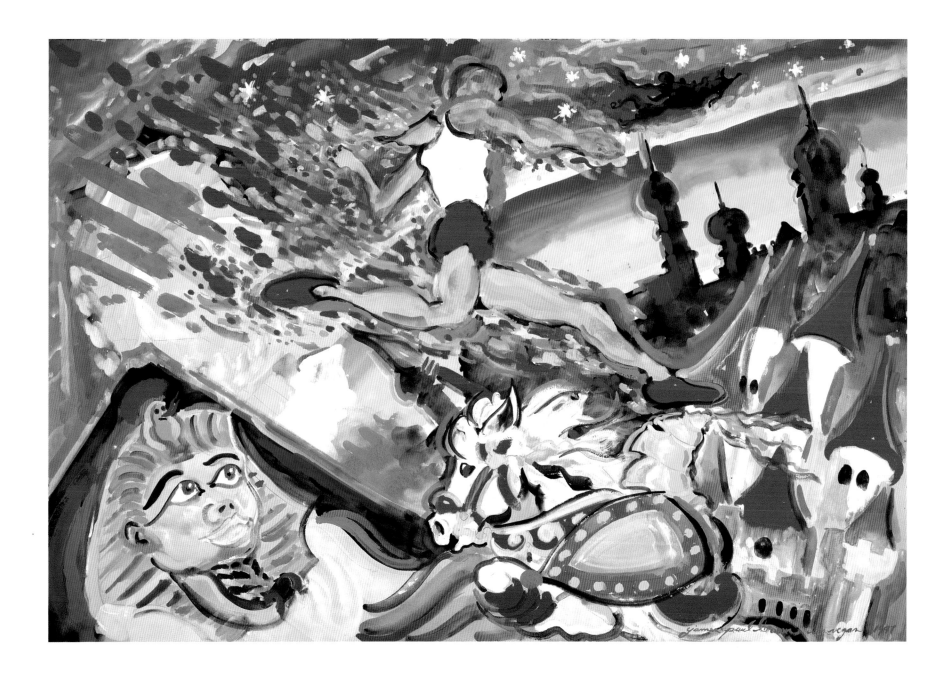

Las Vegas Marathon (gouache)

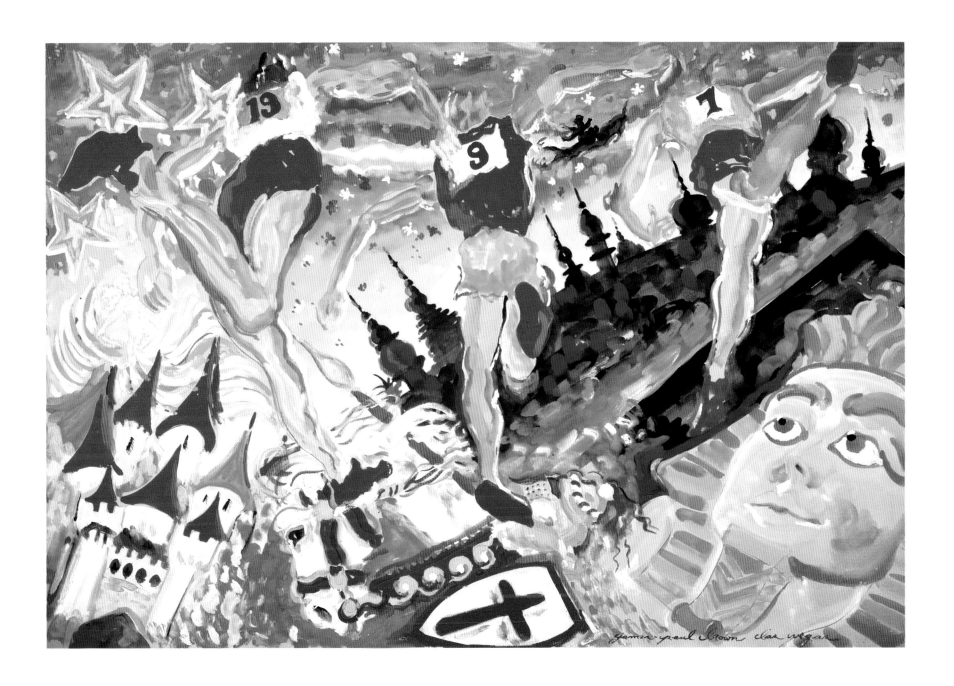

Las Vegas Marathon II (mixed media)

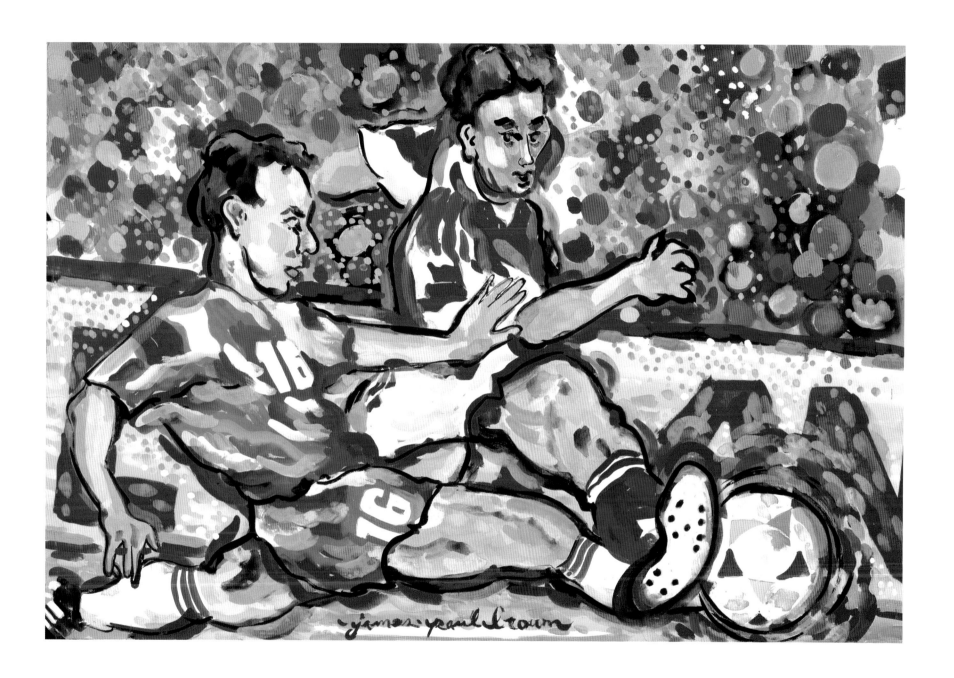

Soccer II (mixed media)

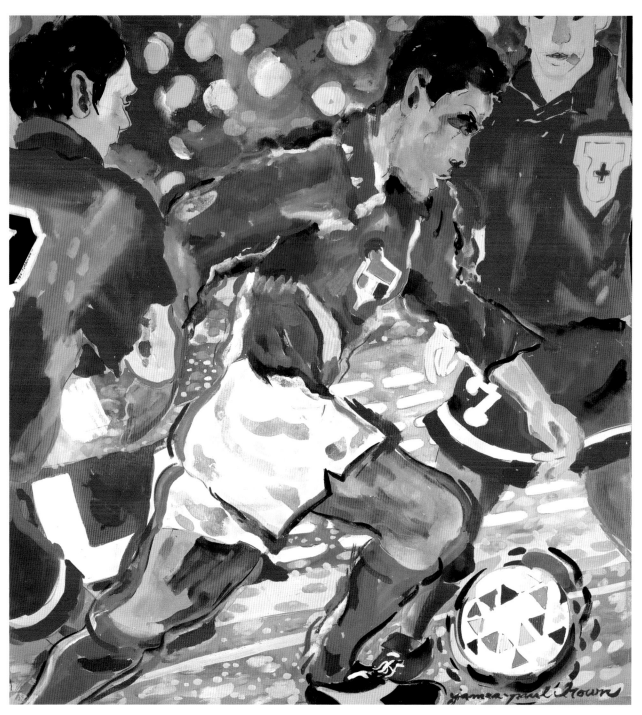

Soccer III (mixed media)

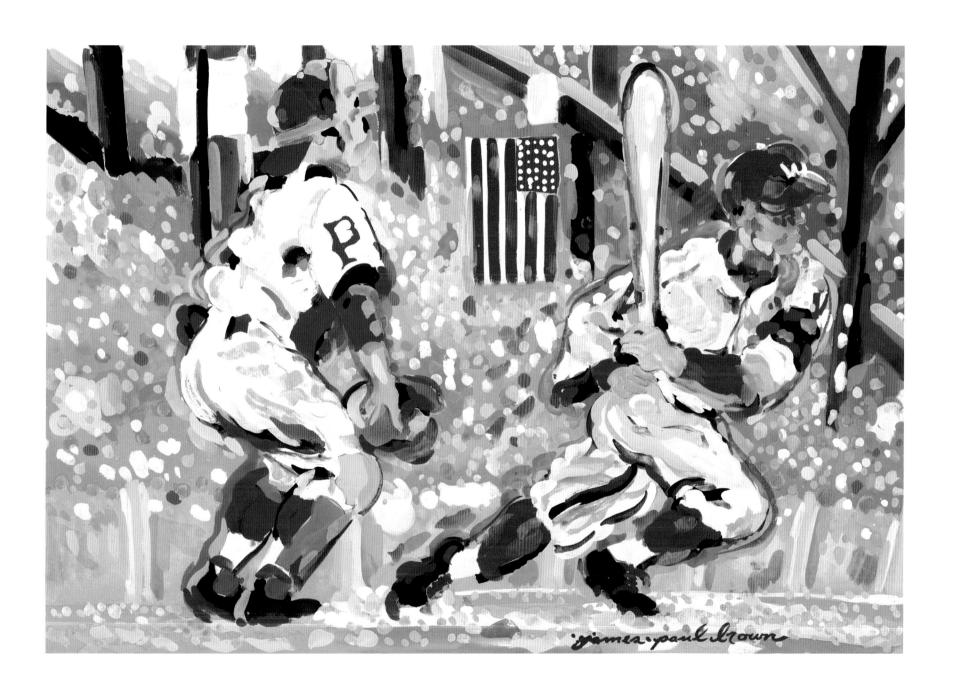

Baseball (gouache)

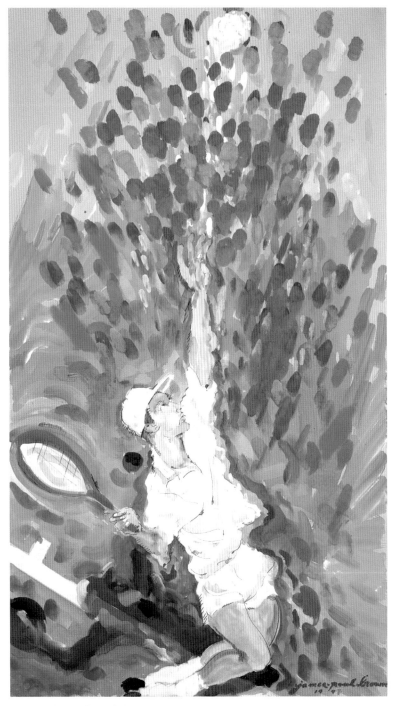

Tennis I (mixed media)

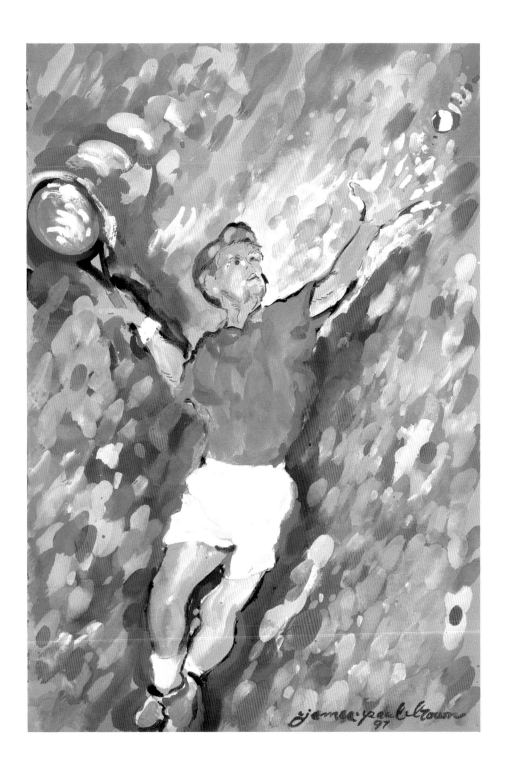

Tennis II (mixed media)

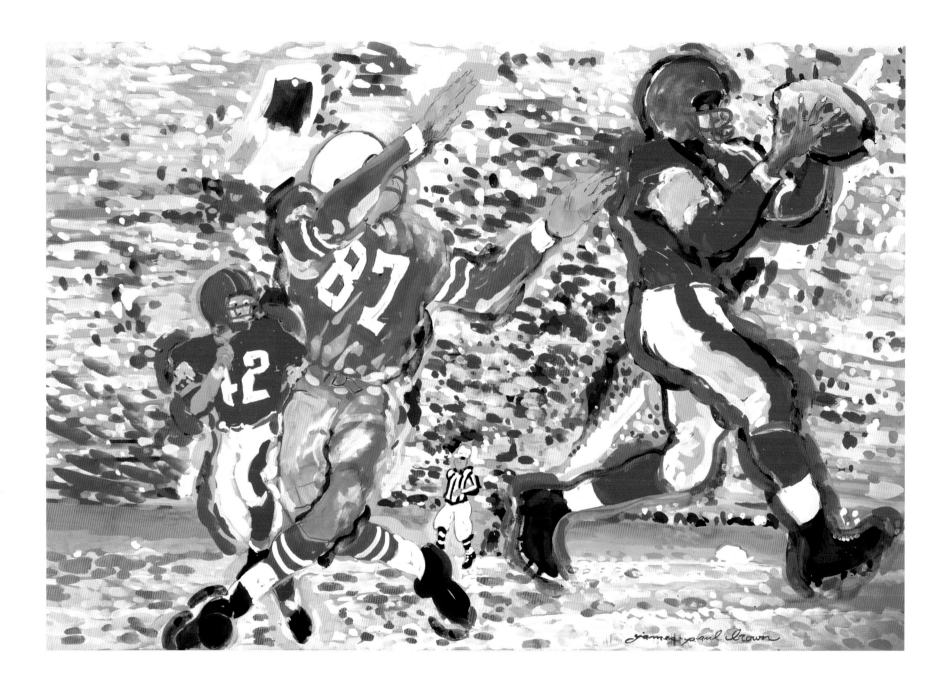

Super Bowl IV (mixed media)

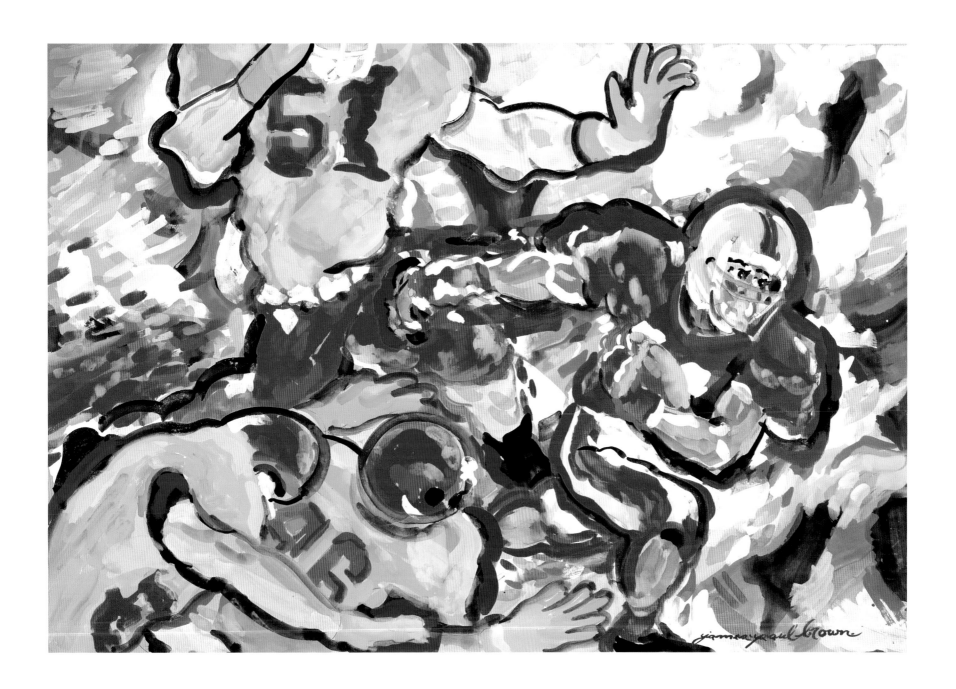

Super Bowl V (mixed media)

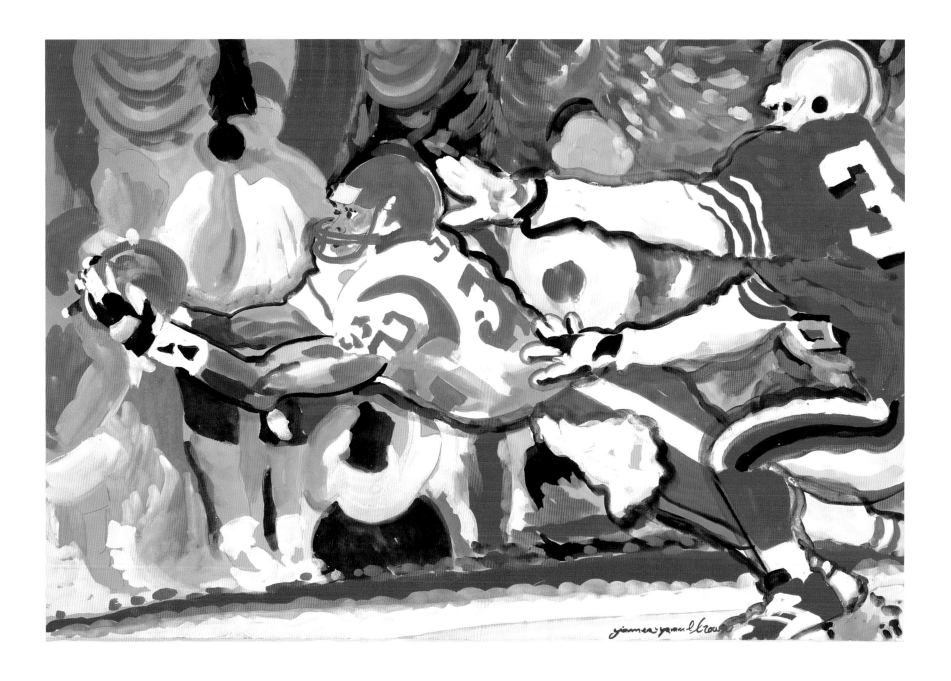

Super Bowl VI (mixed media)

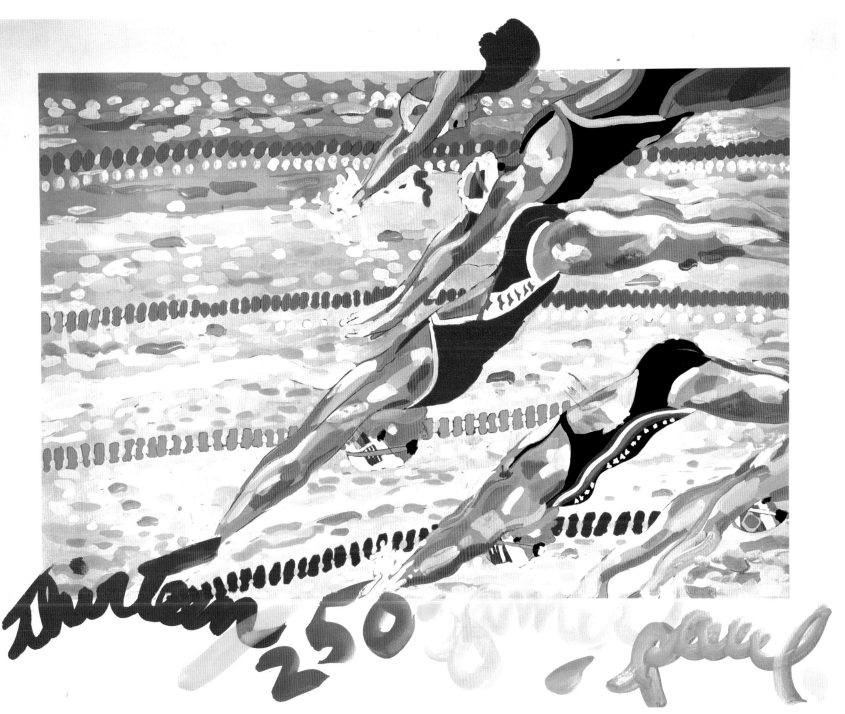

Los Angeles Olympics II (mixed media)

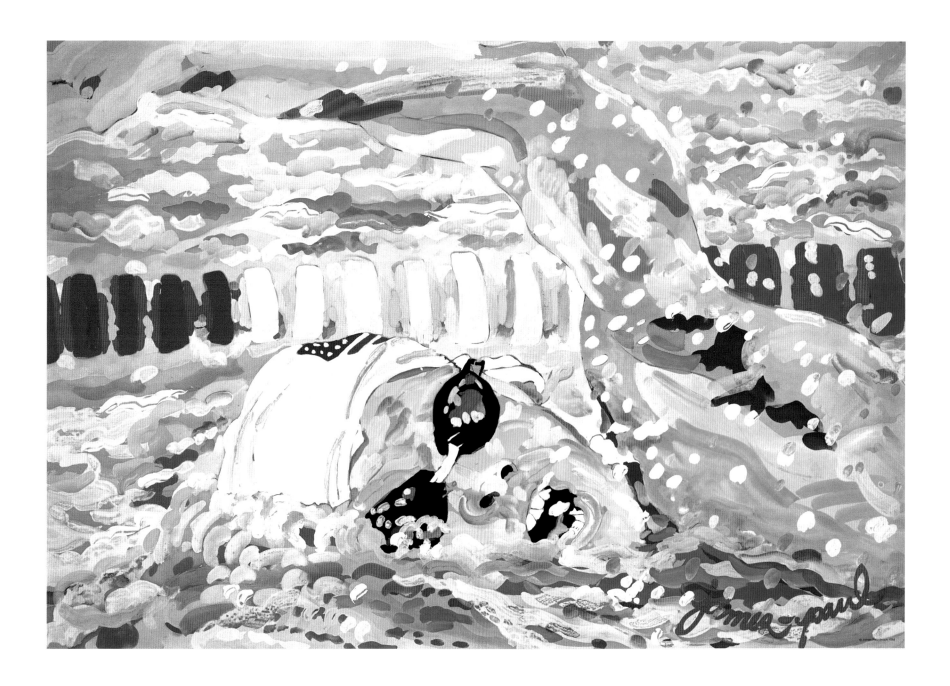

Los Angeles Olympics III (mixed media)

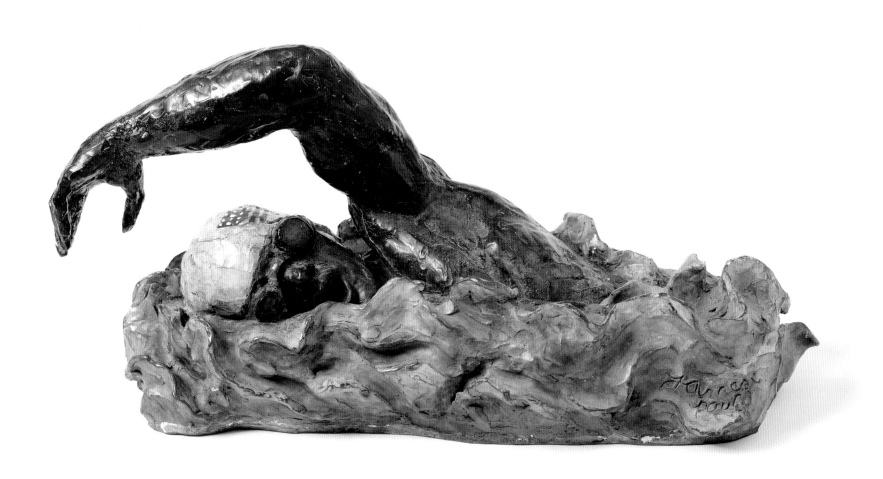

Sculpture, Los Angeles Olympics (bronze)

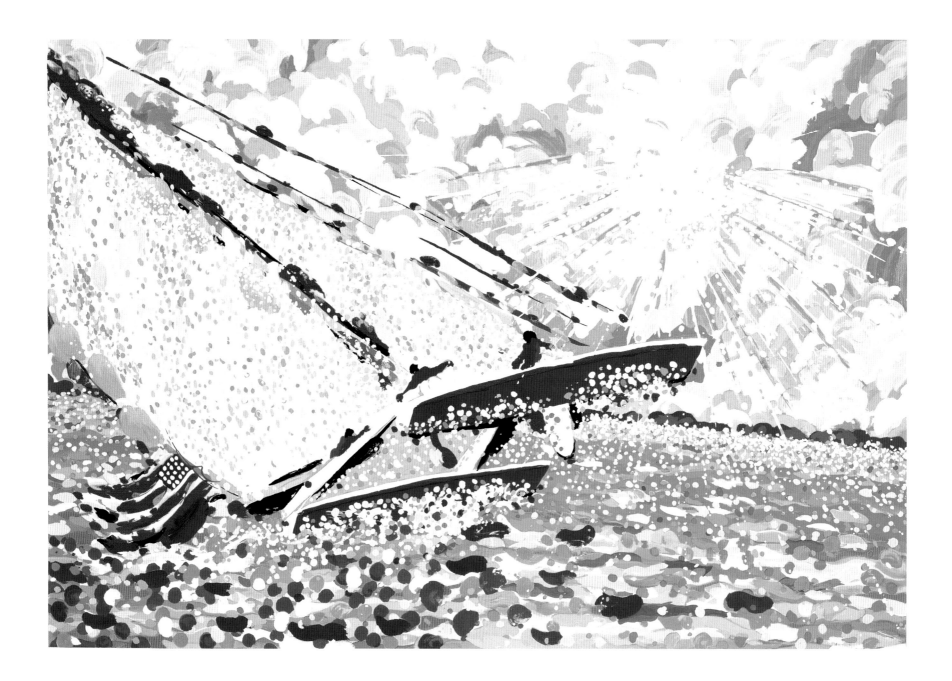

America's Cup (mixed media)

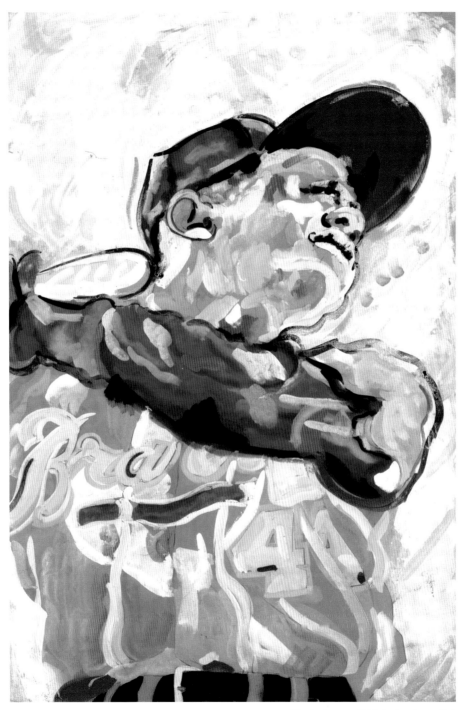

Hank Aaron, 1985 (mixed media)

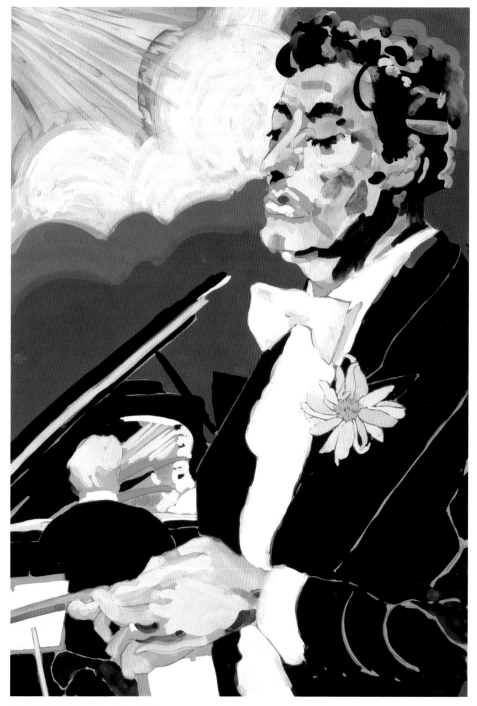

Zubin Mehta I (mixed media)

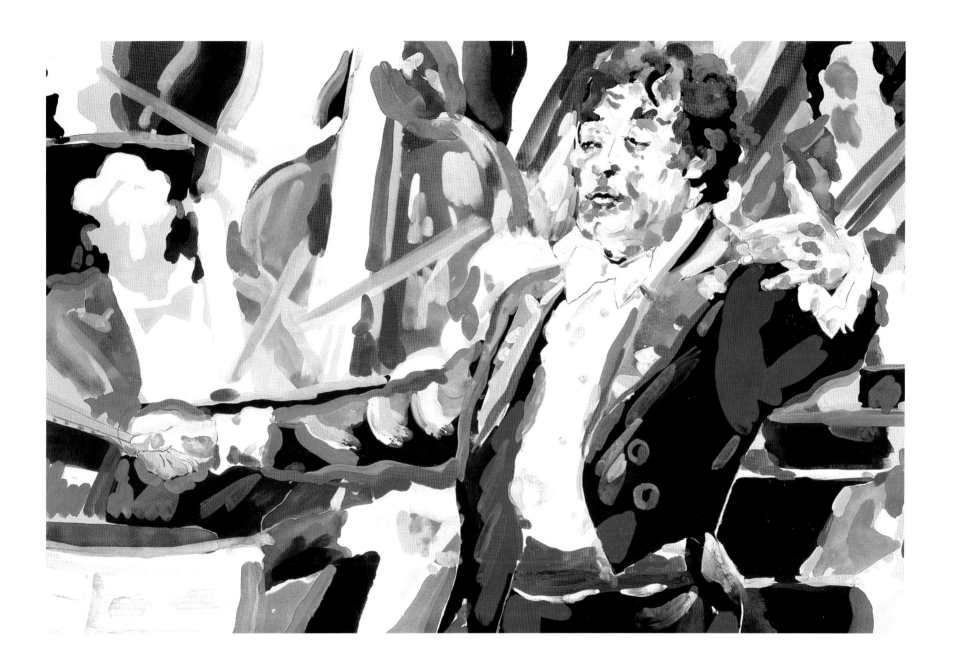

Zubin Mehta II (mixed media)

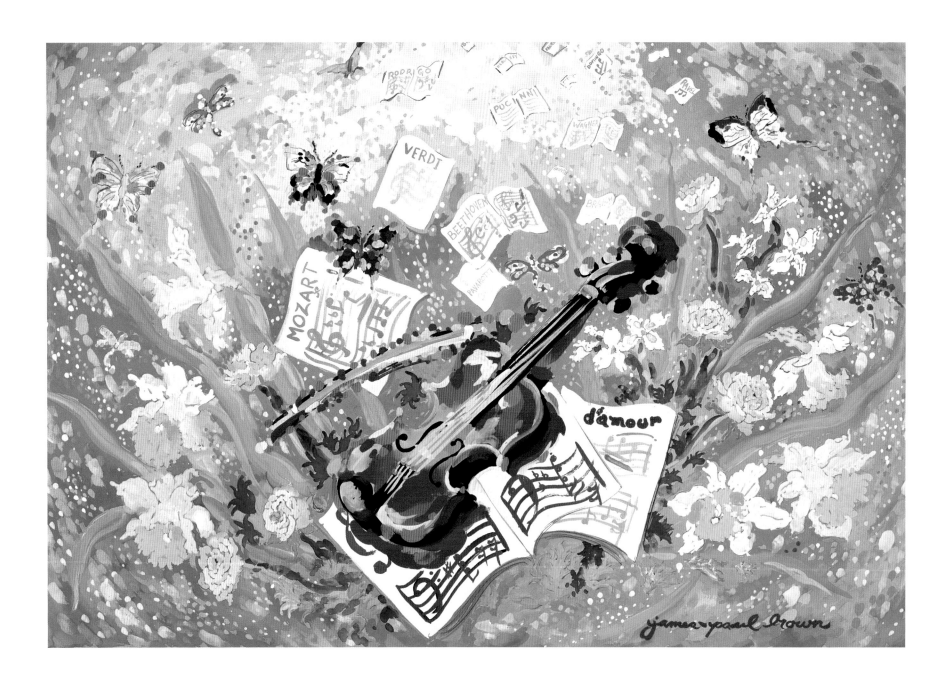

Love of Music I (mixed media)

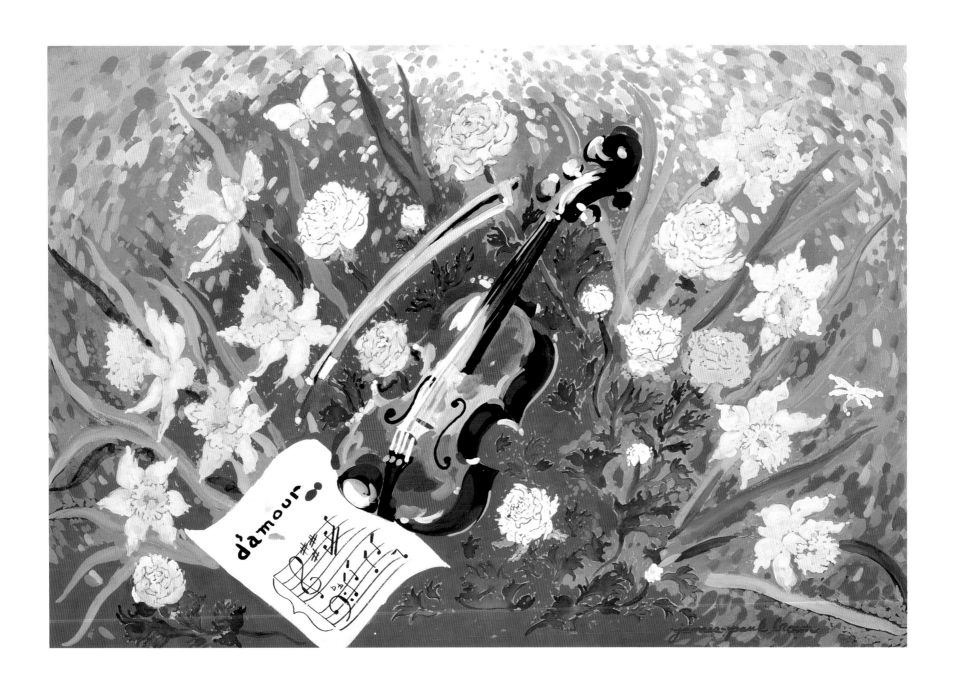

Love of Music II (mixed media)

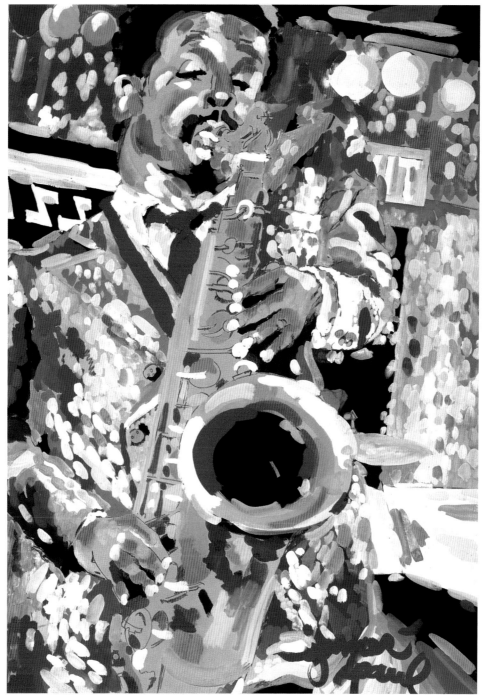

Jazz I (mixed media)

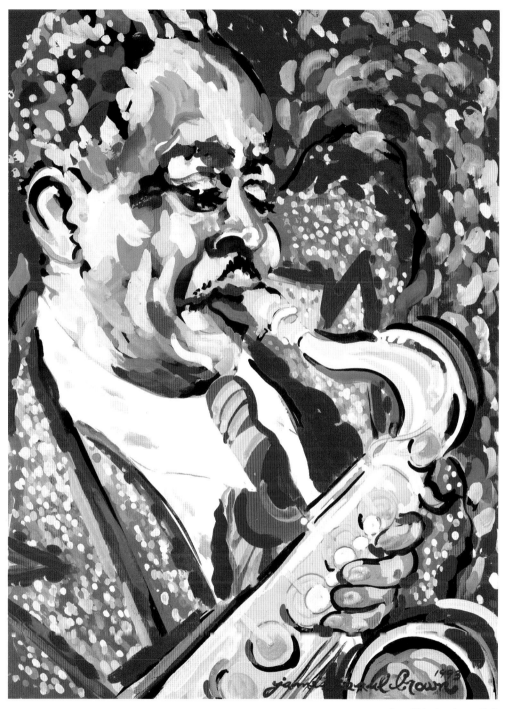

Jazz II (mixed media)

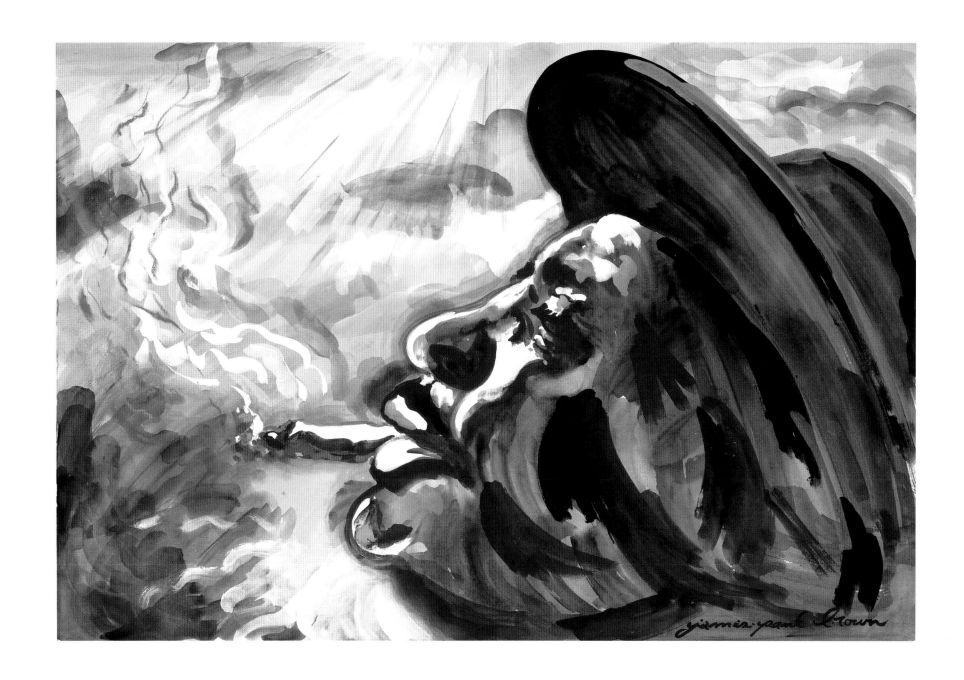

Monk I, 1995 (mixed media)

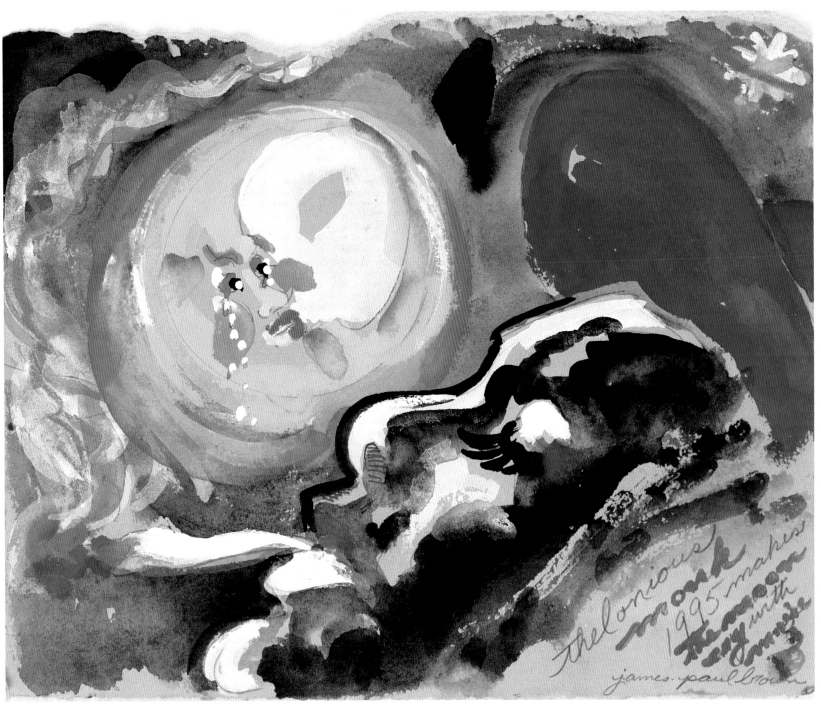

Monk II, 1995 (mixed media)

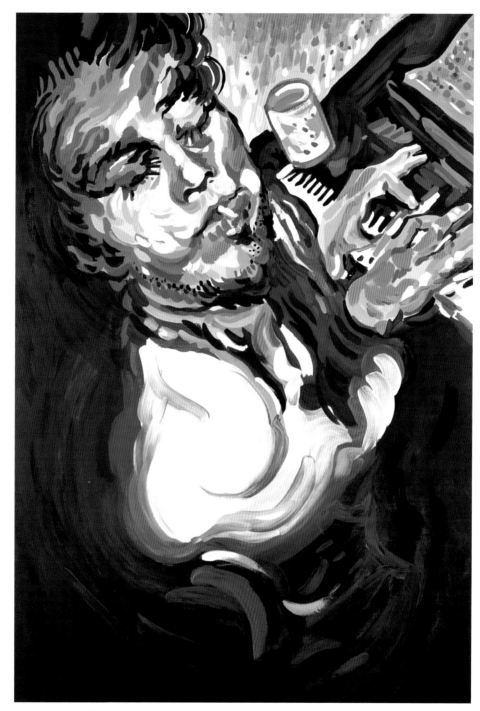

Piano Player, 1996 (mixed media)

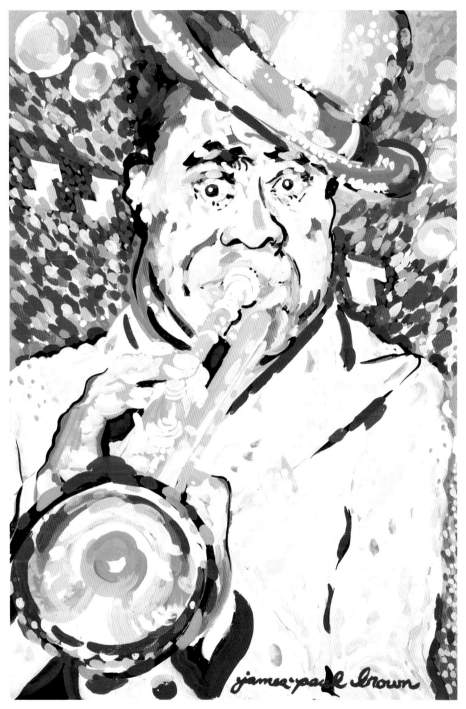

Satchmo (mixed media)

207

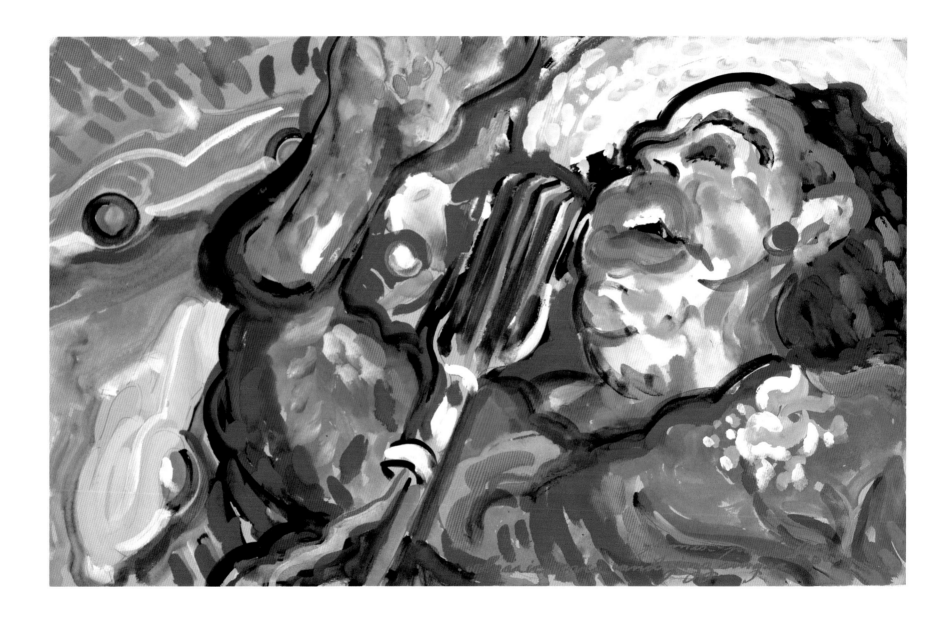

Jazz III (mixed media)

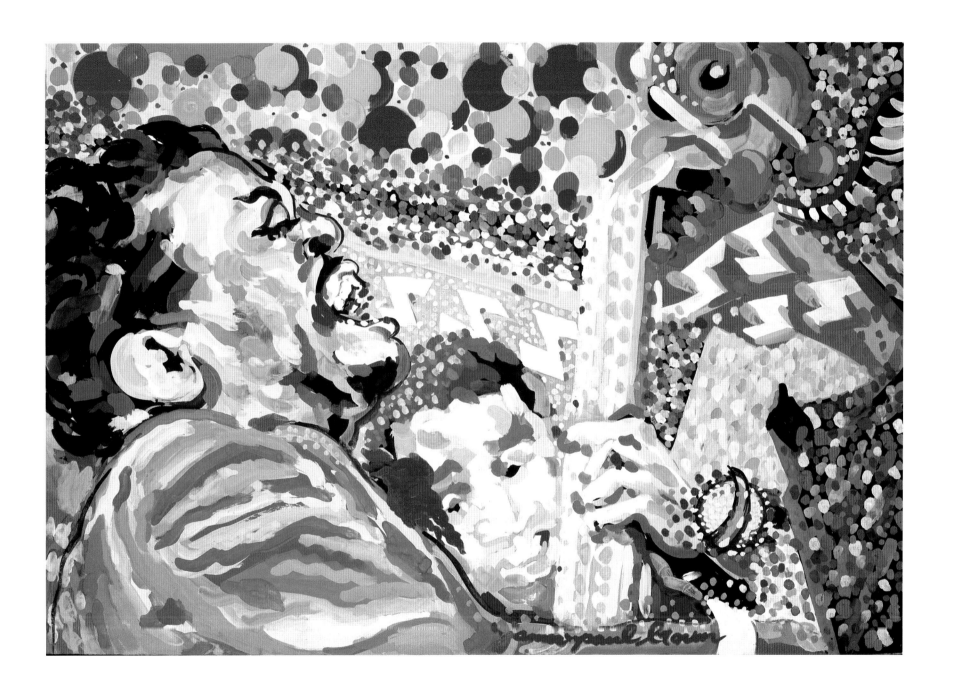

Jazz IV (mixed media)

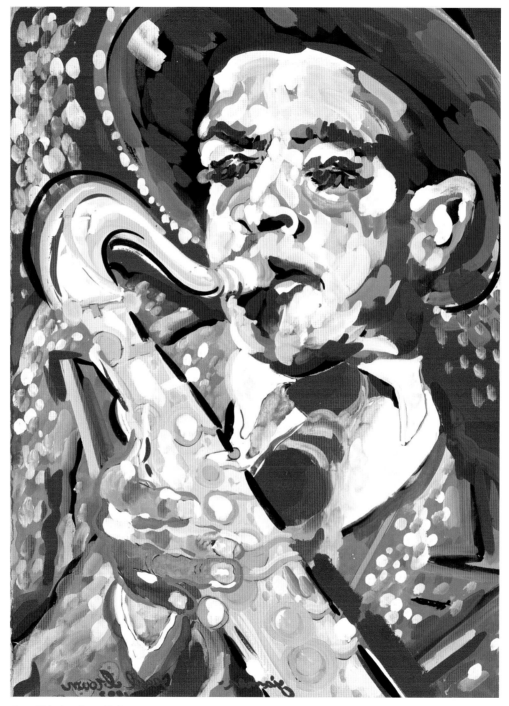

Jazz V (mixed media)

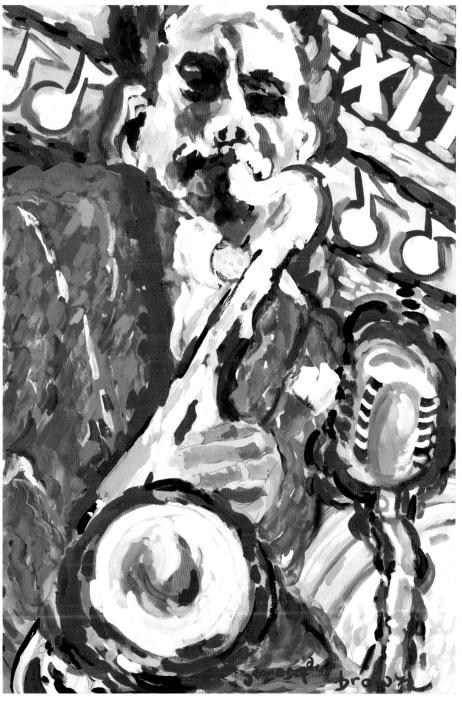

Jazz VI (mixed media)

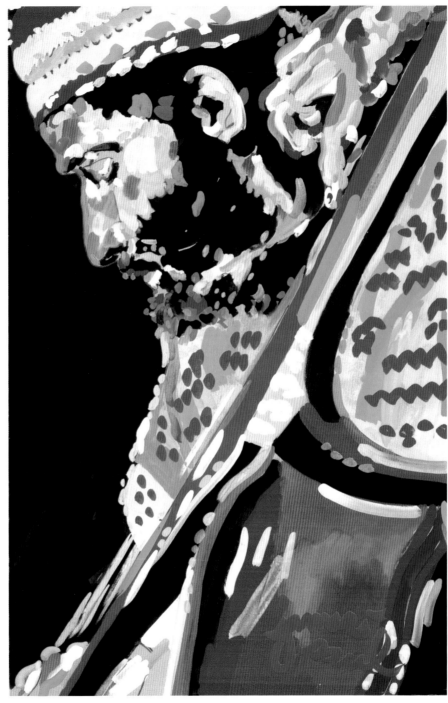

Jazz VII (mixed media)

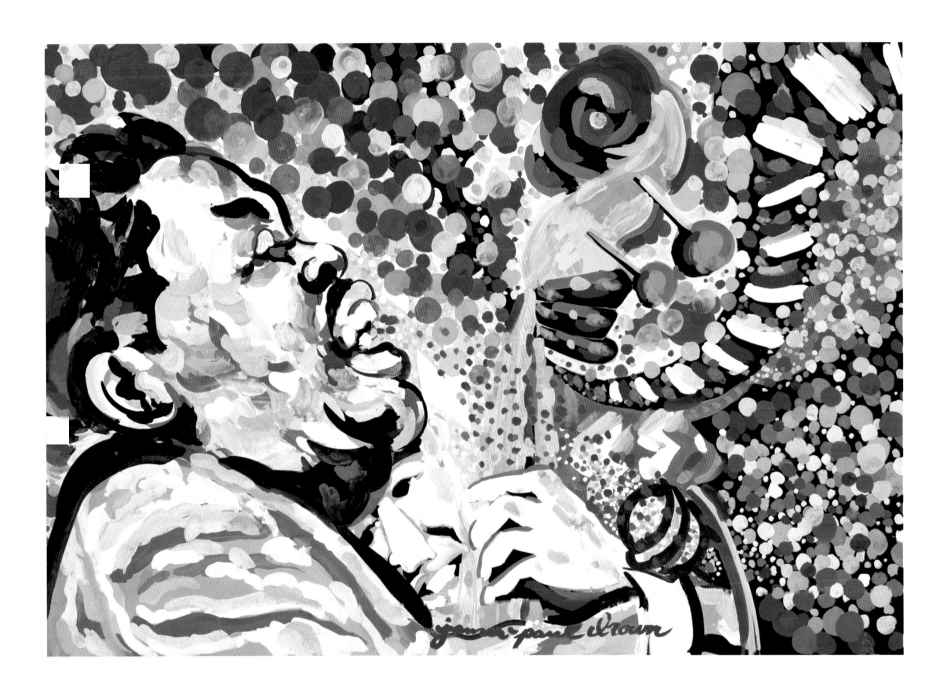

Jazz VIII (mixed media)

213

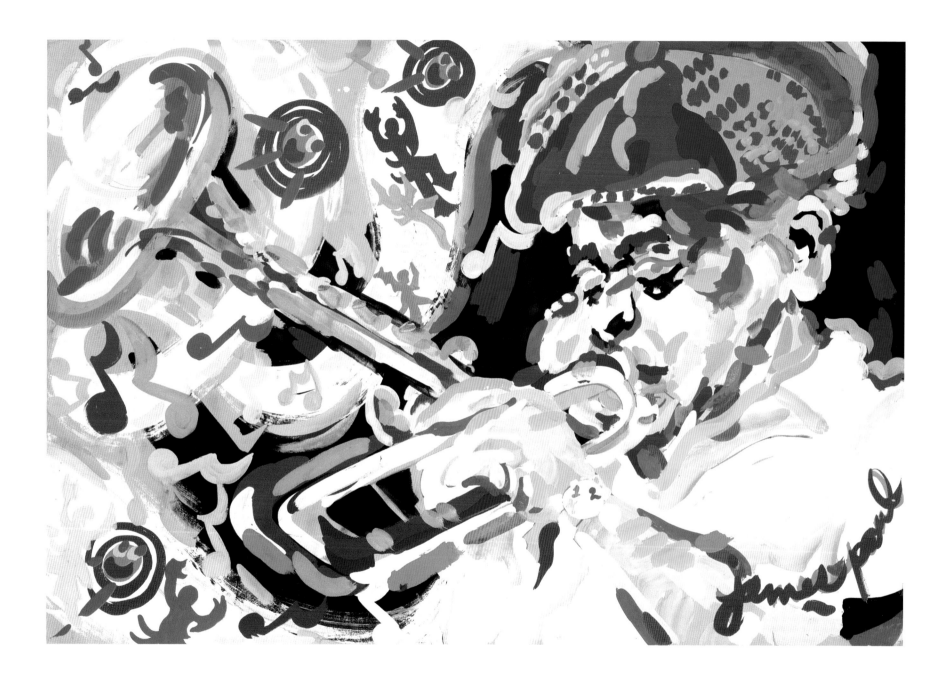

Dizzy (mixed media)

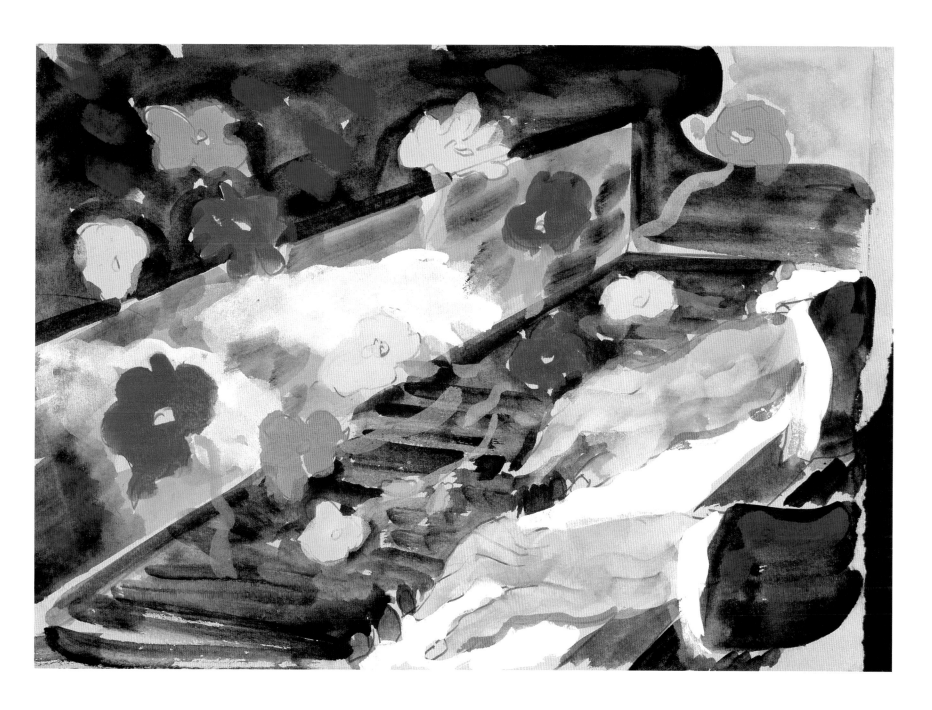

Love of Music III (mixed media)

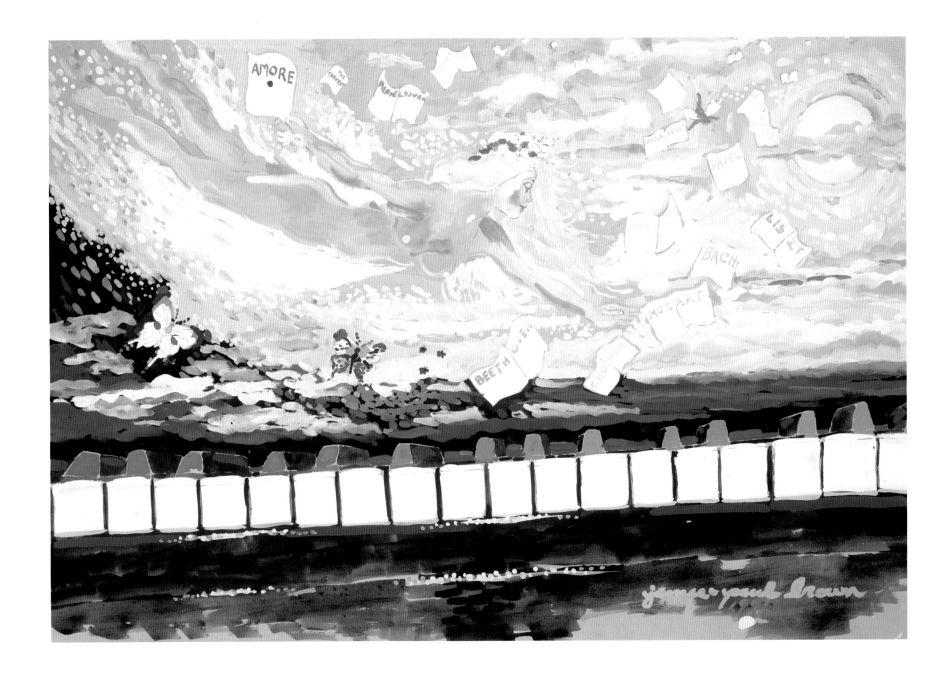

Love of Muse-ic, 1991 (mixed media)

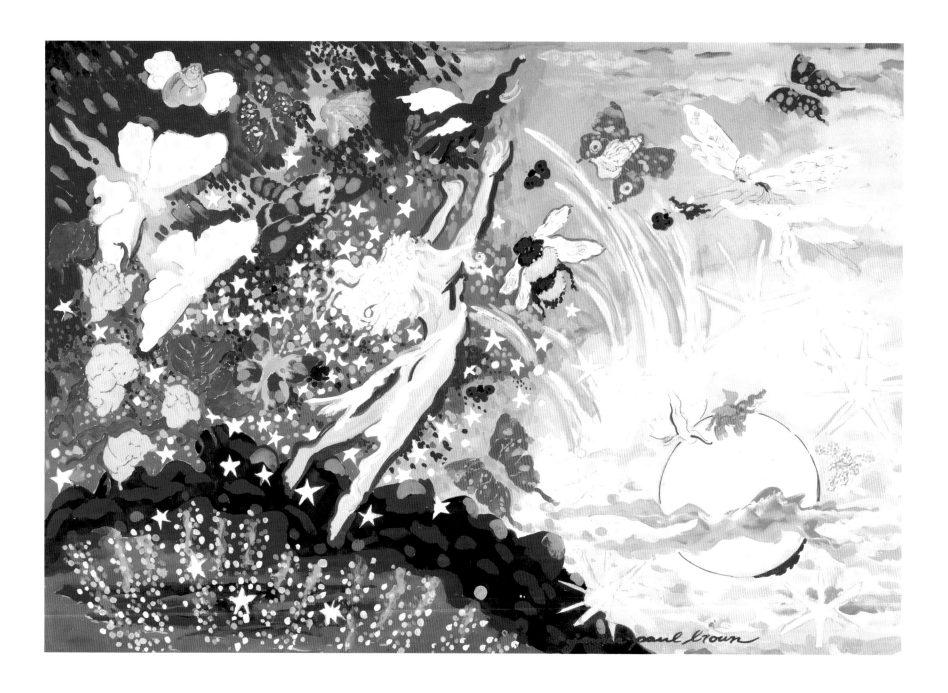

Muses at Play, 1995 (mixed media)

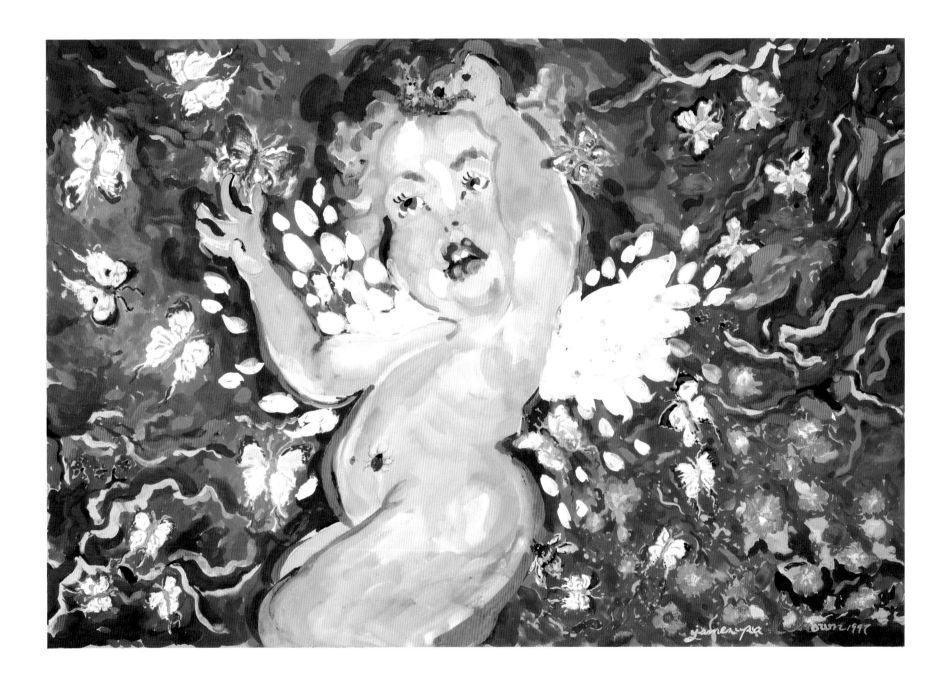

Cherub I, (mixed media)

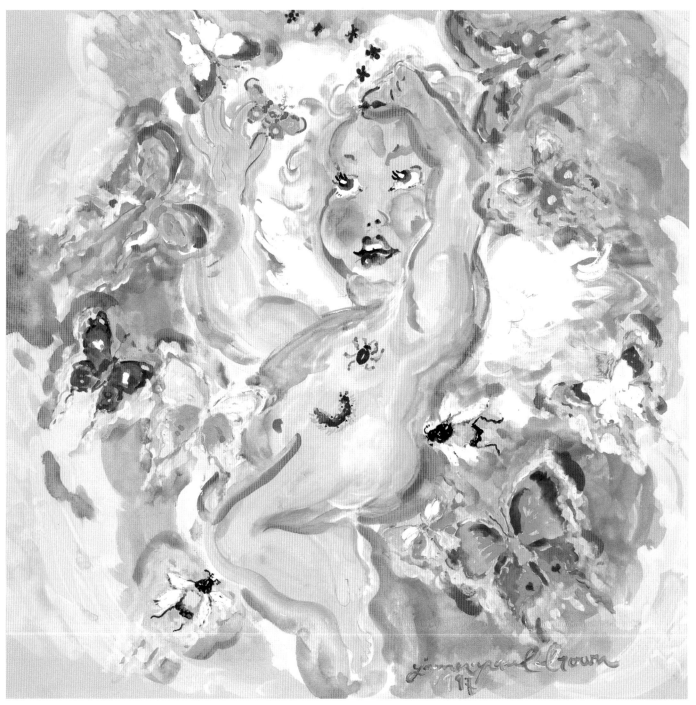

Cherub II, (mixed media)

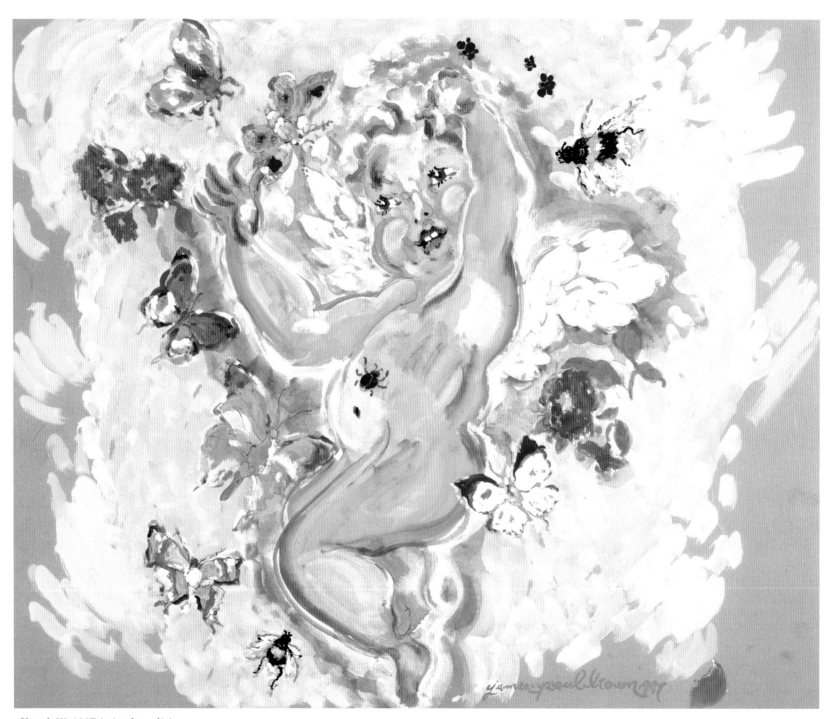

Cherub III, 1997 (mixed media)

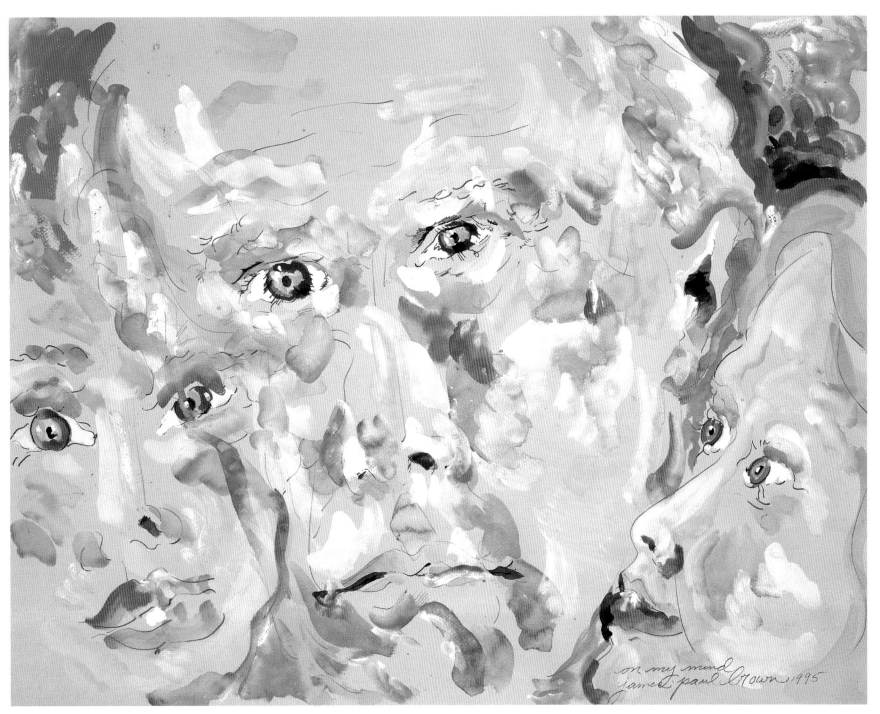

On My Mind, 1995 (mixed media)

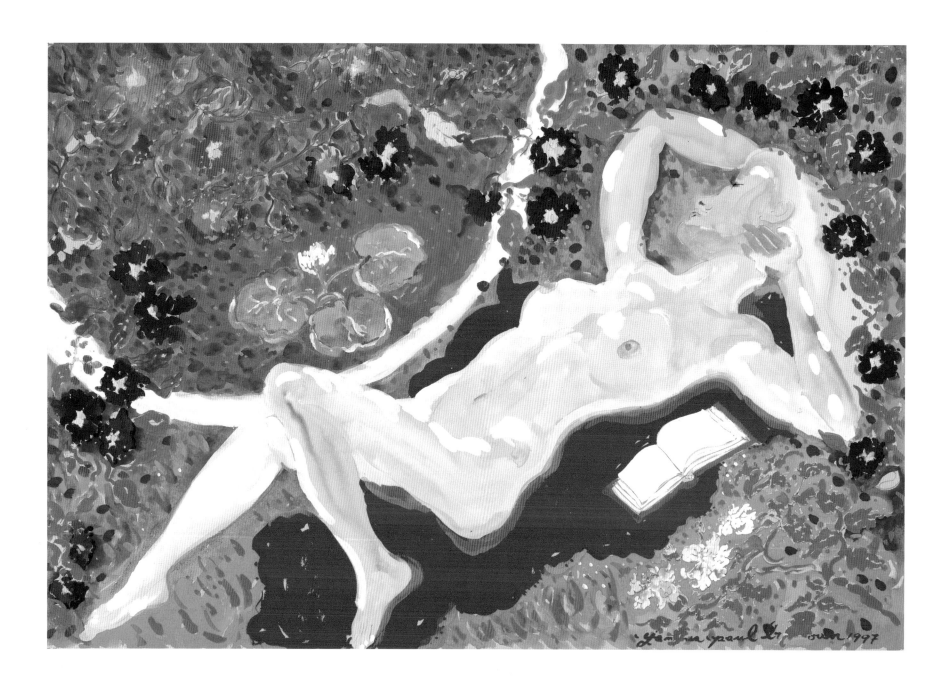

In the Garden (mixed media)

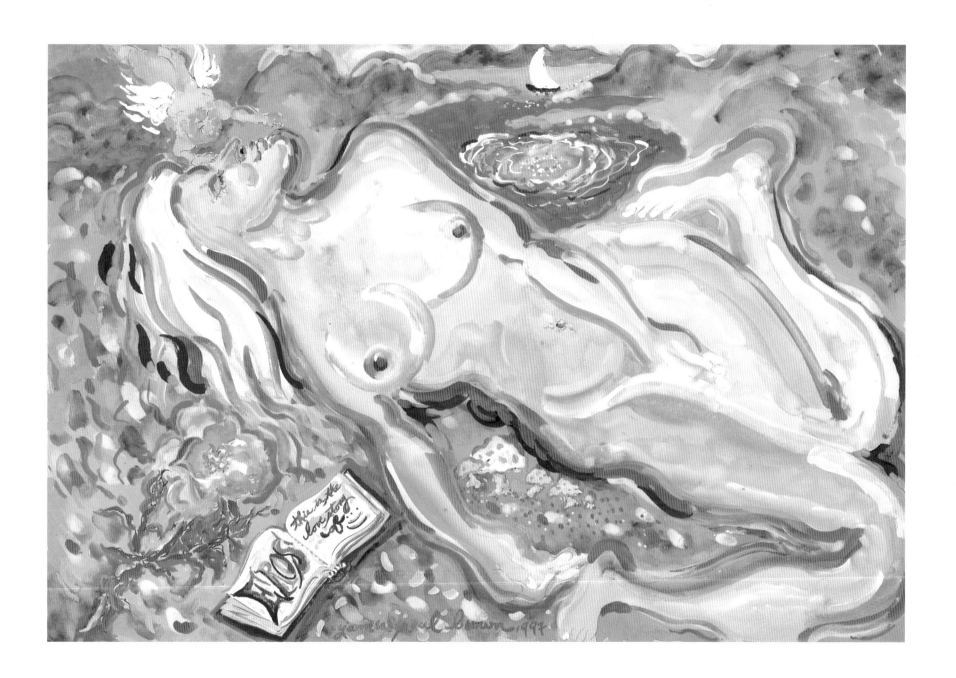

Eros, 1997 (mixed media)

Juliet (mixed media)

Juliet in St. Barts (gouache)

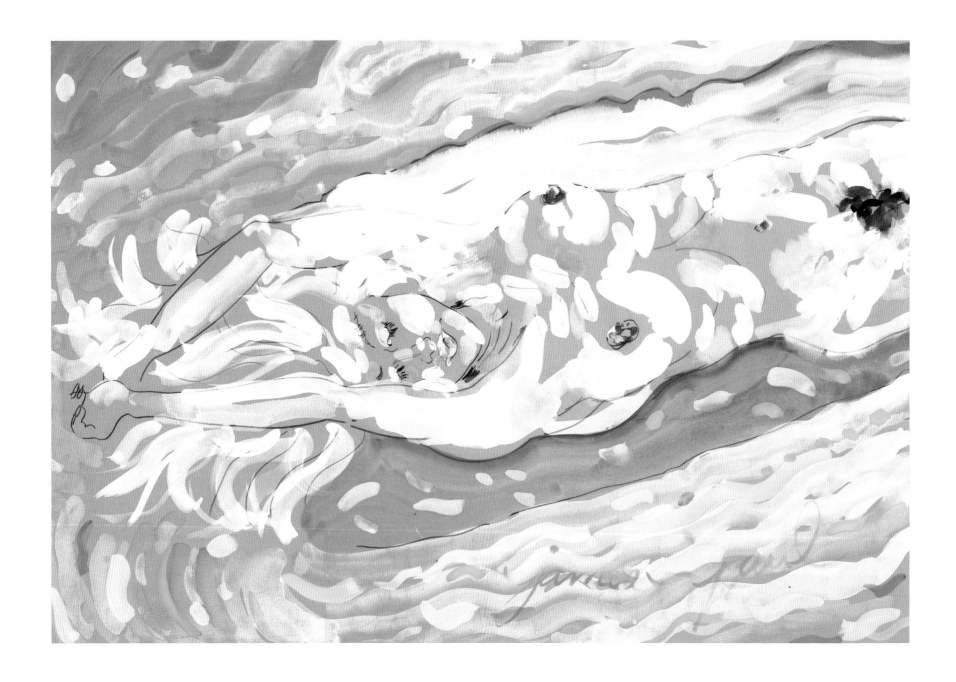

The Artist's Muse (mixed media)

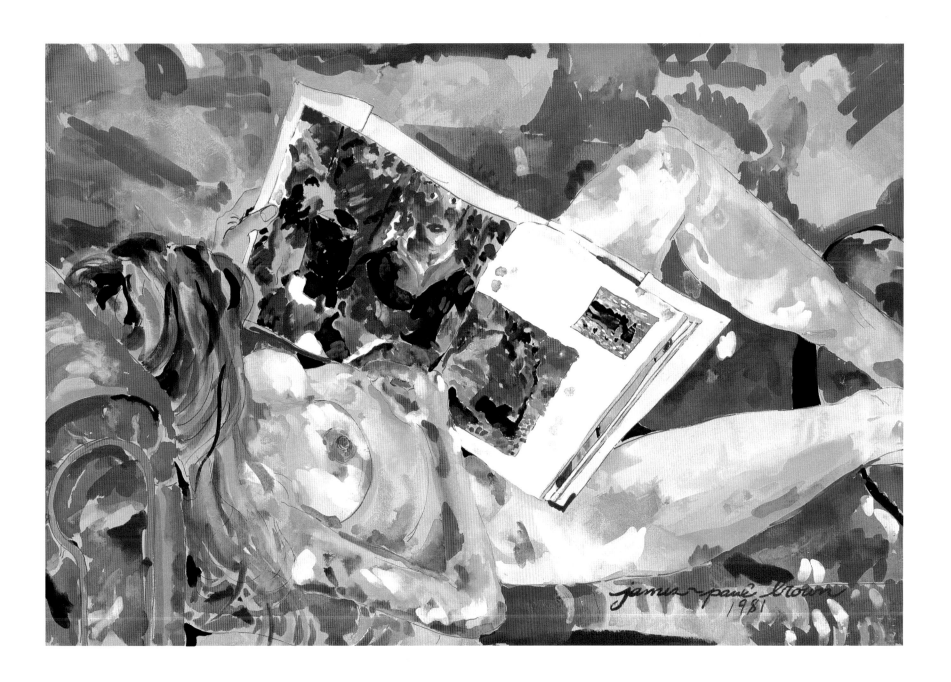

Nude Reading, 1981 (mixed media)

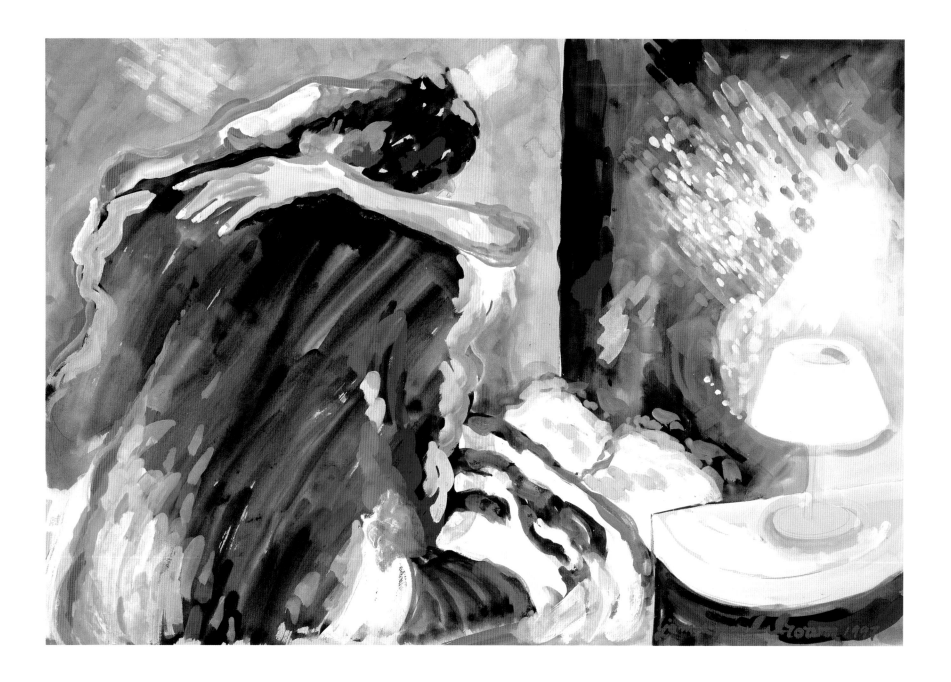

Seduction, 1997 (mixed media)

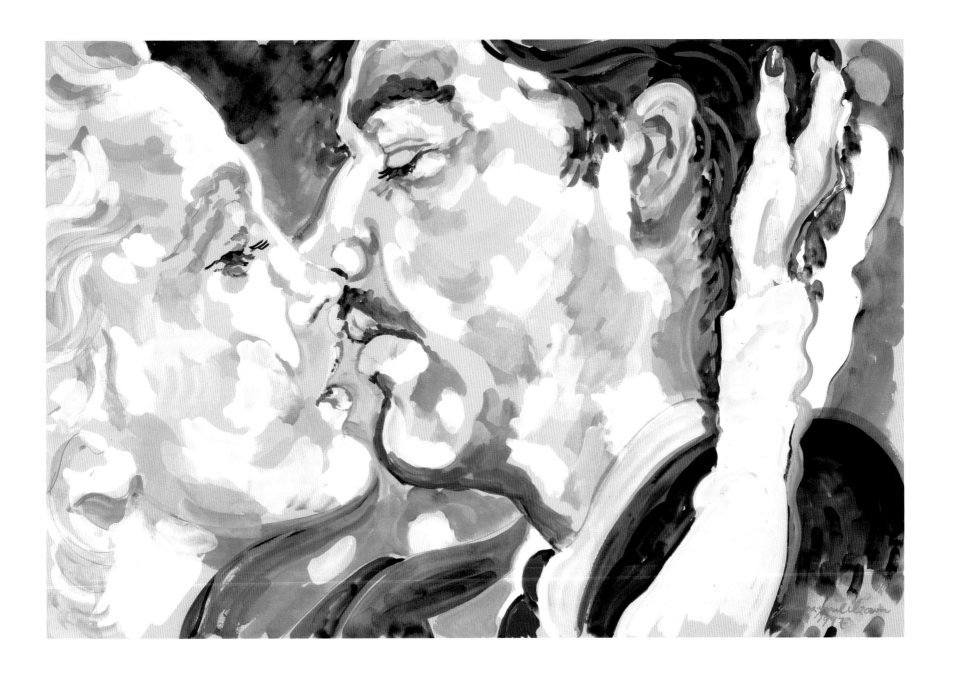

The Kiss, 1997 (mixed media)

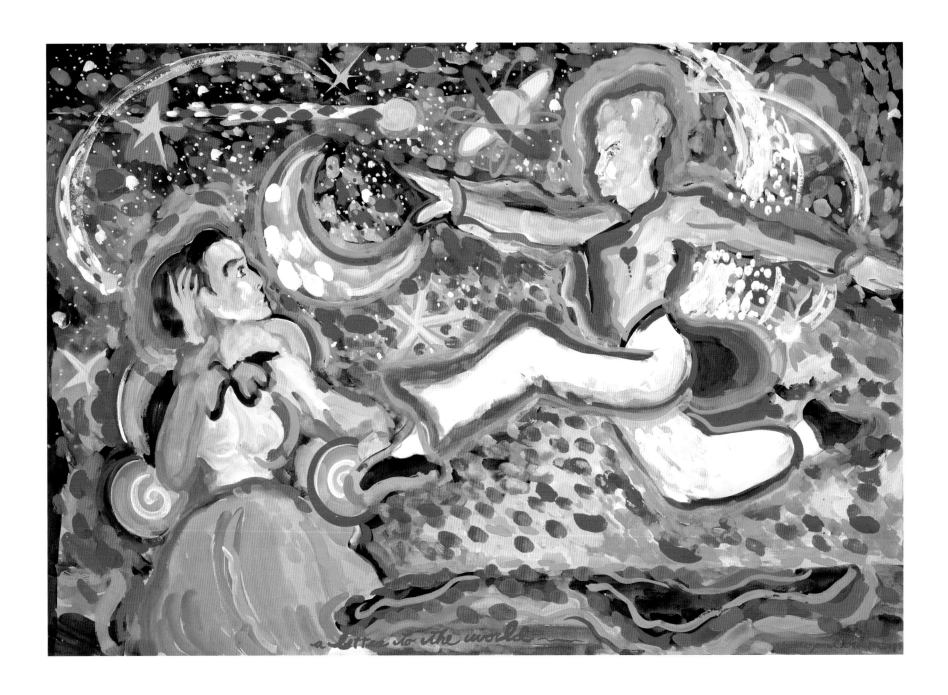

A Letter to the World, 1995 (mixed media)

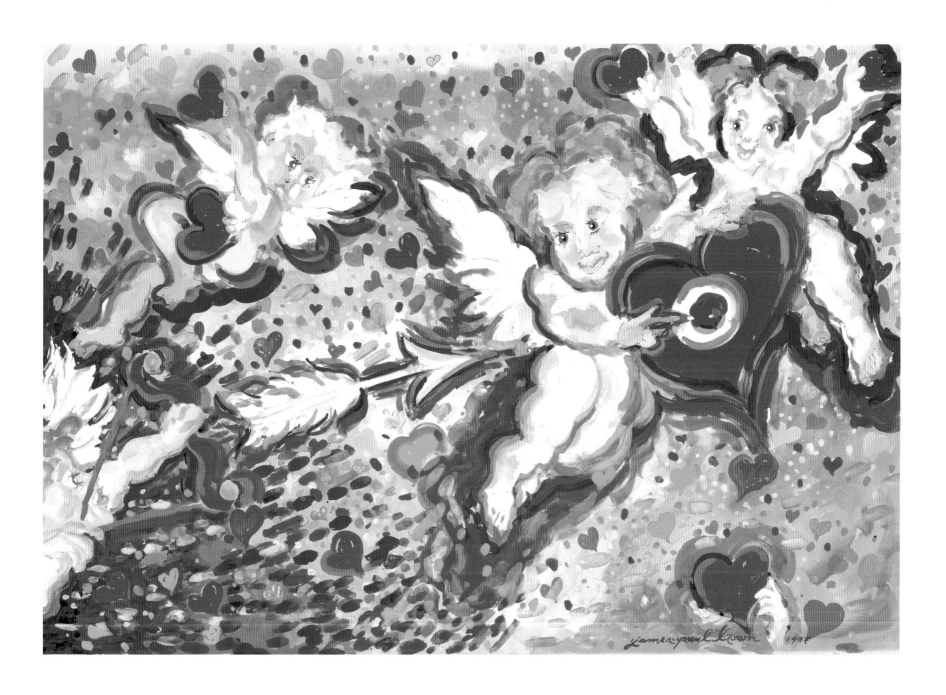

Cupids I, 1997 (mixed media)

231

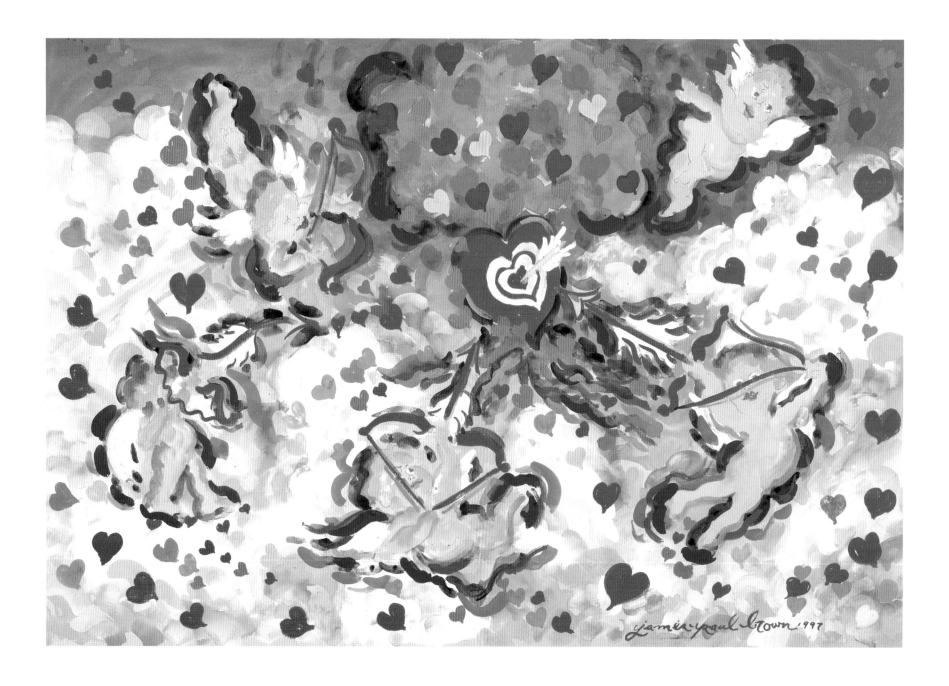

Cupids II, 1997 (mixed media)

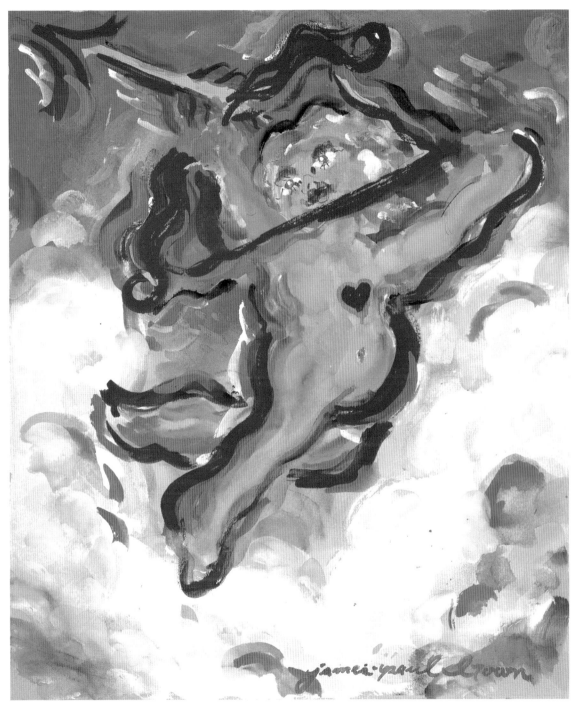

Cupid Takes Aim, 1997 (mixed media)

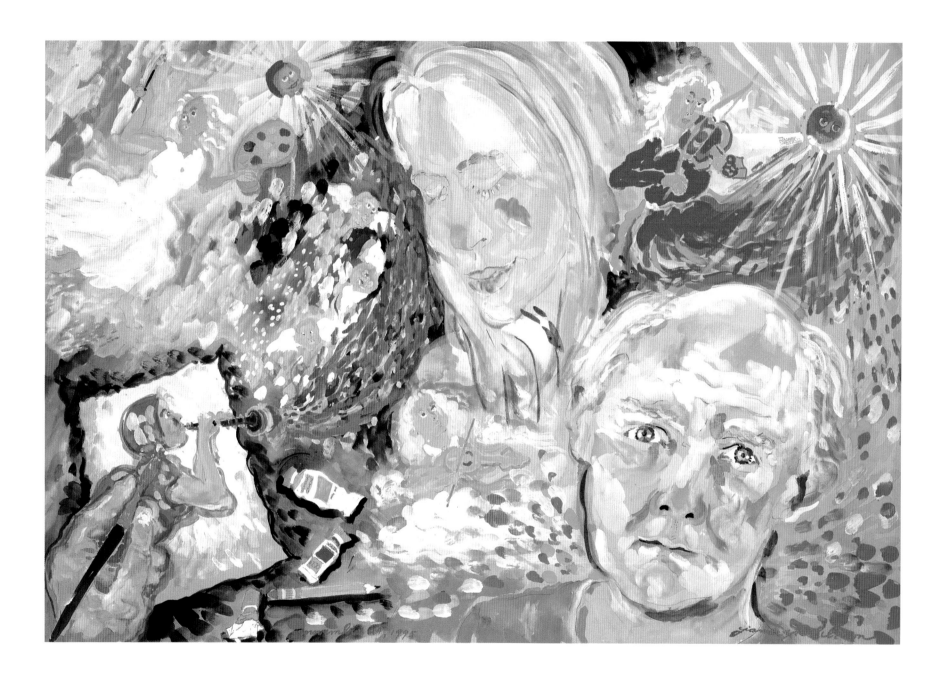

On My Mind II, 1995 (mixed media)

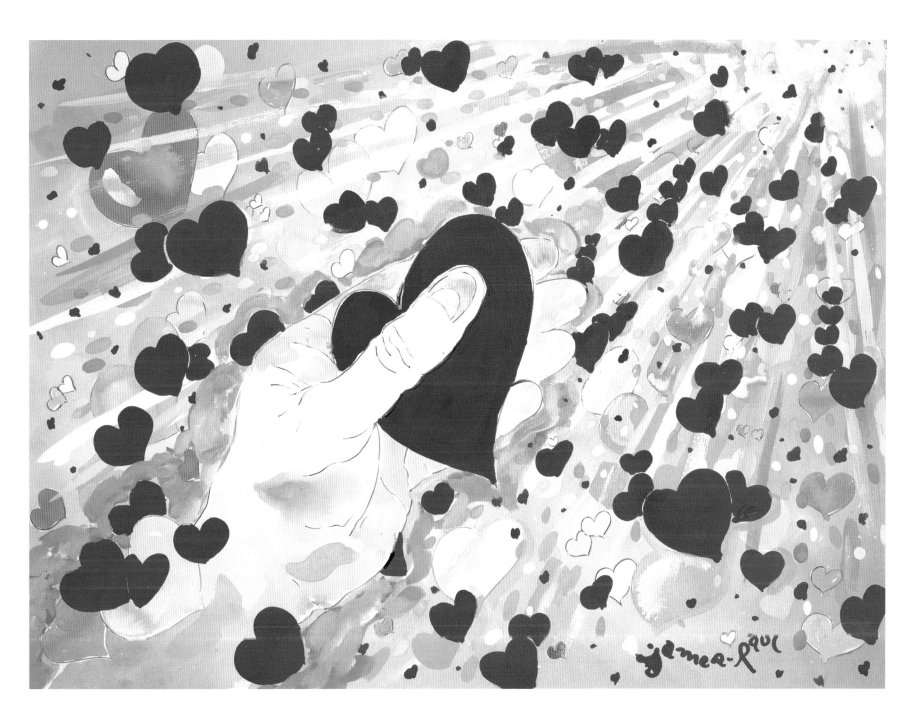

Heartfelt Love, 1993 (mixed media)

235

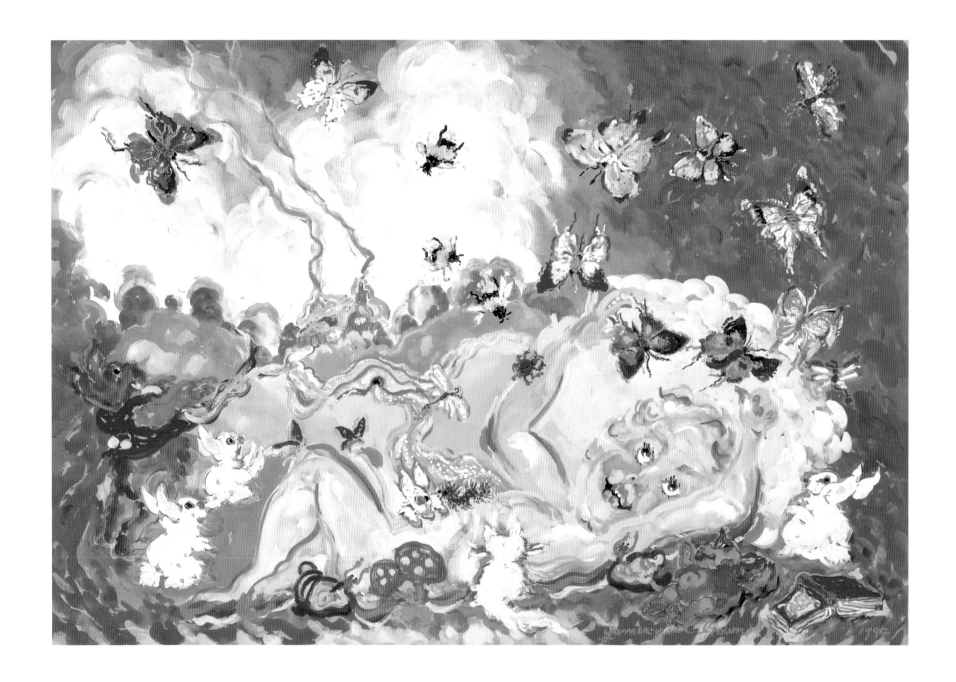

Cherubs IV, 1997 (mixed media)

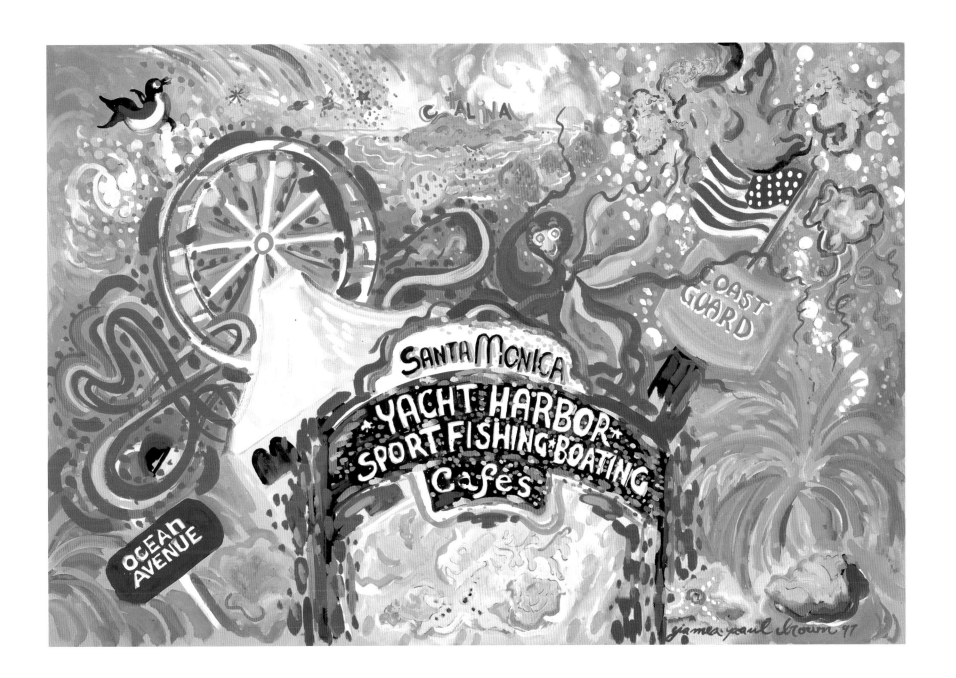

Santa Monica Harbor, 1997 (mixed media)

237

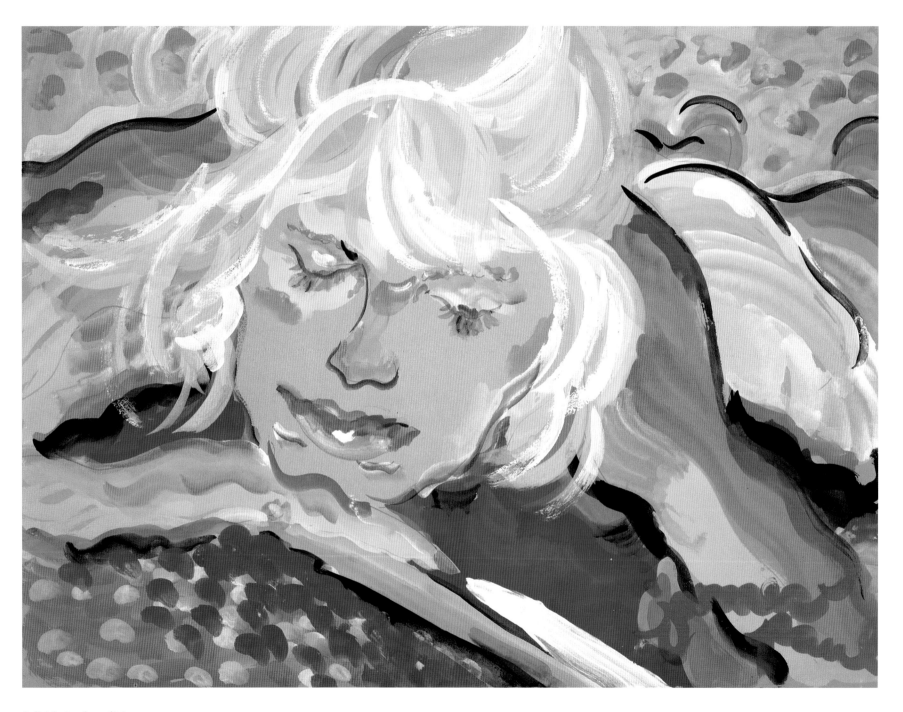

Juliet (mixed media)

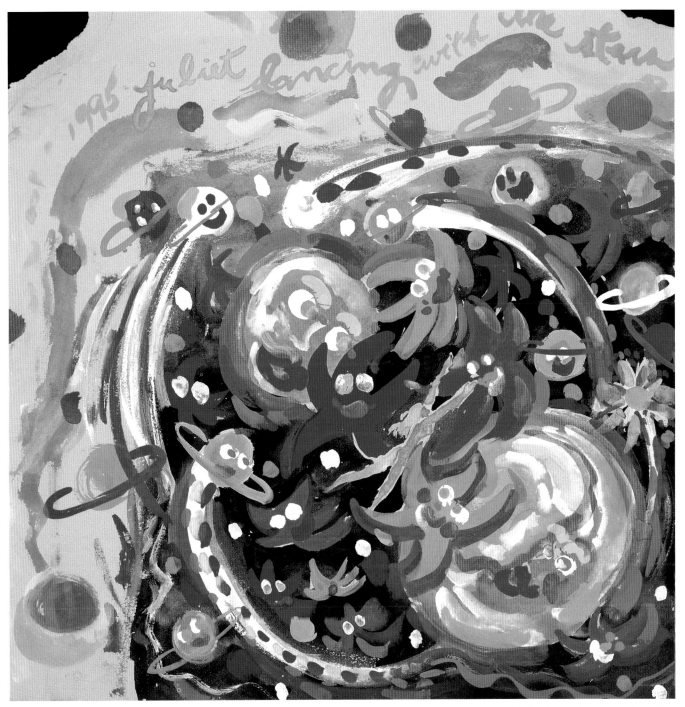

Juliet Dancing with the Stars, 1995 (mixed media)

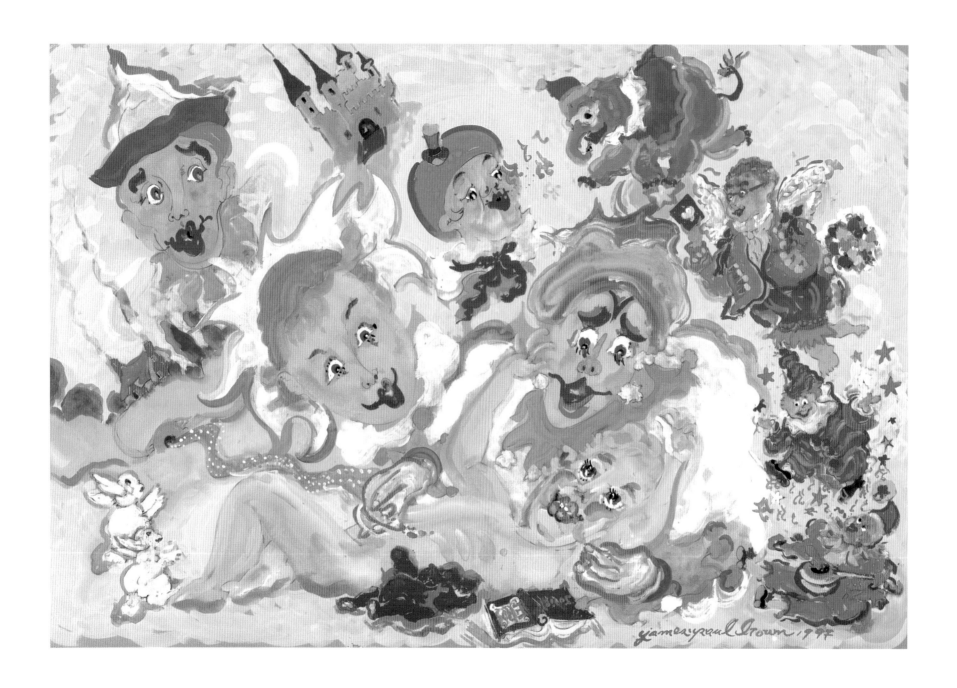

A Life Full of Love 1997 (mixed media)